PAINTING PEOPLE

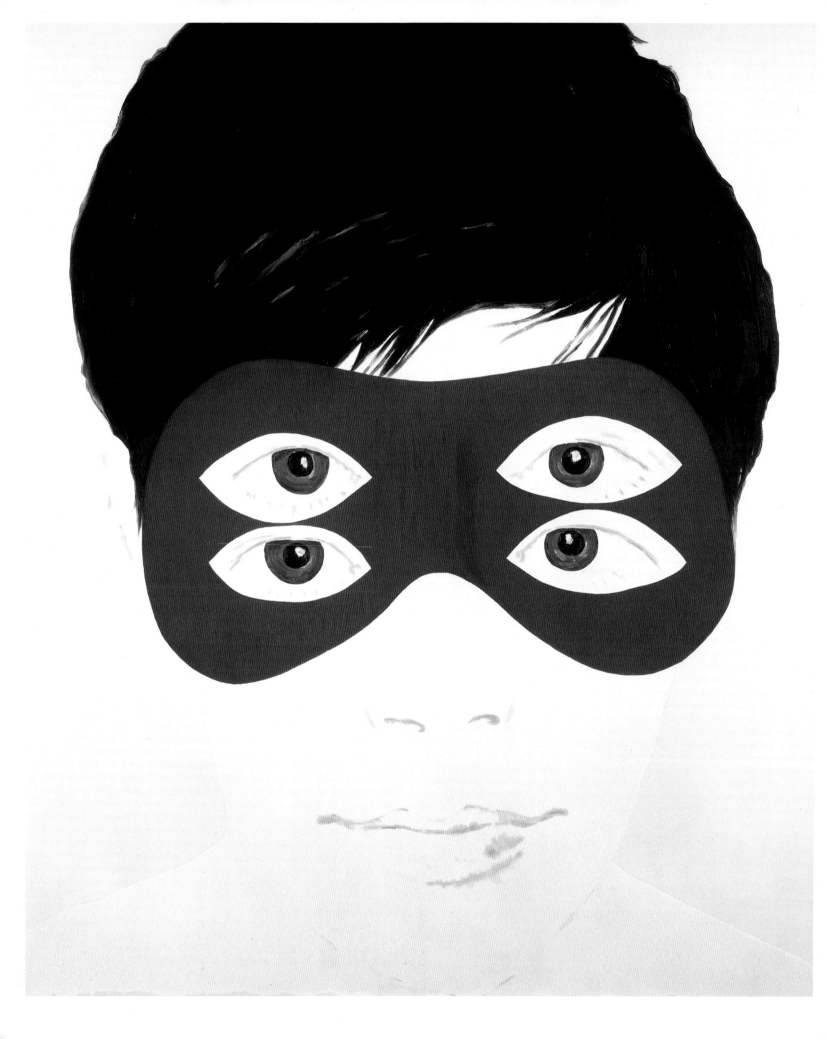

PAINTING PEOPLE

figure painting today

Charlotte Mullins

d·a·p

Frontispiece
James Rielly
I looked at him, he looked back at me, 2004

 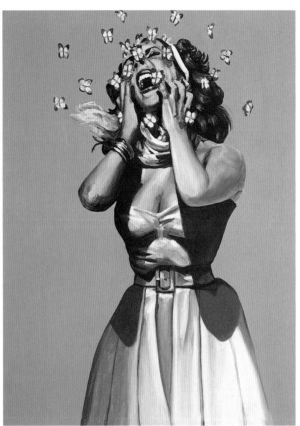 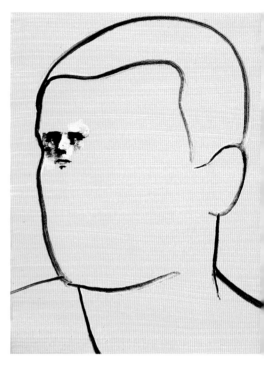

Elizabeth Peyton
*Truffaut at the Cinémathèque, 1968
(François Truffaut)*, 2005 [left]

Dawn Mellor
Elizabeth Taylor, 2002 [centre]

Wilhelm Sasnal
Untitled, 2004 [right]

Published and Distributed in America by:
D.A.P./Distributed Art Publishers
155 6th Avenue, 2nd Floor
New York, NY 10013
T: 212-627-1999
F: 212-627-9484

Copyright © 2006 Thames & Hudson Ltd, London
First paperback edition 2008

Library of Congress Cataloging-in-Publication Data
A catalog record for this book is available

ISBN: 978-1-933045-83-2

Printed and bound in China by C & C Offset Printing Co. Ltd

Contents

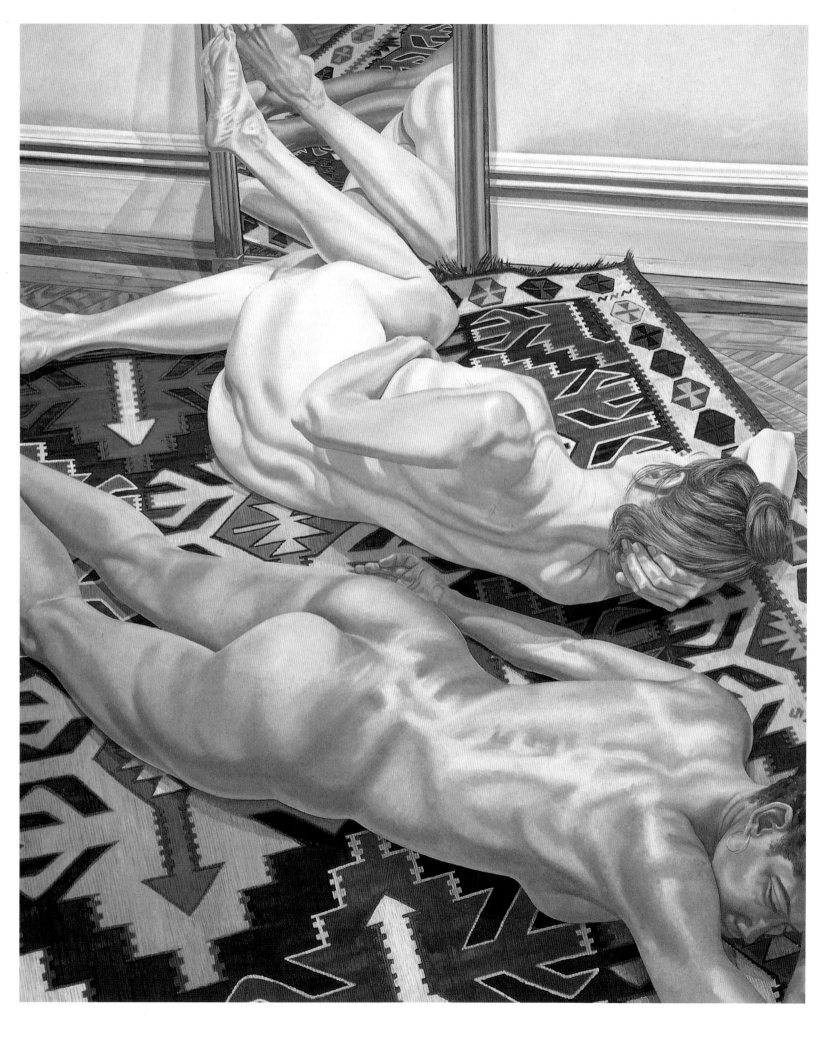

Introduction

An increasing number of emerging artists are today turning to the figure, and to painting, to express their ideas. Painting offers artists a chance to subtly segue between fact and fiction, to layer each work with the time it takes to complete it, to retain a sense of fluidity while working so sections can rise and fall in importance. It is process-based, requires the artist's physical touch, and provides artists with an infinite number of styles. Cecily Brown has described painting as alchemy: 'the paint is transformed into image, and hopefully paint and image transform together into a third and new thing.' Lucian Freud says he uses paint to capture 'the colour of life', while Peter Doig loads his canvas with colour so that by the process of making it, the painting assimilates how the viewer is 'absorbed into a place or landscape'.

The figure within painting offers the artist a chance to communicate directly to our senses – we recognize the anthropomorphic forms of a fellow human being, whether they are the last person on earth, as with Dana Schutz's paintings of Frank, or in fact not of this earth altogether, as in the work of Murakami protégée Aya Takano, or Inka Essenhigh. Figures give scale to cityscapes in the work of Martin Maloney or Jules de Balincourt, and make us aware of the subjective croppings of photographs and television footage when reporting on human activity, such as expressed in the work of Luc Tuymans or Wilhelm Sasnal. They connect us to complex histories – as seen in Zhang Xiaogang's paintings or those of Mathew Weir – or to the everyday banalities of contemporary life, as in the cool interiors of Eric Fischl. Freud and Brown use paint as flesh to talk of all bodies; Philip Akkerman and Margherita Manzelli use their own selves to explore how bodies are perceived and received.

But why should this be the case? Why do we paint ourselves? What is it about humankind that inspires the desire to reproduce the physiognomy of fellow humans? In classical mythology, the first ever painting was a portrait, a profile of the Maid of Corinth's lover drawn by her around his shadow on the wall of a cave before his departure overseas. But figure painting also extends beyond this desire for a likeness, a memento, a replica of life. Among the first marks made by humans – on the cave walls of Chauvet and Lascaux in France thirty thousand years ago – were handprints, a desire to leave a trace of the self for posterity, a marker saying 'I was here'. But they had a dual purpose, as did the charcoal and ochre paintings of mammoth and bison and man himself. At first, the aim of these paintings seems to be to simply record life, the world according to the scale and viewpoint of humans. But there is a growing belief that the paintings symbolize more than they depict, that even these early works of art were invested with a power beyond the descriptive. Often located in the far recesses of cave structures where no natural

Philip Pearlstein
Two Models on a Kilim Rug with Mirror, 1983

light could pass, these paintings would have been transformed in the firelight from representations of the specific – the single bison, the prone figure – into universal symbols of man and beast, signifiers of something beyond the present, of a belief system.

Figure painting has continued to occupy these two territories: the human form as subject, and as the vehicle for communicating a broader or greater subject. Portraits – whether in miniature for delivery to prospective royal suitors or to mark a marriage, death, a ceremony – are commissioned to provide a memento of the sitter's life, a painting in which the sitter will never change. Portraits cheat death, and have the lure of immortalizing the sitter. Despite the advent of photography, portraits have continued to be commissioned, their ability to capture the essence of the sitter over the time it takes to paint it often charging such images with much more authority than a single snapshot.

However, on the whole, *Painting People* is not concerned with portrait painters. For a book whose subject is artists who paint the figure, this might seem strange. But this book focuses on artists who use the figure – whether specific examples or anonymous bodies – to engage with wider themes. This is not to undermine the skill and technical ability of portrait painting, or its continued relevance. But it is because the portrait, by its very nature, reflects the emotions and actions of its specific subject, and its subject alone. It does not engage with universality, and the focus remains squarely on the named individuals

Maggi Hambling
Dorothy Hodgkin, 1985

who are represented. To give an example: Maggi Hambling's expressive portrait of eminent chemist Dorothy Hodgkin from 1985, at the National Portrait Gallery in London, captures Hodgkin's indefatigable energy in her seemingly moving hands, her scientific acumen represented by the papers strewn over her desk, the molecular models, the files racked up behind her. It creates a vivid impression of how she looked and how she was. But it says nothing about other female scientists, or the work of scientists in general. It is wholly about one woman's achievements. It is woman as subject.

In contrast, take a work such as Gerhard Richter's *Betty*, from 1988. Here is another portrait from around the same time, also of a woman. But this woman is unknown to us – we are only given her first name, and her head is turned so we only see the back of her head. Although the painting is in fact based on a photograph of the artist's daughter, we can't deduce this from the picture – it doesn't function as a portrait at all. She is twisted around so we see no identifying features, her body is shown cropped by the sides and bottom of the canvas, the surface slightly blurred. Painted in a photographic style, it has more to say on the status of painting, on photography and our reading of images than on its given subject. Betty, the woman, functions as a vehicle through which we approach the larger debate on issues of representation, both photographic and painterly.

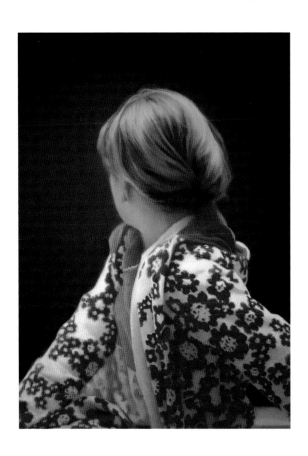

Gerhard Richter
Betty, 1988

Consequently, Richter is represented in this book and Hambling is not. But that's not to say that you won't find a single portrait in *Painting People* – where crossovers occur from the particular to the universal, as in the work of Lucian Freud for example, exceptions have been made. Freud may use live models to paint from, many of whom are well-known, but through painting them he creates a figure to whom we can all relate, one which has been pushed beyond an individual representation through his combative handling of paint, as he constantly reworks the theme of what it is to paint flesh and bone.

WHY PAINTING NOW?

Figure painting is currently experiencing a major revival. But why? In recent decades, painting as a whole has often been talked about as being in the doldrums, of being moribund or even dead. Following modernism's demise after its long search for the perfect self-referential painting, in the form of the ultimate abstract canvas, Douglas Crimp asserted – in his inflammatory 1981 essay 'The End of Painting' – that painting had martyred itself. In achieving its nihilistic aim, it had painted itself into a corner from which there could be no escape. Other influential theorists such as Yve-Alain Bois, who wrote the essay 'Painting: The Task of Mourning' in 1986, confirmed Crimp's diagnosis, and artists themselves appeared to hammer in the final coffin nails as they publicly embraced new media such as video and photography, or turned to installation-making, at the expense of painting. But, as Sabine Folie, one of the curators of the seminal 2002 figurative painting show 'Cher Peintre, Lieber Maler, Dear Painter' at the Centre Pompidou, Paris, has commented, artists did continue to paint. In fact, painting was just biding its time until critical attention returned to find it in rude health. 'Painting may have been for a short time somehow denied by an overexposure of video computer-art or photography,' says Folie, 'but in the end, its methods of representation and transformation were enriched by all those media and not diminished.'

Painting, and particularly figurative painting, has found itself increasingly favoured by artists, curators, critics and collectors since the turn of the new millennium. It's true, painting no longer exists in the sanctimonious pole position of art genres as abstraction once did at the height of modernism. That notion of hierarchy is as dated as the art work it supported. There's no longer the sensibility that one genre should dominate contemporary art in its entirety, as was claimed for abstract expressionism in post-war America. And there's no longer a sense of having to choose which style of work you exhibit, if you happen to be like Philip Guston and dramatically switch from abstraction to figuration mid-career. With the advent of postmodernism, which embraced diversity and

multiple viewpoints, and represented a fracturing of stylistic hierarchies and a knowing sense of historical irony, artists such as Gerhard Richter became modernism's antagonists, with their broad sweeps across a variety of subjects and painting styles.

As a result, young artists rarely pin themselves down to one specific area of expertise, shunning specific descriptive names such as 'painter' or 'sculptor' as they dart from one medium to another, often building their eclectic portfolios out of photography, installation, painting, film and performance. Such a variety of approach is encouraged by art schools across the Western world and beyond, as tightly categorized departments – painting, printmaking, performance – are merged and artists continue to reject training in one particular skill for a more general approach to making art. However, *Painting People* is primarily concerned with artists who place both painting and the figure at the heart of their practice.

PAINTERS OF MODERN LIFE

The figure is an important subject for contemporary artists. Artists see, as we all do, the world through the eyes of their own body (and, if they are Margherita Manzelli or Philip Akkerman, they don't get any further than their reflection in their search for subject matter). Artists see other figures in action as they go about the most mundane tasks – going to the supermarket, watching the news, having a drink in a bar. Figures, people, are all around, and – importantly – are always on the move, changing the dynamics of a space, changing the atmosphere of a particular location, emotionally charging environments built for their interaction, precipitating events.

The majority of artists in this book paint the figure in some way interacting with the world around them in new ways. Although Chapter 1 does explore the work of artists who chiefly focus on the appearance of the body and how it breaks down under scrutiny, the other chapters explore how the figure responds to or appears in certain situations both real – as in Chapter 2 – and imagined, as in Chapter 3.

Baudelaire wrote his treatise 'The Painter of Modern Life' in 1863, based on the illustrator Constantin Guys. But its central character was most typified by Baudelaire's friend Edouard Manet, who looms large as an overarching influence as artists continue to be curious about the world they live in. Manet's fascination with the complexities of Parisian nightlife in the 1860s and 1870s has been transposed by contemporary artists into tower-block landscapes or American diners. Photography was already big business at the time of Manet's masterworks, such as *Olympia*, 1863, and *A Bar at the Folies-Bergère*, 1881–82; Salon artist Paul Delaroche, on seeing his first daguerreotype, had already declared that 'from today painting is dead', shortly before his own death in 1856. But Manet created scenes – as today's artists do – that couldn't have been achieved by photographic or any other means.

People still ask why artists continue to paint today, when photography can also achieve results both real and – with the help of a computer and Photoshop – imagined. Why spend

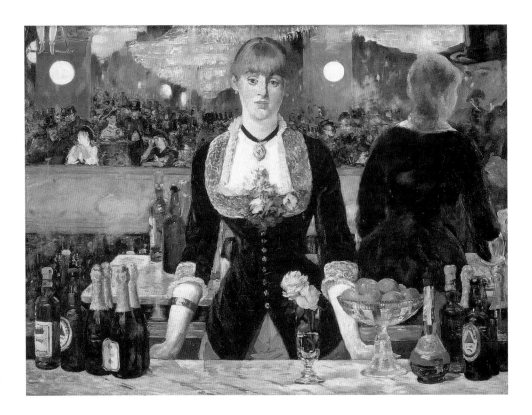

Edouard Manet
A Bar at the Folies-Bergère,
1881–82

the time it takes to paint a cityscape and populate it with everyday citizens when you could capture it digitally? Perhaps Manet's *A Bar at the Folies-Bergère* can offer an answer: photographs of the Folies-Bergère, taken around the time of Manet's paintings, also exist, but it is the painting that captures the isolation and complexity of the barmaid's position, her relationship with the man at the bar (only seen as a reflection) and with the clientele at large. It tells a myriad of stories across its singular canvas, one overlaid on top of the other.

Theorist Thierry de Duve, in a recent conversation with curator Bernhard Mendes Bürgi published in the catalogue that accompanied the 2002 Basel exhibition 'Painting on the Move', concluded that from the time of Manet until the 1970s, when Gerhard Richter started gaining recognition, no artist had continued Manet's explorations into what it was to paint modern life. Modernism, the unrelenting tread of abstraction and art for art's sake, he said, closed eyes to the possibility of engaging with the world around them. For de Duve, by the time the 1970s dawned, he feared for painting's survival: 'Painting no longer seemed able to speak of the world but only of itself. This self-reference brought a risk of sterility.' It is in this post-war period that contemporary figure painting has its roots.

ABSTRACTION LOSES ITS CROWN

Bernhard Mendes Bürgi, in the same conversation with de Duve in the 'Painting on the Move' catalogue, summed up where painting stood at the end of the Second World War: 'Remember the role that was attributed to abstraction as the universal language of the

post-war period: it was destined to overcome figuration, which seemed corrupted by Fascism. This was the modernist ideology of the post-war period.' Abstraction had risen out of painting's increasing concern with its own ideology, which began once its representational role had been diminished as photography burgeoned in the late nineteenth century. Douglas Crimp – in a recent interview in the 'Painting on the Move' catalogue that dealt with the legacy of his essay 'The End of Painting' – explained abstraction's end game as this: 'Painting became self-reflexive and constantly sought to renew itself, a renewal that seemed to tend "logically" toward reduction and ultimately to an end. Modernist painting is thus energized by being threatened, even or especially in all those instances in which painters claim to be making the final paintings, the paintings that will bring about the end of painting.'

Esteemed art critic Clement Greenberg championed abstraction when it stormed New York following the Second World War. He admired its integrity as representing itself first: it was a picture foremost, an object, rather than an illusionistic 'window' on the world. But as abstraction ran out of places to go, artists and critics began to tire of it. In a dramatic move, abstract painter Philip Guston switched to painting grotesque cartoon-like figuration in 1970. Ten years earlier, he was already questioning the validity of abstraction: 'There is something ridiculous and miserly in the myth we inherit from abstract art: that painting is autonomous, pure and for itself, and therefore we habitually analyse its ingredients and define its limits. But painting is "impure". It is the adjustment of "impurities" which forces painting's continuity. We are image-makers and image-ridden.'

He wasn't alone in responding to abstraction's tired ideals with fully-fledged realism. American pop artists, photorealists and new realists (such as Philip Pearlstein and Chuck Close), German capitalist realists, English pop artists and the 'School of London' – Frank Auerbach, Lucian Freud – all returned to realism, rescuing the figure out of the hands of Fascism and placing it back in the high-art arena.

COUNTERING MASS REPRODUCTION

Andy Warhol's screen-printed idols and Roy Lichtenstein's appropriation of comic strip style using the Ben Day dots of newspaper reproduction, precipitated an interest in mass-produced images that Walter Benjamin had first commented on in his influential 1936 essay 'The Work of Art in the Age of Mechanical Reproduction'. Benjamin raised questions of originality and authenticity, as photography, film and cheap printing processes increasingly distributed images to an ever-wider audience. While applauding these processes for allowing art – as a reproduction – to be disseminated to far more places than the original could ever reach, he noted that the 'aura' of the original could never be reproduced. The reproduction lacked the history of the original, its presence in time and space. As Benjamin noted: 'The presence of the original is the prerequisite to the concept of authenticity.'

In Germany, artists such as Sigmar Polke and Gerhard Richter, who briefly came together as German pop artists (later known as capitalist realists) in 1963, also started using mass-produced images as a way of questioning their role and veracity, further exploring Benjamin's ideas. Reacting to the hegemony of abstraction, and feeling the influence of American pop, they both chose to work with found photographs from newspapers and journals, exploring how the repetition of an image could divest it of its subjectivity, meaning and purpose. In this way, they occupied similar ground to Warhol, who chose to reproduce photographs of electric chairs and car crash victims on canvas, multiplying horrific images so they became mere surface pattern, their content transformed through mass reproduction into an objective series of shapes and forms.

Richter chose to use found images to explore the relationship between photography and painting. He worked in a variant photorealist style, painting portraits and family groups, Nazi soldiers and aircraft, flowers and candles, blurring each one to imply both the painting's photographic source material but also that it was an illusion – these paintings weren't 'windows' on the world either, despite their figurative content; they were objects, the image smeared on in a thin layer over the surface. Richter also painted abstract canvases to further illustrate his concerns as to the validity of representation. His gestural strokes of colour over canvas were all in fact carefully copied from details of photographic slides taken of earlier oil sketches he had made. At a time when images were bombarding you in the street, in magazines, on the bus, asking you to believe in what they were selling, Richter was highlighting their covert codes, their position as false idols of reality, by making you question what you were in fact really looking at. (The issues Richter continues to investigate are looked at in more depth in Chapter 5, along with the artists who have followed him in questioning the sincerity of mass-produced images.)

POST-WAR EXPRESSIONISM

British pop was less cynical than its German counterpart, and artists such as Eduardo Paolozzi, Peter Blake and to a certain extent David Hockney, celebrated the new flood of imagery from America. Hockney's faux-naïve style of painting at this time had a flavour of Freud's early works; by the 1960s Freud, in contrast, had begun to build up his portraits with faces chiselled into faceted planes. Both Hockney and Freud have been preoccupied by the figure throughout their careers, and their work, both historic and recent, continues to exert a strong influence on a range of artists from Elizabeth Peyton to Ridley Howard.

Freud's painting style – and that of others in the movement dubbed the 'School of London' such as Frank Auerbach and Leon Kossoff – was essentially expressionistic. They worked from life, often painting each other before they could afford models, and using thick strokes of paint to build up faces and bodies. This style of painting, while flourishing in London in the 1950s, was eclipsed by the cool consumerism of pop that affected artists

across Europe and America. But pop, in turn, gave way to a whole range of new styles as art expanded to include giant works made in the landscape, performance pieces, conceptual and feminist art and the birth of video as an art form. Painting, perhaps not surprisingly with so many new developments, was neglected by curators and critics during the 1970s, as attention was given to the nascent art forms. But at the start of the 1980s, expressionist painting suddenly coalesced to become a multinational phenomenon, encapsulated by the exhibition 'A New Spirit in Painting' at the Royal Academy in London in 1981.

A NEW SPIRIT IN PAINTING

The exhibition included a diverse group of artists collectively referred to as neo-expressionists. The group included the Neue Wilden (Wild Ones), from Germany, including Georg Baselitz (see p. 20), Jorg Immendorf and Anselm Kiefer, and the Transavantgardia (Beyond the Avant-garde) of Italy, represented by Sandro Chia and Francesco Clemente (see p. 21) among others. American painters Julian Schnabel, David Salle and Eric Fischl also sheltered under the umbrella of the intercontinental term, each cluster of artists loosely connected by their concurrent return to painting and their fiercely expressionistic figurative style that often placed the artist himself at the centre of the work.

But no sooner had neo-expressionism hit the big time, it seemed, than it was 'over'. American critics renamed it 'Bad Painting' because of many of the artists' apparent lack of conventional skills and their clumsy, crude subjects. It seemed that, at least critically, theorists such as Douglas Crimp and Yve-Alain Bois, who were metaphorically killing off painting at this time, were right. Although all the neo-expressionist artists continued to make commercially successful work, and continued to find a private audience, as did other artists from 'A New Spirit in Painting', such as Paula Rego, the public sphere of galleries and critical attention was mainly closed to them. Younger artists such as Peter Doig in England, John Currin in America and Takashi Murakami in Japan began to exhibit their own paintings commercially and to a degree publicly, but they were the exceptions to the rule, and the art world's ever-roving eye was essentially blinkered to painting once more.

PAINTING'S RESURGENCE

The Young British Artist (YBA) phenomenon, that lasted for most of the 1990s, was seen as being typified by installation art and video, as made by Damien Hirst, Tracey Emin, Sarah Lucas and Jake and Dinos Chapman. Painters such as Gary Hume and Marcus Harvey, Chris Ofili and Jenny Saville were also included in the seminal YBA group shows of 1995–97 that took YBA art to Minneapolis ('Brilliant' at the Walker Arts Center), Venice ('General Release' as part of the Venice Biennale), as well as Houston, Sydney, Copenhagen, Johannesberg and back to London ('Sensation' at the Royal Academy), but the overriding memory of the YBA decade is one of three dimensions, not two.

So, perhaps not surprisingly, the resurgence of painting did not begin in Britain. In America, figure painters such as John Currin and Elizabeth Peyton led the way. European artists like Luc Tuymans and Marlene Dumas exhibited internationally more frequently, and in Japan, a group of young artists including Takashi Murakami and Yoshitomo Nara were challenging the centuries-old traditions of Japanese painting to create work that fused the flatness of traditional Japanese *nihonga* painting with American pop art and the Japanese cartoon styles of *manga* and *anime*.

FIGURE PAINTING GOES GLOBAL

Across Europe and America in the late 1990s, group painting shows started to emerge that connected previously isolated protagonists. Early examples included the three-way show of work by Elizabeth Peyton, John Currin and Luc Tuymans at the Museum of Modern Art, New York, in 1997, and 'Examining Pictures' from 1999, organized by the Museum of Contemporary Art in Chicago and the Whitechapel Art Gallery, London, that featured one work by fifty-six artists including Richter, Guston, Manzelli and Glenn Brown. 'New Neurotic Realism', that opened at the Saatchi Gallery, London in 1998, profiled the work of British newcomers Martin Maloney, Chantal Joffe and Cecily Brown.

As the new millennium dawned, public exhibitions became more ambitious as an increasing number of exciting new painters started to appear worldwide. In 2002, three major museums in Basel – the Kunsthalle, Kunstmuseum and Museum für Gegenwartkunst – came together to present 'Painting on the Move', a sprawling exhibition by curators Bernhard Mendes Bürgi and Peter Pakesch that covered the entire twentieth century, from Claude Monet to Neo Rauch and Chéri Samba. A year earlier, the Walker Arts Center in Minneapolis organized 'Painting at the Edge of the World', curated by Douglas Fogle, which included thirty artists and was supported by a substantial catalogue. It introduced young European painters such as Eberhard Havekost to an American audience, as well as helping to re-establish the work of Martin Kippenberger, who would also crop up a year later in both 'Painting on the Move' and the Centre Pompidou's pivotal show 'Cher Peintre, Lieber Maler, Dear Painter'.

KIPPENBERGER AND PICABIA

While 'Painting at the Edge of the World' examined Yve-Alain Bois's concession from his 1986 essay 'Painting: The Task of Mourning' that if painting were to survive, it would do so in the most unlikely of places, 'Cher Peintre…' looked at the long-running and once conservative genre of figurative painting. The eclectic work of the late German artist Kippenberger – whose oeuvre is proving increasingly influential to a whole roster of young contemporary artists coming out of art schools today – explores, as Richter has done, what painting can be in a world already crammed full of disparate images.

Martin Kippenberger
Untitled, 1981 (from the
series *Lieber Maler Male Mir*
(Dear Painter Paint For Me)

Another artist no longer alive but equally influential to today's artists is Francis Picabia, whose works from the 1940s were the starting point for 'Cher Peintre…'. Known for his involvement with Dada and surrealism, Picabia's illustrative copies of soft-porn photographs were rarely exhibited after his death in 1953. Critics just didn't know how to deal with such a shift in style. But artists saw in Picabia someone constantly striving to communicate his ideas irrespective of style – the clumsy nudes are now interpreted as a caustic reaction to Nazi attitudes to modern art and their degenerative art exhibitions. In a 1979 interview, Richter compared himself to Picabia; Museum of Modern Art curator Robert Storr, in his 2003 book on Gerhard Richter, summed up Picabia's importance to Richter and to many other artists: 'By the 1960s, few artists in Europe or America thought, as Pollock and Willem de Kooning had twenty years earlier, that Picasso was "the man to beat", but in Europe, as distinct from America, the idea that Picabia's multifariousness might open paths through the unified theory of modernism had taken hold.'

THE IMAGE EXPLODES

Artists who paint are aware of the history of the medium, and references to paintings from all ages can be found in the work of many of the artists in this book. With the prevalence of cheap colour printing, scanners and the internet, painting's history is laid out like a web in front of each artist, the work of Rembrandt as accessible as that of Rousseau or Rauschenberg, and artists such as Rosson Crow and Richard Wathen dart across it effortlessly. All artists, to some extent, operate with the knowledge that these vast stores of images are available at the click of a mouse.

This relentless proliferation of high-quality reproductions seems at the core of much contemporary art produced today, whether used as source material or as a subject that continues to be addressed. Photographs are a vital tool for twenty-first-century artists. Photography is no longer seen as the assassin of painting, as Delaroche and others initially feared it would be, but as an accomplice to painting's continued existence. In the 1970s, Chuck Close created airbrushed portraits of himself and close friends that were scaled-up copies of original photographs. They were at once a copy (of a photograph) and an original (work of art). Close's more recent work continues to explore the fertile ground between photography, painting and representation, but now his giant portraits resemble pixellated digital images. (Over the past decade there has been a new flowering of photorealist art, and while there are several artists who do add a new twist to the style – the gothic realities of David Hancock; Jason Brooks's squatting women; the portraits of Luke Caulfield, Tim Gardner, Antje Majewski, Jan Nelson – on the whole the genre hasn't moved on significantly, and consequently doesn't feature in this book.)

Some contemporary artists do refuse to embrace the totalitarianism of photography, and have chosen to work in a style that resembles folk art, or outsider art, seeing the clunky authenticity of art by the untrained as a salve for the slick, surface gloss of the photographic images that proliferate today. Current neo-folk art, as seen in Chapter 4, refuses the perspective and framings of photography and film, and prefers the subjective scale of memory as seen in the paintings of Henri Rousseau or the illustrations of Henry Darger. Artists such as Christoph Ruckhäberle and Jocelyn Hobbie tuck awkward figures into strangely distorted rooms that echo dreams or nightmares, an imprint of a past event as it is engrained on their subjectivities, rather than a photographic record of it.

FIGURE PAINTING RIDES HIGH

Most artists who have chosen to concentrate on painting seem in agreement that painting offers an antidote to the rat-tat-tat of images that are shot at us from every corner of our daily lives. Paintings create pauses in life, and offer distillations of subjects rather than unconnected snapshots. We experience the world as if it were a painting being completed – multiple views are built up over time to become fused in our memory. We don't see in the present, but through knowledge compiled in both the recent and distant past. We don't understand the world through a series of frozen moments seen out of context and subjectively cropped, divested of meaning. We all operate like painters, not photographers, in this way.

But figure painting has also risen up to counter the instant-hit brashness of much of the work of the Young British Artists and the slick consumerism of Jeff Koons's sculpture. And figure painting's current success has as much to do with audience receptivity as artistic practice, as evinced by the increasing number of major museum shows dedicated to the subject. Lucian Freud's retrospective at Tate Britain, London, in 2002 was followed by another at the Museo Correr, Venice, to coincide with the 2005 Venice Biennale. The 2004 Whitney Biennial acknowledged a prevalence of artists painting the figure and featured work by Brown, Peyton, Barnaby Furnas and Hernan Bas, as did the 2004 Carnegie International – which showcased Doig, Rauch and Mamma Andersson among others – and the 2005 Prague Biennale, with its central theme of 'Expanded Painting' that included Wilhelm Sasnal, Michaël Borremans and Dawn Mellor. In London, the Saatchi Gallery's 2005 gargantuan multi-part exhibition entitled 'The Triumph of Painting' that featured Kippenberger, Dumas and Doig, shows that even major collectors such as Charles Saatchi, who was in part responsible for the YBA phenomenon, has noticed the sea change and trimmed his sails accordingly.

Figure painting is buoyant on a rising tide: and looks set to continue on this course for quite some time to come. This book aims to whet your whistle with work by eighty-five of the most exciting artists from all over the world who are painting the figure, and the themes that are currently fascinating them.

1 The Figure Unravelled

Lucian Freud is the most influential figure painter of his generation. Born in Berlin in 1922, he came to England in 1933 – he still paints from his top floor studio in Paddington, London. The studio has seen famous sitters such as Kate Moss sprawl across its tattered sofas, illuminated by an overhead lightbulb that casts harsh shadows under bent arms and legs and tints the skin like a yellowing bruise. Freud's early paintings show each person luminously painted, every hair delineated, large glassy eyes reflecting innocence and fear. They have an other-worldly naïvete to them, and are now influencing many of the artists looked at in Chapter 4. But Freud's style continued to develop over the decades and his figures are now encrusted with granular paint, their skin rubbed raw by the paintbrush. His nudes are not nudes in the tradition of, say, Titian or Rubens – buffed folds of suggestive flesh soft like ripe peaches – but are brutally honest depictions of naked bodies shown for what they are.

Although Freud has always painted in a figurative style, his work is as far removed from a photographic likeness as you could imagine. He works from life, each painted figure the distillation of his observations from sometimes hundreds of sittings. He uses paint as if it were the building blocks of life, creating each figure on canvas by constructing them out of facets of grey and ochre and veridian and vermillion. Unlike a photograph, in which every element of the subject represented is necessarily given equal weight by the freeze-frame flattening of it, Freud's paintings are subjectively composed with more attention paid to things that interest him. A foot is bigger than a head; male genitals and female faces are swollen and sanguine. The perspective of the sparsely furnished studio changes as he walks around the figure and consequently the room often appears off-kilter on the finished canvas. These works are painted

Lucian Freud *The Artist Surprised by a Naked Admirer, 2005*

Georg Baselitz *Der Schmuggler*, 2003

over time, and consequently time itself is captured in the accumulations of paint, in the shifts in perspective, in the physicality of the subject. And while Freud often paints recognizable people it is rare that their identity becomes more important than the direct communication that his works achieve about what it is to paint flesh.

Freud continues to push his work in new directions, as *The Artist Surprised by a Naked Admirer*, 2005, reveals, with its complex psychological narrative. And his work continues to influence many other artists who paint the figure, from Cecily Brown and Yan Pei-Ming to Jenny Saville. Saville made a name for herself – as Freud did – straight out of college in the early 1990s, and her monumental early nudes, based on her own body, raise questions about what it is to paint a naked woman, the imperfections of beauty and the realities of flesh. Her painting style has always been muscular and tempestuous, and in her latest large-scale heads its sheer energy threatens to rip apart the subject. Only the eyes of each person remain in stasis, deep pools of tawny-brown or grey, that somehow draw you into them as if they were the eye of a hurricane.

Lisa Yuskavage similarly paints naked women, but in contrast her style is soft-edged, her well-endowed fantasy blondes generously lit and posed. But they also raise questions about the iconography of painting women, particularly the tradition of male painters painting female nudes in recumbent, provocative poses. Yuskavage's women replicate those frequently seen in porn magazines, their physique on first impression matching the stereotyped bleached-blonde bimbo. But these women are painted by a woman, and at second glance, their bored glazed eyes and unaroused nipples imply they are simply going through the motions. (Other artists in this chapter – from Marlene Dumas to Chantal Joffe and Mika Kato – raise further questions about gender and stereotypes.)

The physicality of Freud's later paintings is absent in the work of Yuskavage, but it is present in the work of Yan Pei-Ming and Cecily Brown. In their paintings, as in the energetic faces of Saville, the figure is in danger of flying apart as the paint is whipped into an effervescent lather. In Pei-Ming's reworking of centrefold images, and Brown's naked couples in the landscape, the energy of the paint's application effectively becomes the subject. For Brown, the paint reinforces the physicality hinted at by the confusion of limbs that can just be made out in many

of her paintings. The figure is threatened by the energy of the process that has created it. Similarly in the work of Rezi van Lankveld, the figure is all but invisible as the process of painting – layers of paint poured over the canvas on the floor, the image suggesting itself – takes over. Her work fluctuates between abstraction and figuration as if you are looking at a Rorschach blot. A two-colour swirl of paint momentarily coalesces into a naked couple only to dissolve into a pool of paint once more.

Van Lankveld lets the paint dictate the subject. For Margherita Manzelli and Philip Akkerman, the subject leads. Both artists only use themselves as subject matter – in the case of Akkerman, this singular vision has been in operation for twenty-five years. By repeatedly painting themselves, they both explore how public identity, our persona, is created, how we present ourselves to the world in a variety of guises, and how we change throughout the days and years. Manzelli portrays herself against different backdrops that seem to dwarf her; Akkerman focuses solely on his head, at times wearing a hat, often without, a record of his emotions on each of the days he chooses to paint.

Yi Chen's work feeds into this exploration of identity in the way he builds up his meticulously painted faces using elements from magazines as his starting point. His faces are identikit, an alluring eye floating above a grimacing mouth. There is no single identity, but an amalgamation of many people, many visions of beauty. The face breaks down, and the viewer is left with the task of reconstructing it, like a plastic surgeon.

Francesco Clemente *Untitled*, 2003

Chuck Close

Andres II, 2004 [below]
Self-Portrait, 2004–05 [opposite]

Close has been painting time-consuming portraits of family, friends and himself for forty years, as a means of exploring the idiosyncracies of photographic representation. Ever since his giant airbrushed *Self-Portrait* of 1968, that helped to define photorealism, Close has used a grid to allow him to scale-up photographs with breathtaking honesty. Initially the grids he used were extremely fine, almost invisible, but they have come to dominate his work. His recent self-portrait looks like a pixelated digital image, and soon breaks down into a matrix of concentric circles and lozenges. The lurid colours rebel against the geometry of the grid and writhe and twist around his beard, across his forehead. The coloured shapes turn the central subject, the face, into an abstract mass of activity. Even in the grisaille portrait *Andres II* (of fellow artist Andres Serrano), the surface is animated by both the colouration that underpins it – olive and smoke, silver and mushroom – and the dynamic feel achieved by turning the grid through forty-five degrees.

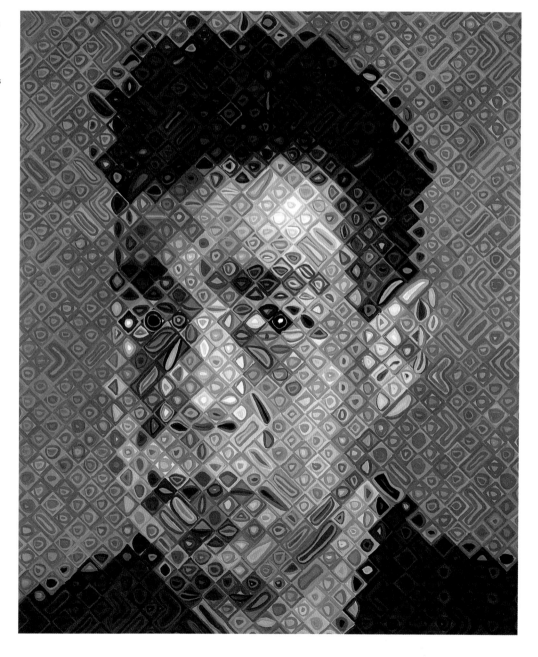

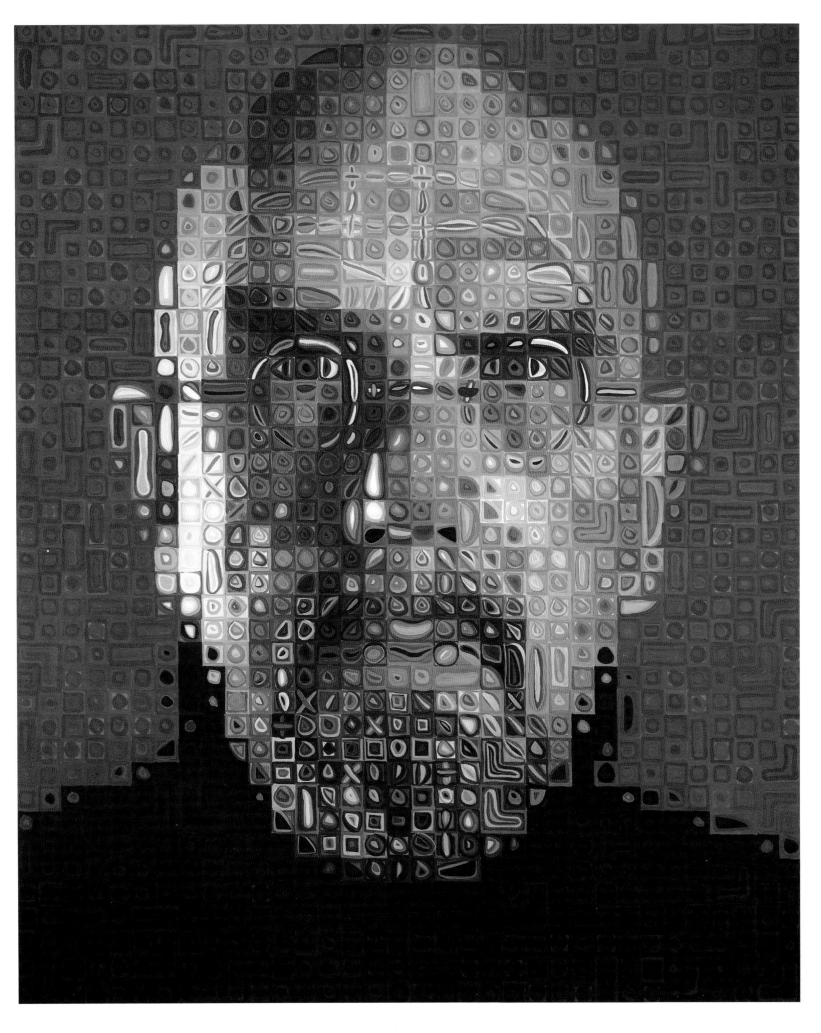

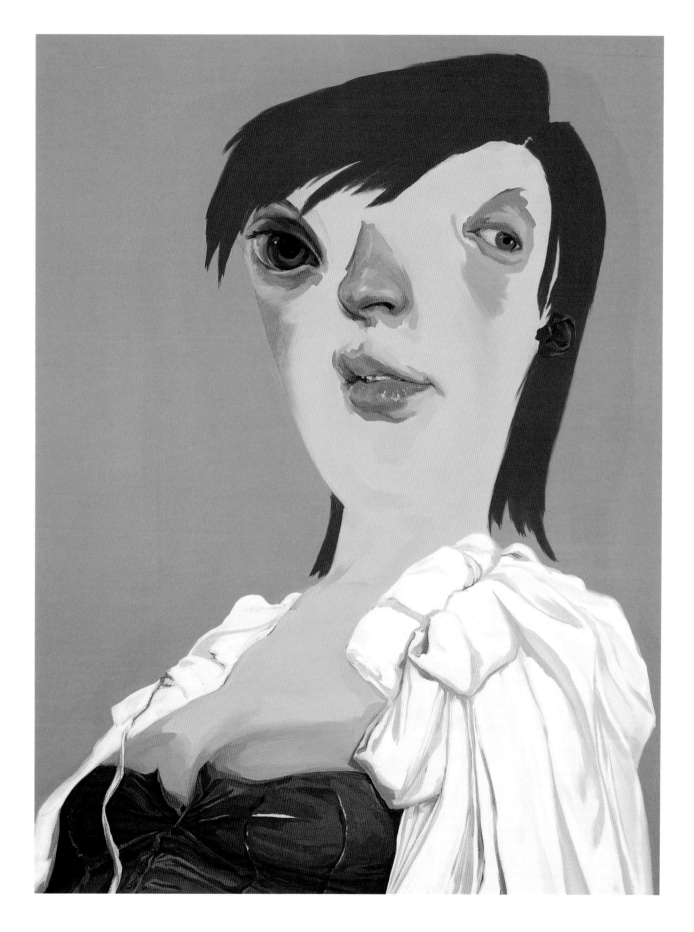

Yi Chen

*Easy, Breezy, Beautiful Cover Boy –
Refurbished*, 2004 [right]
*Nastaya's Complete Facial
Makeover*, 2004 [below right]
Isabel, 2004 [opposite]

Chen's hybrid portraits have their roots in
collage. He assembles unlikely faces from eyes,
mouths, noses and ears cut from Asian fashion
magazines and advertisements and then paints
part-illusionistic, part-abstract faces based on
them. The results are uncanny – faces where
all the component parts are in the right place,
but are mismatched and lopsided. His paintings
draw allusions to plastic surgery or cloning,
the concept of designing a face to order. Born
in Beijing, but living and working in New York,
Chen raises awareness of the trend in Asia
of using surgery to appear more 'Western', to
conform to the images of beauty presented in
the media. But in Chen's work, the resulting
beauty is in fact grotesque, and through
patchworking facial elements he creates people
with no identity left to call their own.

Mika Kato
Constellation, 2004 [opposite]
Gossamer, 2005 [left]
Kanten, 2005 [below]

Kato meticulously paints portraits of doll-like figures, the frame close-cropped like a photograph. Her works are based on photographs of dolls that she makes and clothes, clasping oversized bracelets round their necks and decorating their hair with crystals and scarves. They appear flawless and remote, like powdered geishas or *manga* heroines. As with *manga*, their perfection doesn't last long. Tiny details, introduced by Kato, serve to undermine their stylized beauty – in *Gossamer*, a circular scab can be seen in the doll's unplucked eyebrows; in *Constellation*, the left eye sports a burst blood vessel. Lacing her paintings with flaws undermines their position as beautiful objects to be enjoyed and brings them into our own sphere of flesh and pain, as they reflect the weight of our world in their downcast eyes.

Philip Akkerman

Self-Portrait, No. 43, 2004 [left]
Self-Portrait, No. 8, 2004 [centre]
Self-Portrait, No. 50, 2003 [right]

Dutch artist Akkerman has been painting self-portraits since 1981. Not as his fellow countrymen Rembrandt or van Gogh once did, as punctuation marks in their varied artistic careers, but as his sole subject. Akkerman has limited himself to painting his own face, and so far he has created over two thousand versions, each painted in a day. He works life-size on wooden panels in thin glazes of oil, his head turned in three-quarter pose, bodiless, unsmiling, intense.

It's not an intensity of emotion that Akkerman captures but concentration – his head has become an abstracted motif as he repeatedly paints the same subject yet ends up with an infinite number of variations. Through endless repetition he tests the possibilities of painting, and in this way, the end results are less about the image – a straight-forward portrait of the artist – and more about the making of the image, the process that leads to such diversity.

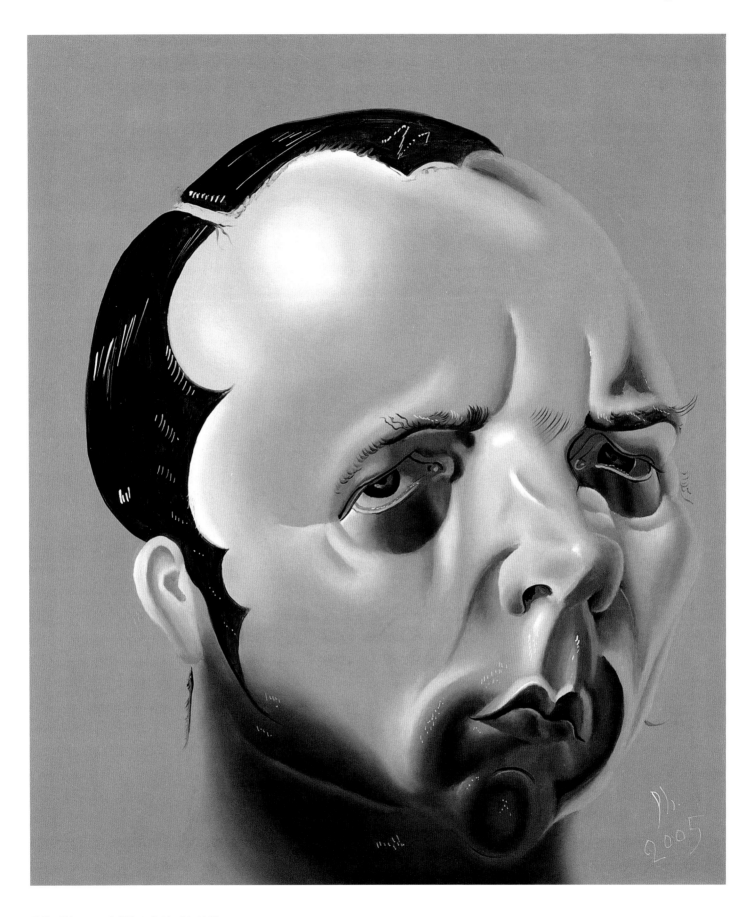

Philip Akkerman *Self-Portrait, No. 34, 2003*

Margherita Manzelli
Mr Grigio, 2003 [opposite]
Dream Brother, 2003 [right]

In Manzelli's large paintings, solitary figures – often naked – are overwhelmed by their surroundings. In *Mr Grigio*, a spotlight highlights black patterned wall. A woman, too short to be centred in its beam, stands stiffly to attention, her body slipping into shadow. In *Dream Brother*, another naked woman, this time on her knees, looks out at you from the end of a receding block that stretches to the distant horizon. Manzelli paints the spaces of dreams, of nightmares: the women trapped in unreal and yet somehow familiar environments. All the women in Manzelli's paintings bear a striking resemblance to each other, and while she admits she does not set out to paint self-portraits, elements of herself are imprinted in each one, a legacy of her earlier performance work where she used her own body to explore the links between the artist and the creative urge.

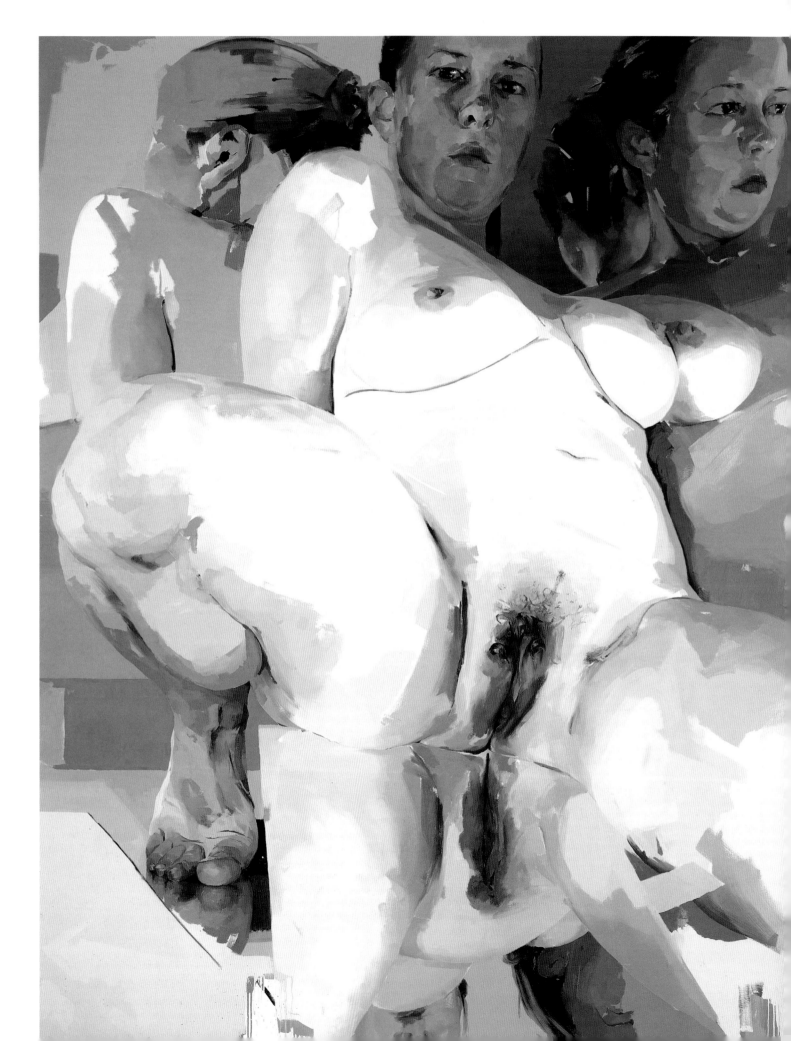

Jenny Saville

Reflective Flesh, 2002–03 [opposite]
Entry, 2004–05 [below left]
Stare, 2004–05 [below right]

Saville has never shied away from depicting the realities of flesh – its corpulence, its vulnerability to bruising and scarring, its pigment changes – and she responds to its variations by changing tones and styles. In *Entry* the battered face has the milk-white gleam of death, the green pallor of sickness and disease, almost-black caked paint around the nose like dried blood. Saville works from photographs, not life, often taking images from medical textbooks as her starting point, transforming them – as in *Stare* – into paintings that make us feel before we even fully grasp what we are looking at. Throughout her career she has used her own body as a 'prop' in her work, often distorted by perspective, filling the canvas. One such painting is *Reflective Flesh*, her small frame squashed into the picture despite the work being three metres tall.

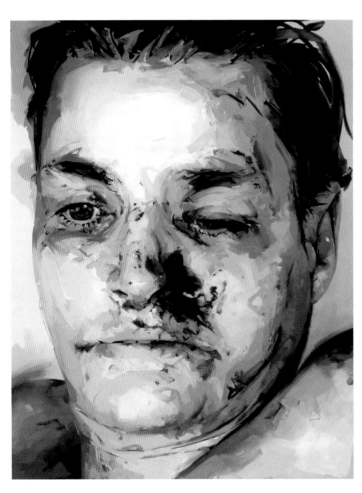

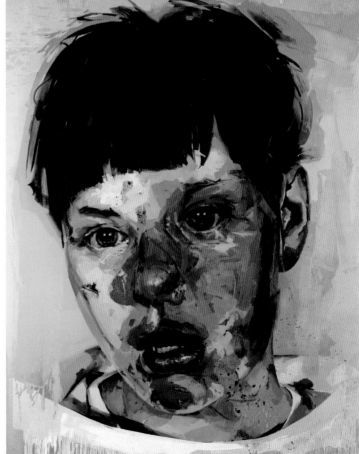

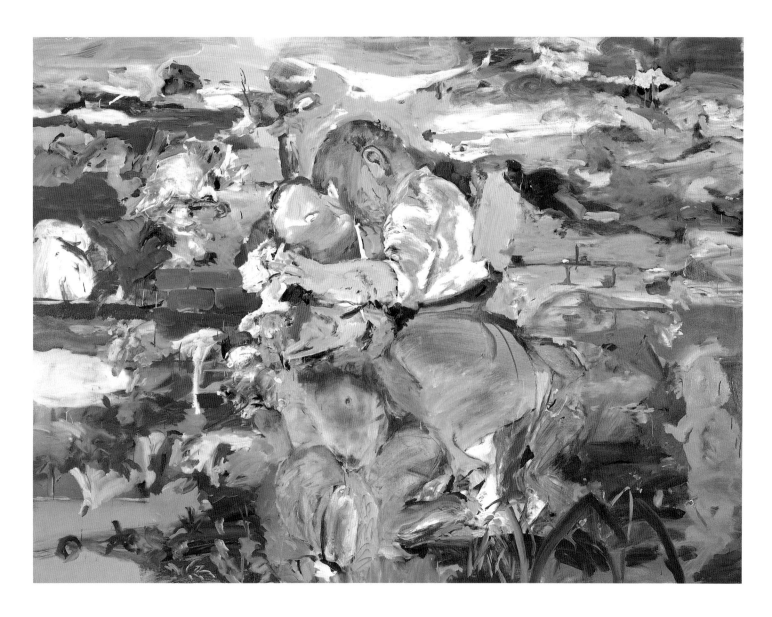

Cecily Brown
Red Painting 2, 2002
Girl on a Swing, 2004 [opposite]

Brown's canvases are maelstroms of colour, orgiastic explosions of paint across surfaces that teeter on the brink of abstraction, despite figurative elements that emerge and are then subsumed again into the riotous mass of paint. Sex is often their subject matter, and in Brown's work, the subject matter and painting style are fused so that the paint stands in for the bodies that bump and grind across the surface. In *Red Painting 2*, the bacchanal seems to have turned violent,

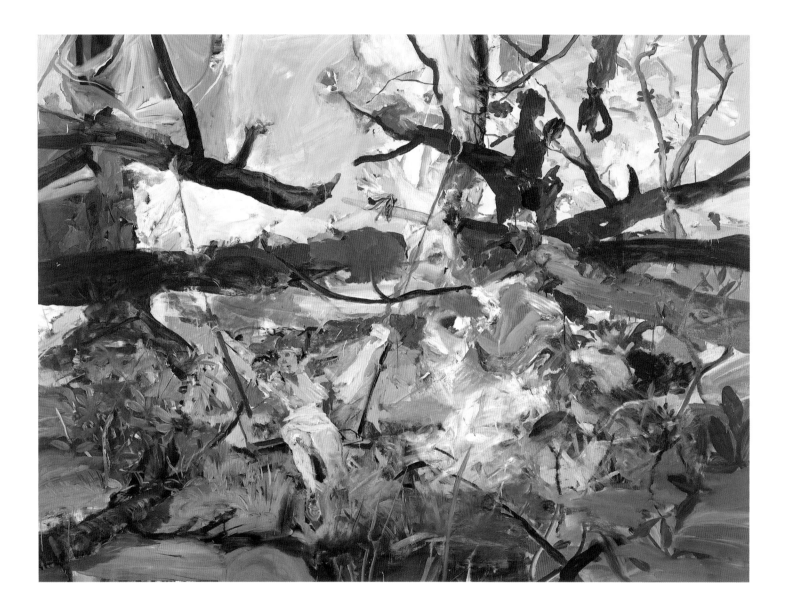

as a centaur-like man grapples with a faceless figure in a style
reminiscent of Willem de Kooning. *Girl on a Swing* transposes
Fragonard's flirty swinger who scissors her legs to flash her suitor –
or us, the viewer – hiding in the bushes. We become implicit in the
painting's action. All Brown's work gives you a voyeuristic thrill,
as you look from paint to the painted and guiltily piece together
her sensual works.

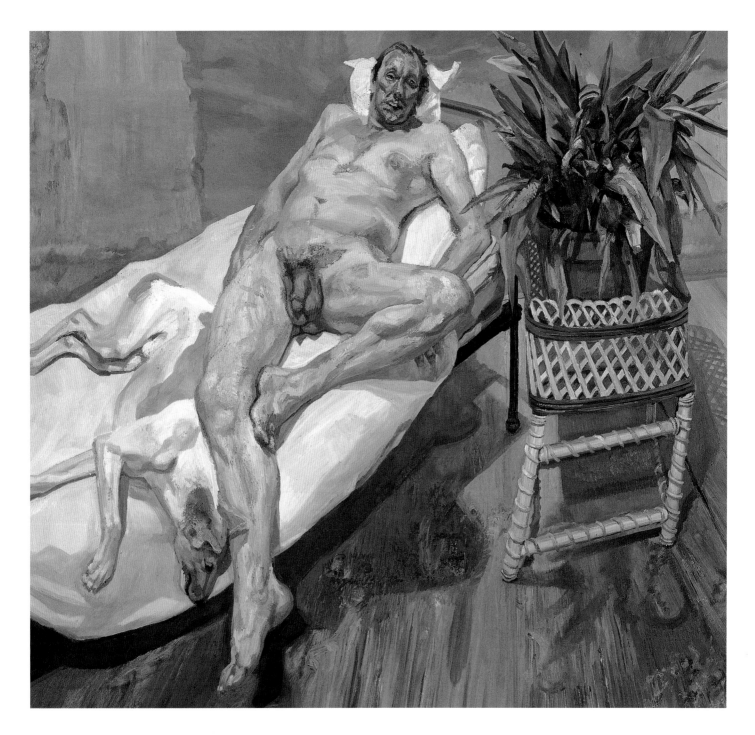

Lucian Freud

David and Eli, 2003–04

Freud is the most famous figurative painter of his generation. For seven decades he has charted the progression of time across faces and bodies, from the spare, hallucinatory luminescence of his first works to the thick darting impasto of his mature style. Freud has always attracted notable people to sit for him, from Leigh Bowery to the Queen of England. His portraits are rarely flattering, but people admire his ability to get to the essence of a figure, to recreate its tones and awkward protrusions. Periodically, he paints himself. In *Self-Portrait, Reflection*, all of Freud's eighty years are apparent, from the deep pits of his pupil-less eyes and the heavy lines that run from nose to chin, to the veined hand that clutches his grey scarf and the oversized jacket that hangs off his bony frame. This is a brutally realistic look at what age does to a figure. And yet there's also an element of mystery, perhaps eroticism – Freud is naked under his jacket.

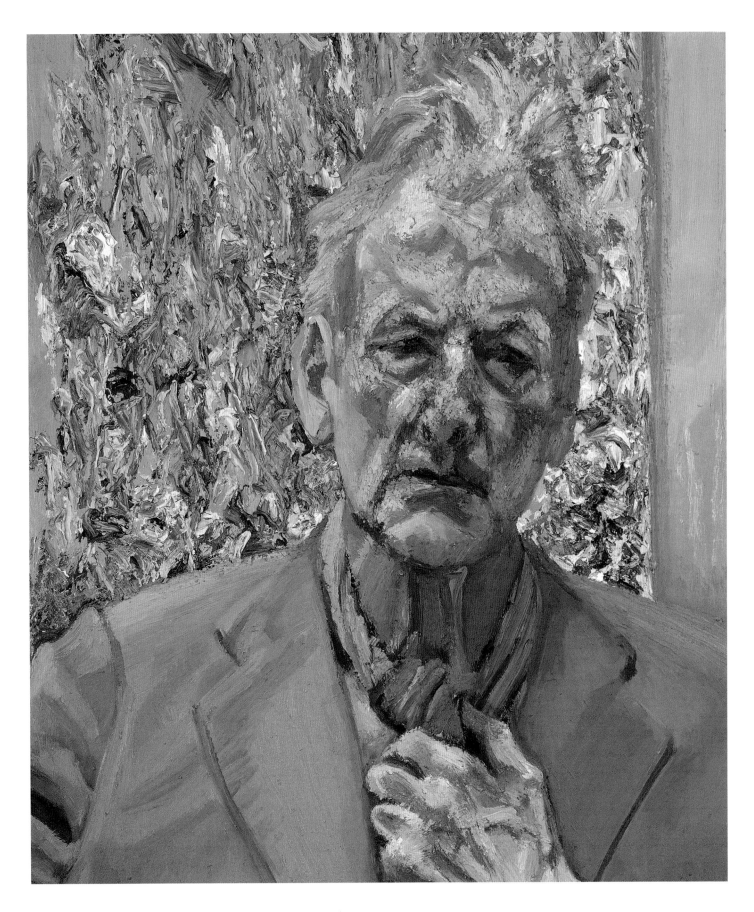

Lucian Freud
Self-Portrait, Reflection, 2003–04

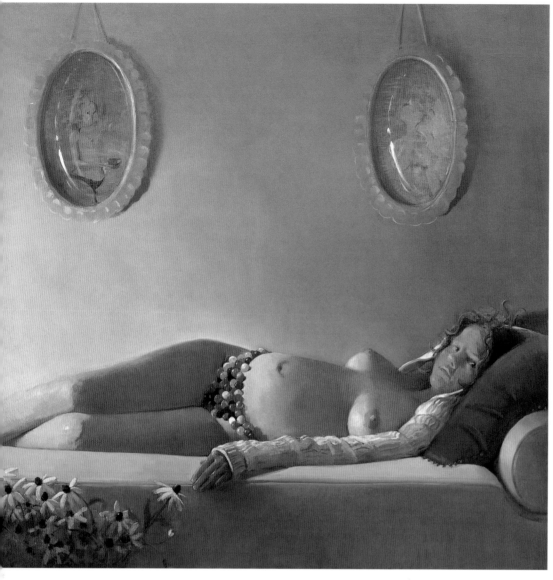

Lisa Yuskavage

Couch, 2003 [left]
Still Life, 2003 [below]
Grooming, 2003 [opposite]

Yuskavage has always been seen as a controversial painter. She paints female nudes, their curves and breasts exaggerated, who passively await your gaze as they preen and pose languorously on the canvas. Yuskavage is a very adept painter – works like *Grooming* verge on the academic – and she makes overt references to historic nudes such as Titian's *Venus of Urbino*, whose pose is imprinted on the fecund teenager in *Couch*. She also makes use of devices first seen in the Renaissance in the work of Cranach, such as adorning her nudes with necklaces and translucent jackets to emphasize their nakedness. But all this rubs people up the wrong way; many male critics feel uneasy with her parody of art historical nudity and the male obsession with the female form as object – somehow it's not soft-porn dressed as art when a woman paints it, but simply porn. And female critics often think she crudely exploits her own sex and has hampered feminism.

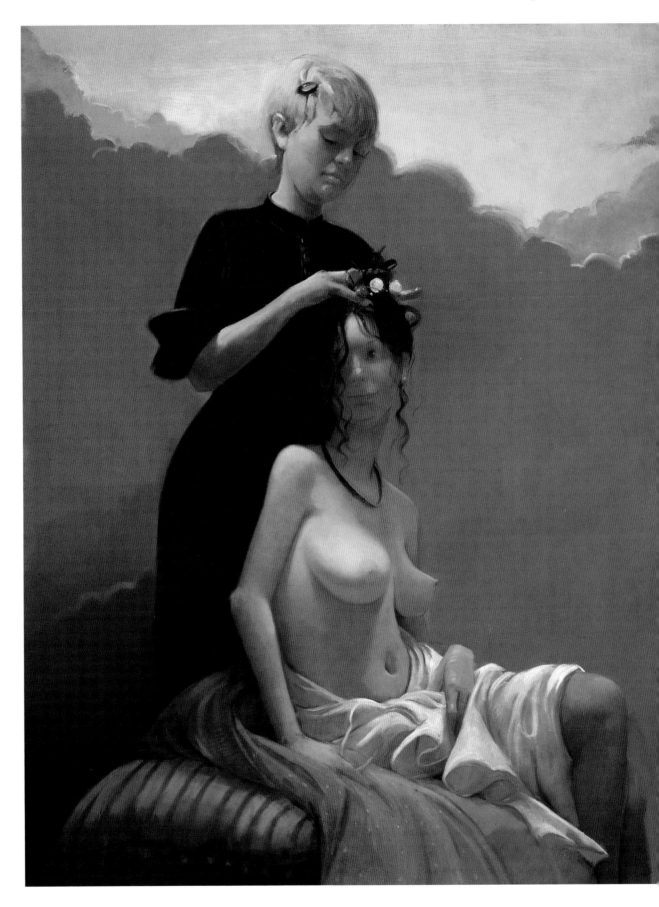

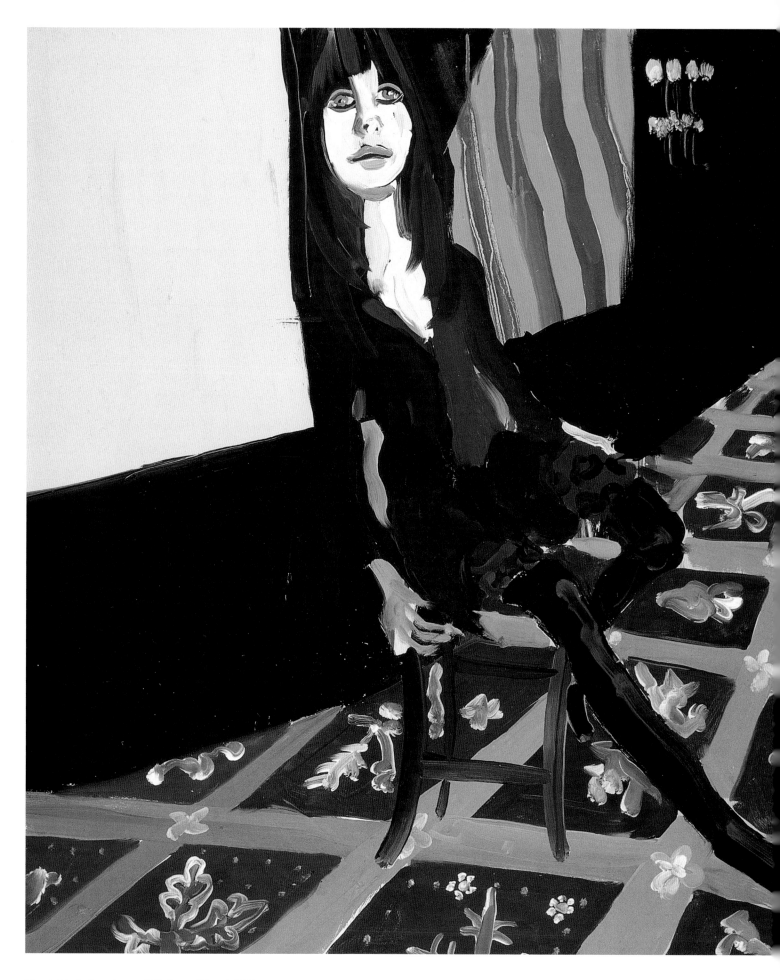

Chantal Joffe *Long Legs with Patterned Carpet*, 2002

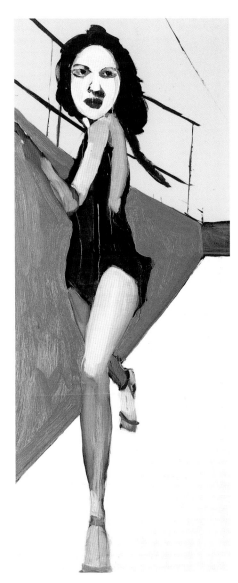

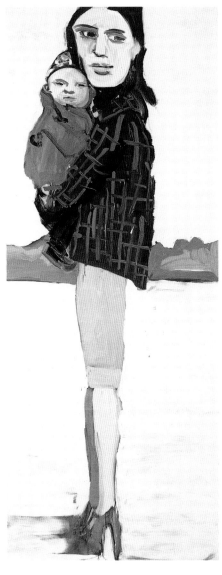

Chantal Joffe
Walking Woman, 2004

Chantal Joffe
Check Jacket and Baby, 2004

Joffe uses paint to suggest the mood of the women she paints – bold, assertive brushstrokes to imply strength in *Check Jacket and Baby*, a more sketchy, uncertain style to fashion the face in *Long Legs with Patterned Carpet* to suggest thought and hesitation. She places them against a simple backdrop – a low range of hills, a concrete walkway, a hotel carpet – that gives little away, leaving the viewer to determine the specifics of each woman's story. *Walking Woman* – a huge painting over three metres tall – shows a woman in a swimsuit running down a ramp, inappropriately dressed for such an activity, as if being pursued. Joffe has said that she wants her work to exist without narrative; we should instead study the thickness of the lush paint, the flat blue sky. But at every turn it is the paint that brings us back to the story, the sky as oppressive as being stuck in a one-person tent, the grey paint dripping down her face and leg like sticky perspiration.

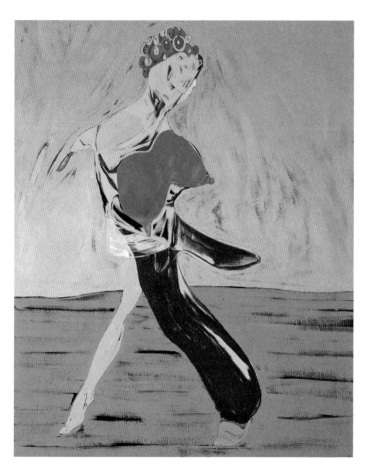

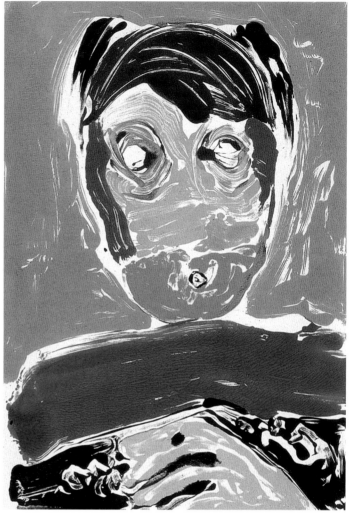

Nicola Tyson
Figure Walking, 2004 [left]
Portrait No. 47, 2003 [above]
Figure with Arm Extended, 2004 [opposite]

In Tyson's early works, her figures were erotic and fetishistic. But increasingly, the women in her canvases are abstractions of bodies, their limbs as thin as flower stalks, their hands and feet and faces missing. They rarely occupy any meaningful ground – a room, for example – but stand hard up against the surface of the painting, itself an abstract plane of only one or two colours. Tyson's style – spare whips of the brush that leave the pale underpainting showing through and yet appear luscious – give the figures great dynamism. The person in *Figure with Arm Extended* appears to lean over, chest and head thrusting forward; the woman in *Figure Walking* gyrating as she moves. (Even the environment she traverses seems to shimmer and sway.) Through these paintings, and her ongoing series of portrait heads, Tyson continues her exploration of how distorted a figure can become as it hovers between abstraction and figuration.

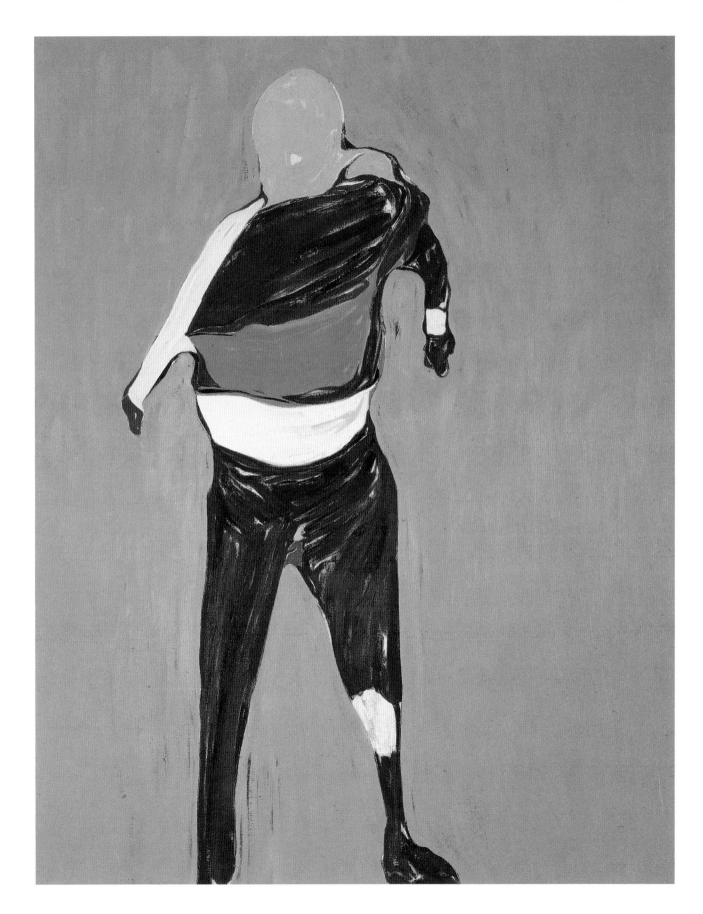

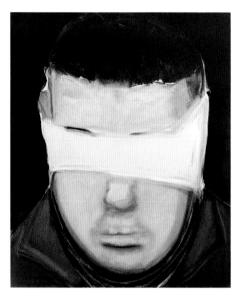 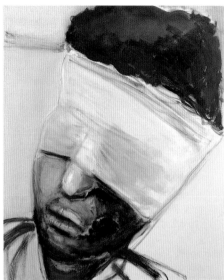 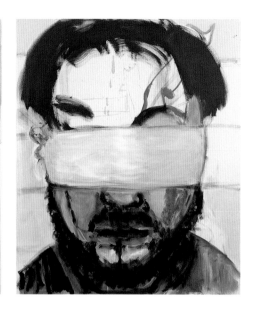

Marlene Dumas
The Blindfolded, 2002

Dumas paints emotions; she wants to force a gut reaction from each viewer. Her paintings are based on photographs from news magazines or her own Polaroids, and while their style can vary dramatically – thin washes of colour, thick matt paint – at each work's heart is a powerful emotional charge, from eroticism to fear. *Stern* is based on the well-known photograph of Red Army Faction terrorist Ulrike Meinhof, cut down from a towel noose in her German prison cell in 1976 (the pressure marks can be seen around her neck). Yet although the pale woman is dead, Dumas fuses her with sexuality – the velvety blackness surrounds her mouth, and her eyes appear shut in ecstasy. Eyes have always been important to Dumas, and many of her previous subjects confront our gaze, despite their nakedness or vulnerability. Yet in *The Blindfolded*, featuring three Palestinian men, eyes have been forced shut. Only we can look on now, viewers of an ambiguous scene – are these men prisoners of war, terror suspects or innocent victims?

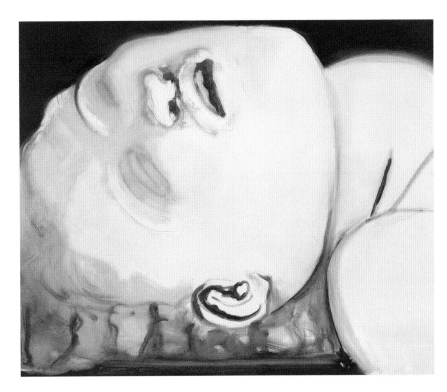

Marlene Dumas
Lucy, 2004

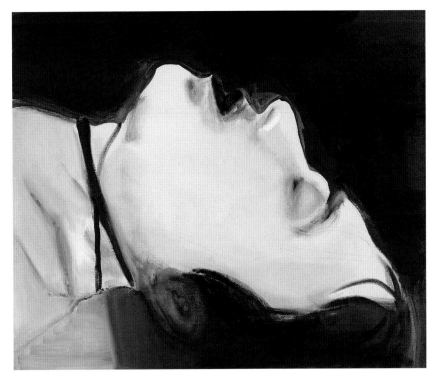

Marlene Dumas
Stern, 2004

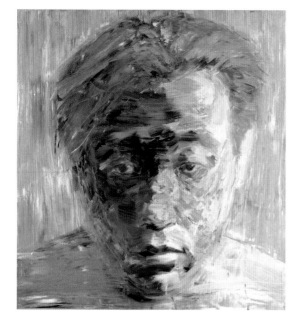

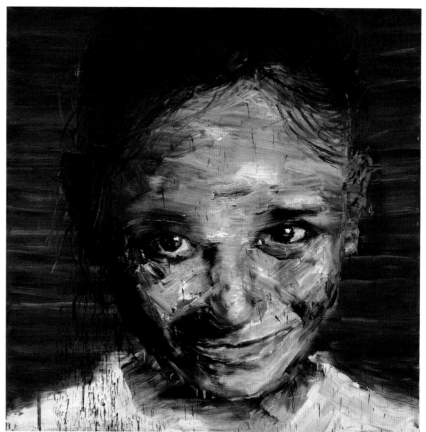

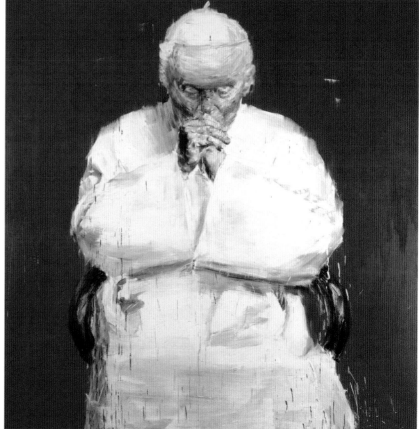

Yan Pei-Ming

Self-Portrait, 2005 [opposite far left]
Petite Mendiante, 2005 [opposite left above]
Pope Jean-Paul II, 2005 [opposite left below]
Mao Zedong's Remains, 2002 [below]

A search for identity is at the heart of Pei-Ming's expressive paintings, whether his own, through his questioning self-portraits, or those who have influenced his life in some way, from Mao Tse-Tung to Pope Jean Paul II. Yet it is those we don't know – like the smiling girl in *Petite Mendiante* – who seem the most intriguing. Many of Pei-Ming's works are painted only using one colour – black or red – mixed with white, a reductionist technique that concentrates attention on his brushstrokes, which seem to have beaten the paint into a likeness. The resulting physicality of Pei-Ming's works is countered by a late smattering of paint flicks that denies the painting an illusion of three-dimensionality and pins the image on to the surface, as your eye races over it.

Mari Sunna

Make it Double, 2004 [opposite]
Embrace, 2004 [above right]
One No One, 2005 [below right]

Sunna's paintings are about absence, even though
her figures seem solid enough at first glance.
In *Make it Double*, a girl appears to run across the
canvas, leaving a trace of herself as she moves,
as if caught in a long exposure. There is tension
in her arms (those clenched fists and taut biceps)
and action in her legs and head. Soon she will be
gone. *Embrace* shows an androgynous pair facing
you across the divide between their world and
yours. As if they were an image from memory,
they have become fused together, faces a smudgy
blur, movements compressed into one image.
These works operate like memories of loved ones
– so palpable as to be almost real, and yet already
fragmented and disappearing from view.

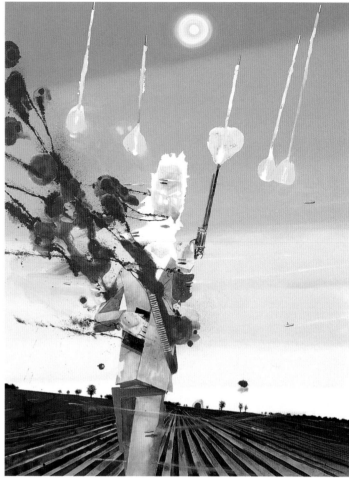

Barnaby Furnas
Untitled (Execution), 2003

Barnaby Furnas
John Brown, 2004

History painting has been modernized by
Furnas in his explosive canvases. While loosely
inspired by the American civil war, Furnas,
working in New York, has painted subjects that
talk as much about Islamic fundamentalism as
they do about American in-fighting. What they
do suggest is that history is an anthology of
violence, and humans cannot get enough of it.
(His paintings of rock concerts suggest an equal
pleasure in both violence and excitement.)
Anti-slavery hero John Brown may hold an old
rifle in *John Brown*, but a clutch of heat-seeking
missiles are about to do his bidding; in *Suicide I*,
a flurry of bullets cause a nameless soldier's
head to explode across the canvas. Furnas seems
equally interested in the formal investigation of
what his home-made paint (powdered pigment
mixed with urethane) can do on the canvas, and
his figures disintegrate into abstraction as
blood-red paint is smeared over the surface.

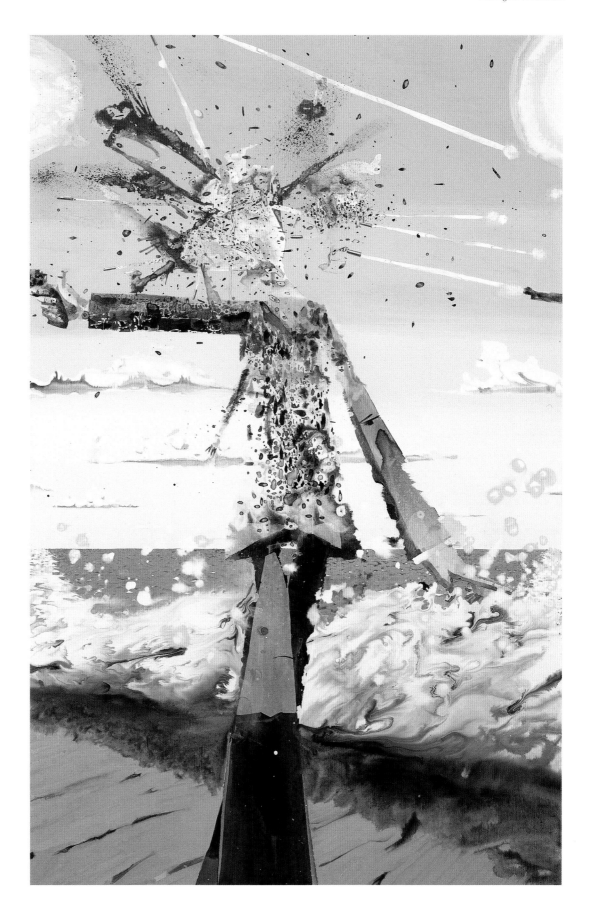

Barnaby Furnas
Suicide I, 2002

Rezi van Lankveld
Pieta, 2005 [opposite]
Linger, 2004 [below]

These paintings look as if they could slide off the wall at any moment. Their surfaces still seem wet, transient, and the figures threaten to disappear at the slightest lapse in concentration. Van Lankveld works on panels on the floor, and applies tonally similar paint until the surface becomes a pool of colour. The image rises out of the meeting of the two colours, and she works instinctively to cajole it into the semblance of a figure. In *Pieta*, a head is thrown back so that only the cheekbone, jaw and exposed throat can be seen, bathed in heavenly light, and a bony knee juts out. But beyond that, the figure refuses to go, and we are left with only suggestions of flesh, of fused spots that could represent a chest, or of paint pushed this way and that into approximations of attendant figures.

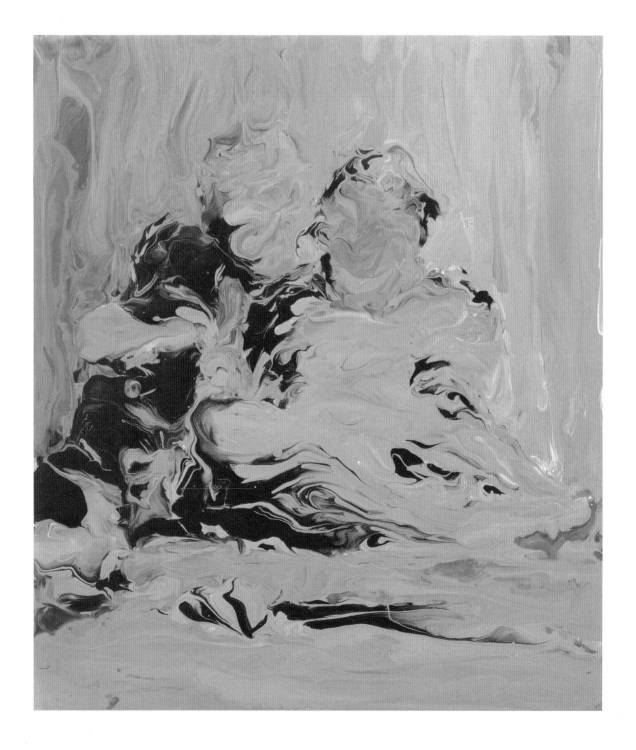

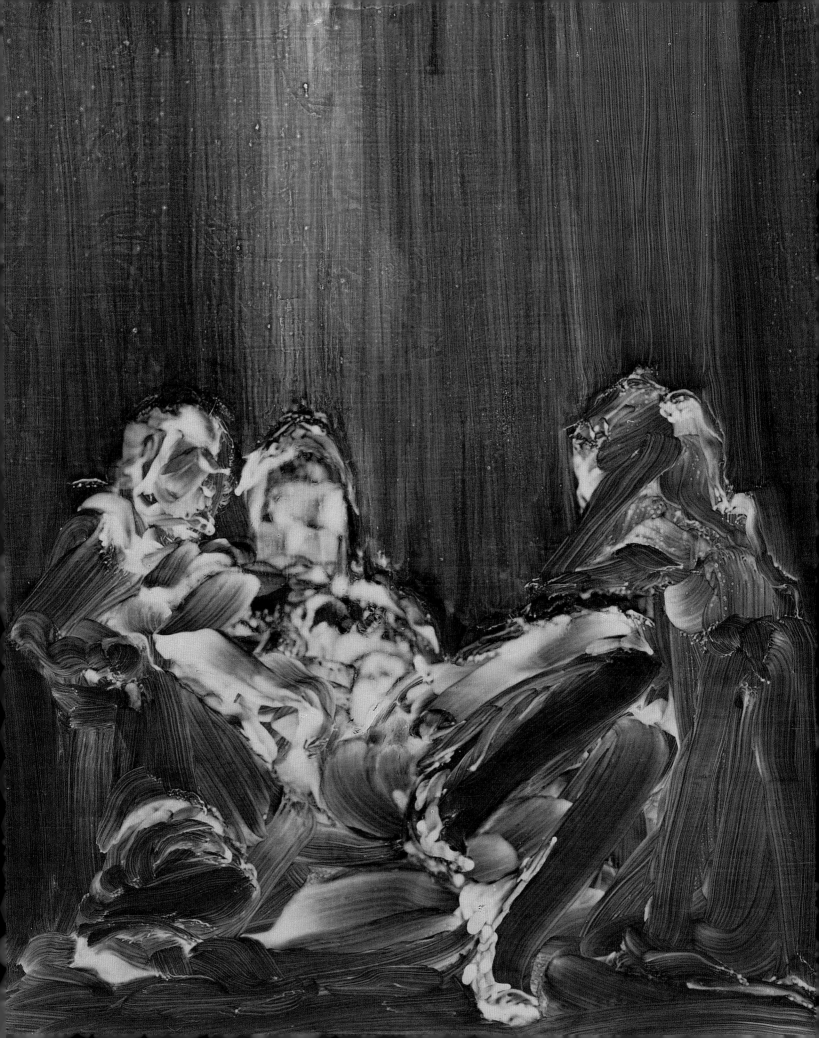

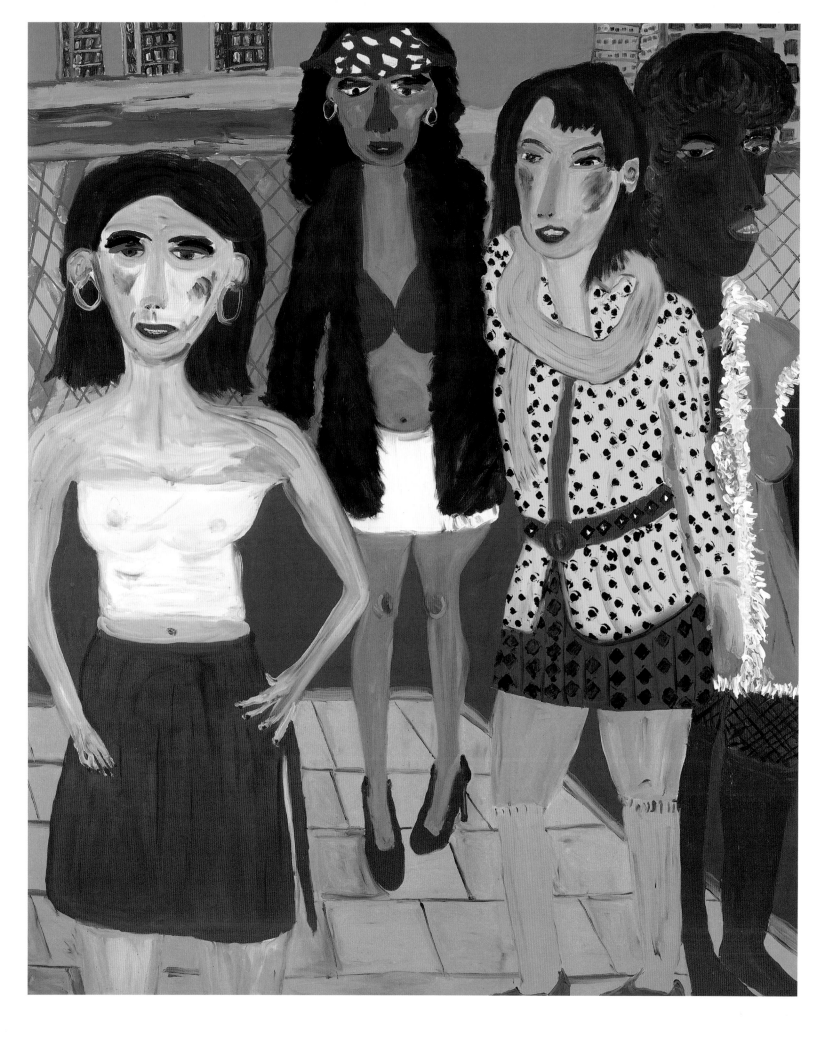

2 The Urban Condition

What does it mean to live in this world at the present moment? That is the question many of the artists in this chapter ask through their work. This is an age where mechanical reproduction has led to a saturation of imagery, from advertising on cereal packets and billboards to mobile phone photographs and full-colour newspapers; where technological advances allow us to talk across continents and send documents around the world at the touch of a button. While these developments have seemingly shrunk the world, making the global local, the proliferation of chain stores and international conglomerates have made the local seem global: the Starbucks you sip coffee in could equally be in Tampa or Tokyo or Toronto. The price we pay for these developments, so artists Mathew Cerletty, Jun Hasegawa and Djamel Tatah suggest, is a profound sense of isolation, of rootlessness. Figures appear against flat monochrome backgrounds, anonymous and exhausted with life.

Cerletty's shattered doctors, faces grey with fatigue, lean against mantelpieces to snatch some much-needed sleep, their white coats and pale ties causing them to blend into the anaemic interior decor. In all his paintings, Cerletty's characters stand alone, sometimes in states of surprising undress that suggests they are not expecting to be joined by anybody soon (not even the viewer).

Both Hasegawa and Tatah's paintings of groups of people should – by comparison – offer a sense of companionship, of comradery. But in Tatah's paintings, the same bland-looking office worker is painted repeatedly, her drab clothes and limp hair, her pallid expressionless face a metaphor for urban life. Hasegawa's works are more colourful, but despite painting clusters of people on bright lawns, their acceptance of solitude, masquerading as self-sufficiency, is equally unnerving.

Beyond the small groups of figures in the work of Jules de Balincourt or Thomas Eggerer, there's more than a whiff of metropolitan entropy, as life threatens to disintegrate. They both make use of the world's concrete edifices that loom large and faceless in their work, and they both explore the relationship between subjects and the buildings that surround them. For de Balincourt, the architecture they rely on begins to intimidate them, either as increasing security is added to home compounds, or hotels become as faceless as the people that staff them.

Yet there's also a sense of a hidden sublime that catches you unawares in de Balincourt and Eggerer's paintings, where the small *mise-en-scène* opens up to an aerial view of a vast cityscape, or a bridge soaring across a valley causes the sky to split apart. In Eggerer's recent work he explores the relationship between mankind and the architecture built to sustain it, most notably bridges. These cut through the picture plane with unstoppable authority; all the faceless figures walking underneath it or looking down from its flimsy railings can do is ogle at it. It is awe-inspiring both to them and to us.

Architecture also underpins the work of Geraint Evans and Martin Maloney. While Evans takes on the British suburbs, Maloney paints inner-city London. Based on the area around his studio – rows of terraced houses, grids of tower blocks and grey office buildings interspersed with the odd strip of parkland – he nevertheless manages to use them to add

Alex Katz *Ada, Late Summer*, 1994

colour and structure to his recent series of ebullient paintings of women conducting daily life. For the series he used the same model to paint each woman – whether old or young, black or white – and while superficially they appear different as they shop or cycle or serve dinners or tout for business, their underlying similarity creates a profound unease, not dissimilar to that seen in Tatah's canvases, despite their rainbow clothing and almost-smiles.

Evans paints the greyness of the failed suburban enterprise to emphasize the futility of the dreams of his no-hoper characters. He depicts a skateboarder who is motionless and despondent in a dried-up swimming pool under a grey lowering sky, and a group of artists who sit painting birds amidst the tower blocks, their imaginations conjuring greenfinches and kestrels on to their canvases from a birdless sky. All spend their time thinking of escape plans – the cleaner who yearns to be in the forest he can see through the window, the burger van chefs who want to be Elvis.

The media dominance of celebrities and their improbable lifestyles provokes many such dreams. Both Elizabeth Peyton's fey portraits of androgynous pop stars and Dawn Mellor's more caustic parodies of the famous explore this territory, where the gloss of fame isn't even skin deep, and stars appear to do anything for coverage. Theirs is the contemporary equivalent of David Hockney's beautiful people from his 1960s Californian pool paintings, Alex Katz's ongoing billboard-style portraits of his wife Ada or the commodification of the figure seen in the work of David Salle, where headless women modelling underwear line up next to orchids and sculpture as just another object for sale.

Muntean and Rosenblum also explore the commerciality of the figure in their paintings, produced collaboratively since 1992. They group together bored looking youths appropriated from fashion magazines, and paint them delicately, locking them into a room or a basketball court where they pout and stare beyond you, as if disinterested in both their own world and yours. Underneath each grouping run words lifted directly from newspapers and magazines, recombined into new sentences that reflect their ennui, such as, 'We look at each other without seeing, we listen to each other and hear only a voice inside ourself.' Many of the other figures in this chapter could well be thinking the same thing.

Thomas Eggerer

The Privilege of the Roof, 2004

Time is distorted in Eggerer's paintings. Skeletal concrete edifices span his canvases, already outdated modernist ideals of construction – the 'modern' ruin that has become a tourist attraction – and yet also somehow futuristic. Children run between slender pillars and hike up steep valley sides to take a closer look. Space, too, is disrupted – while the architectural structures recede dramatically into the painting, any sense of depth is rejected by the Franz Kline-like skies made of orange and magenta girders that flatten the painting and create a distinct tension between the abstract and figurative elements of each work. The generic children in the paintings occupy their own space between these two stylistic camps: in awe of the structure in *The Wisdom of Concrete*; mooching around on a school trip in *The Privilege of the Roof*.

Thomas Eggerer *The Wisdom of Concrete*, 2004

Jules de Balincourt

Poor Planning, 2005 [above]
Amateur Night (Steakout), 2004 [opposite]

De Balincourt creates epic landscapes of urban life. In a recent
series of work, he has painted America – where he lives, in
Brooklyn, New York – as a place obsessed with surveillance
and terror, panoptican watchtowers and search beams making
residents more, not less, fearful. In *Amateur Night (Steakout)* the
cameras and floodlights at first imply a school-bus disaster has
been staged for a television drama, and yet the reporter shivering
in a van's headlights and the number of police cars parked out
of shot suggest otherwise. De Balincourt uses a faux-naïve style
that suggests there's a folksy simplicity to our view of the world
where fear and prejudice run rife. *Poor Planning* has a similar
stylistic clunkiness – the claustrophobic office has no windows
or visible door, and the desk is positioned so that the thick-set
man sitting behind it has little chance of getting out (even if
there was somewhere for him to go).

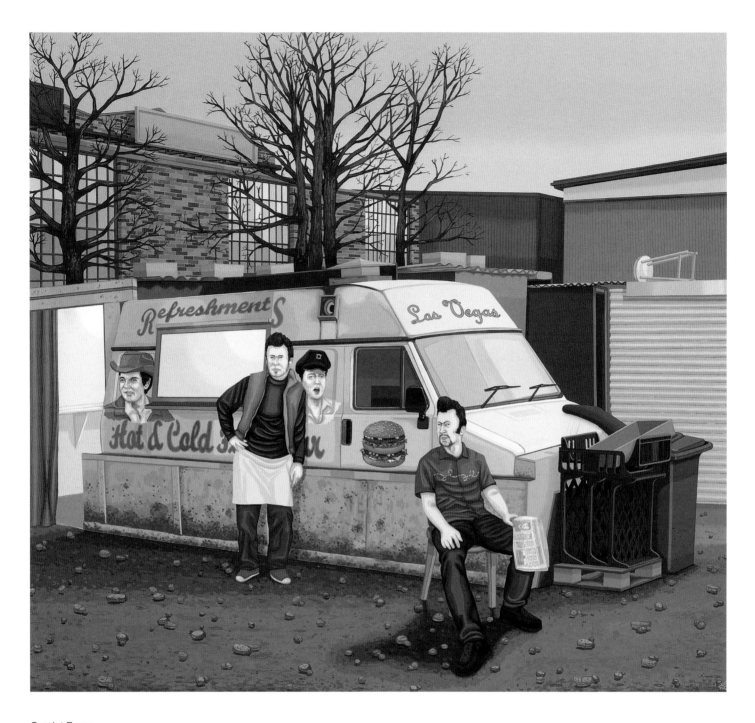

Geraint Evans
Las Vegas, 2002

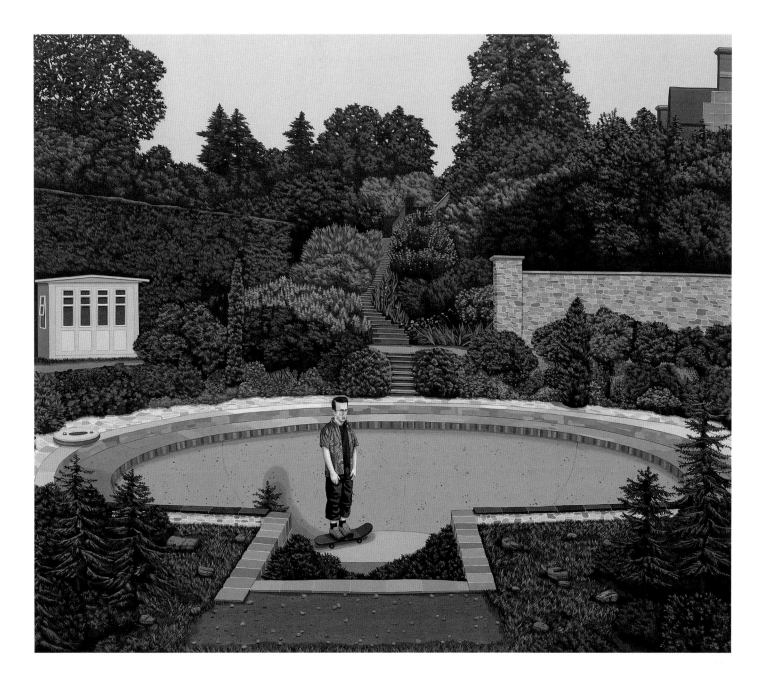

Geraint Evans

A Berkshire Z Boy, 2004

Evans's paintings are filled with suburbanites who dream of escape. Whether it is men running a burger van who style themselves on their American pop idols or a disaffected teenager practising skateboard moves in a drained pool, and wishing he was anywhere else, they all live in a world, a place, they would rather not. Evans replicates the style of suburban amateur painters as he meticulously delineates every needle on the leylandii, every stone in the carpark. Nothing is overlooked in his claustrophobic pictures that capture the sad inevitability of suburban dreams. In *Las Vegas*, the trees are all dead, an abandoned stool lies on a corrugated roof, rubbish waits for collection. Nothing blooms, and yet the men pose, awkwardly unnatural – hand on hip, head turned to show off a quiff – as they strive for Elvis cool before they go back to flipping burgers.

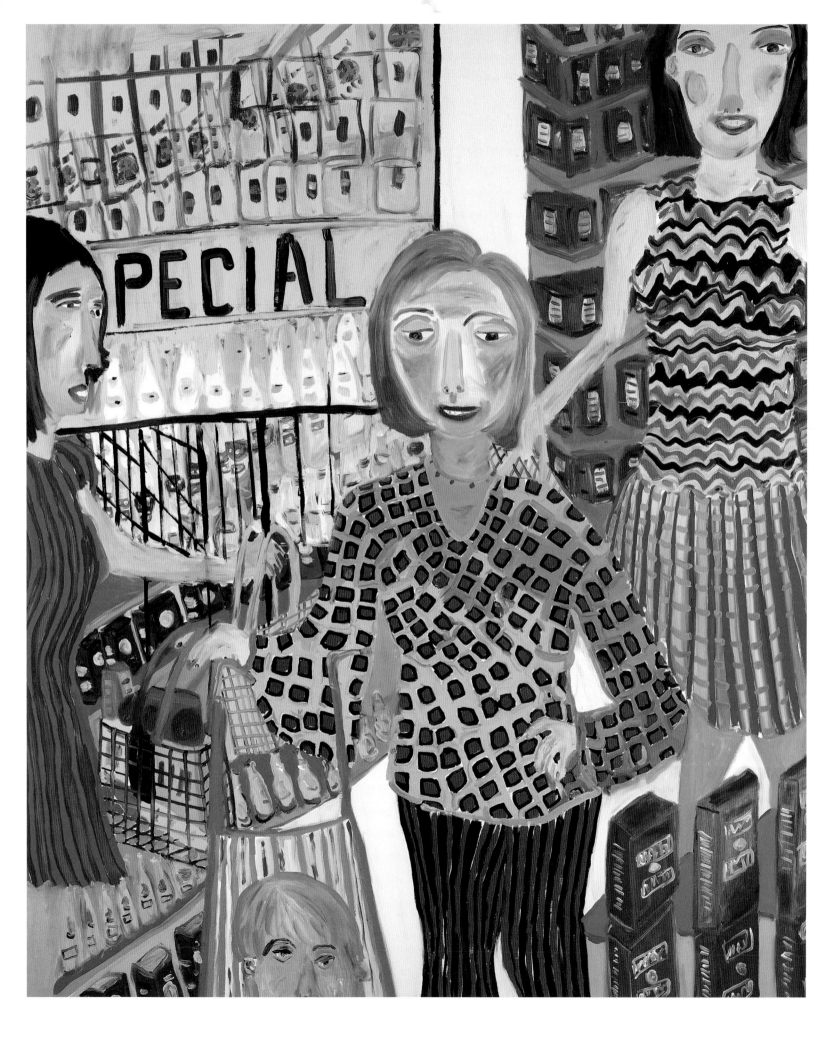

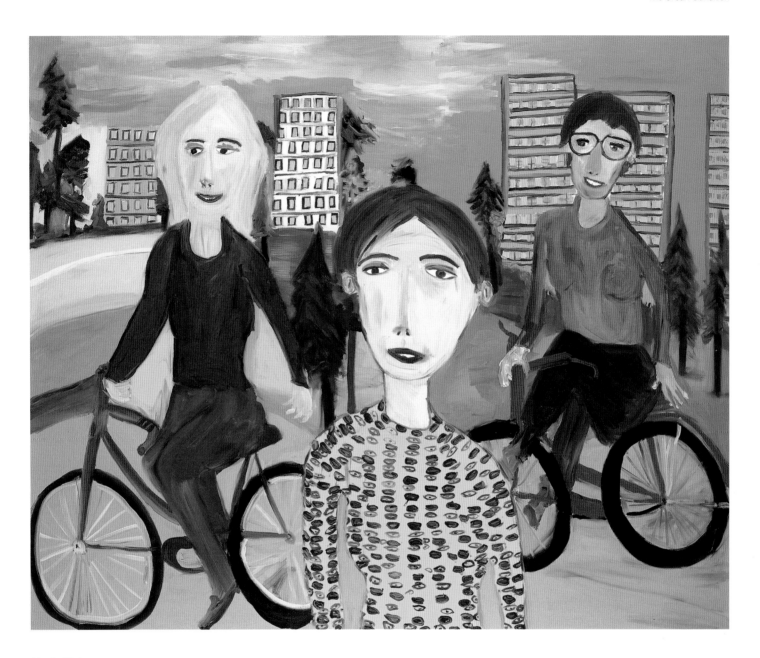

Martin Maloney
Stroller, 2004 [opposite]
Loafers, 2004 [above]

For a recent series of paintings, from which *Stroller* and *Loafers* are examples, Maloney repeatedly used the same model. Whether shopping for cornflakes, serving school dinner, waiting on a street corner or cycling, Maloney's women act out their day-to-day routines against an urban backdrop (based on southeast London, where Maloney has his studio). Their similar features give them a look of inner-city Stepford Wives, a view enhanced by their forced smiles, their repeated static poses.

Maloney paints quickly and confidently, and these large, multi-coloured works are alive with detail, from the clashing patterns on the womens' outfits in *Stroller*, to the jumper that mirrors the tower blocks in *Loafers*. He has an astute eye for contemporary detail – lipstick shades, fashion earrings, supermarket rip-offs of designer gear, school uniform customizations – and these works offer a snapshot of urban existence, in all its colourful, intense and banal glory.

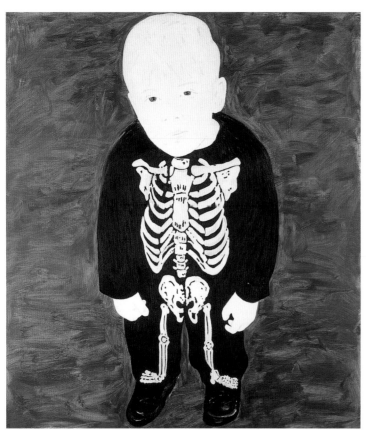

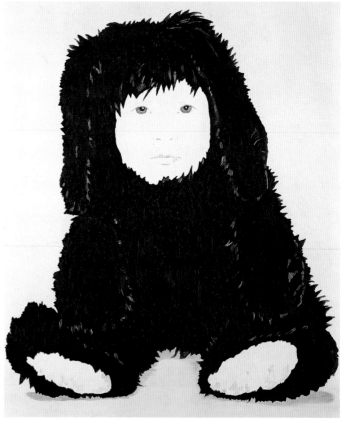

James Rielly
Deep Down I'm Shallow, 2004

James Rielly
Black Rabbit, 2001
In Mind, 2003 [opposite]

Rielly's paintings have always had an uncanny ability to unsettle the viewer. At first glance, everything in these examples seems normal – a boy dressed as a skeleton, a child with Mickey Mouse ears. But the costumed boy is over two metres high, the ears are attached to a racing driver's balaclava, and a baby dressed as a rabbit looks out from an overly mature face, its arms invisible. Rielly uses photographs from the tabloids, magazines and forensic books as the starting point for his disturbing paintings, removing the context of the image so that what may have once seemed acceptable now becomes bizarre, surreal. His style heightens each work's strange effect – faces bleached of colour, like over-exposed photographs, except for the eyes which pierce the viewer with their intensity, unnervingly holding your gaze even as you turn to walk away.

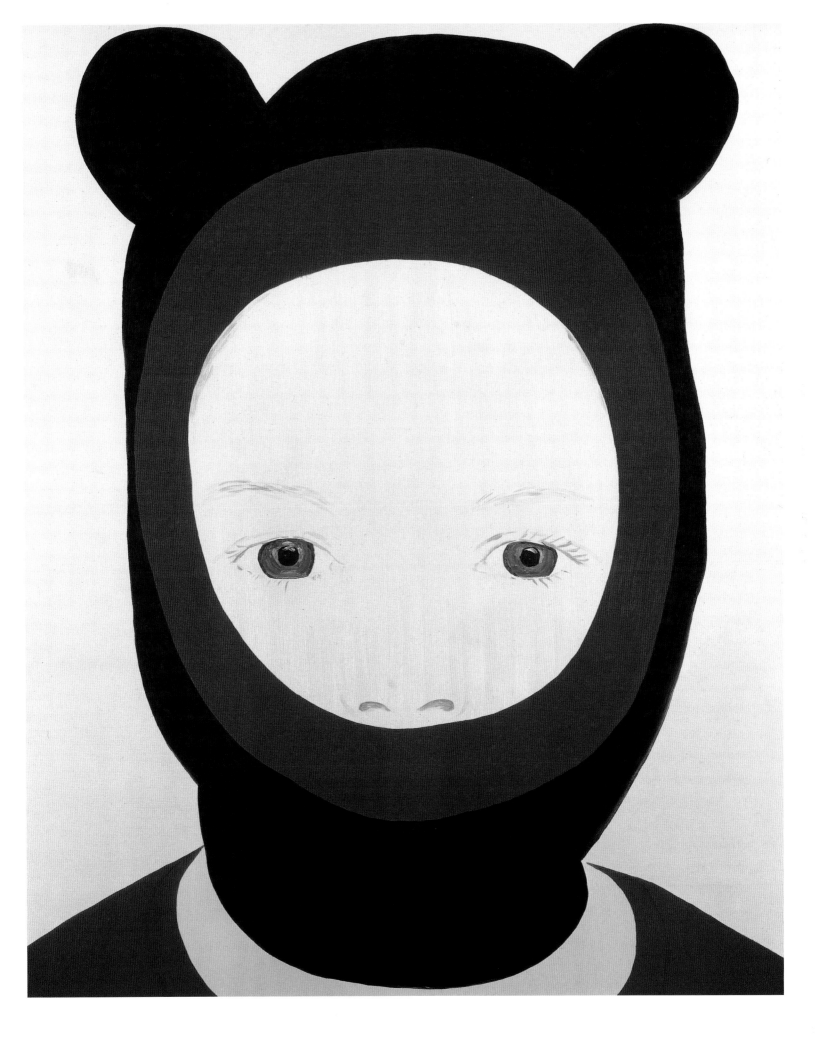

Mathew Cerletty

Untitled, 2004 [right]
Untitled, 2005 [below left]
The Faux Pas, 2004 [below right]

Loosely based on a photograph of Cerletty himself
(as many of his paintings are), *The Faux Pas* appears
to show a doctor snatching a quick break, leaning
uncomfortably on a thin mantelpiece, his pastel shirt
and tie emphasizing his peaky colouring. Cerletty's
characters all appear to rest or wait, devoid of any
life-giving energy, filled with complex solitude. They
appear alone, either trapped in claustrophobic rooms
or garish interiors. In *The Bath*, a man – based on
Cerletty's father – sits still in the tub, the extreme
floral wallpaper reflected in the water and transforming
him into a manly Ophelia. Are all Cerletty's characters
contemplating death – he has also painted bloodless
female suicides – or is it that their resigned, tired faces
merely reflect the isolation and loneliness they find in
the world?

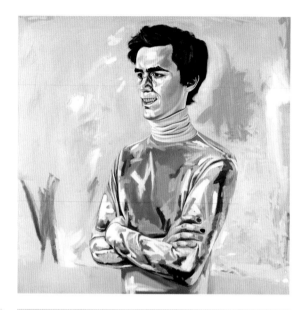

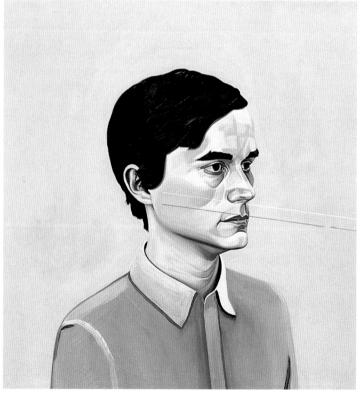

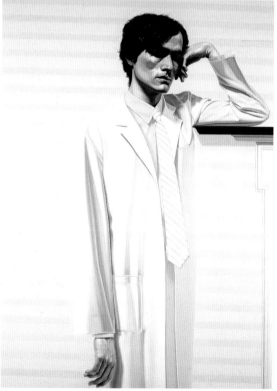

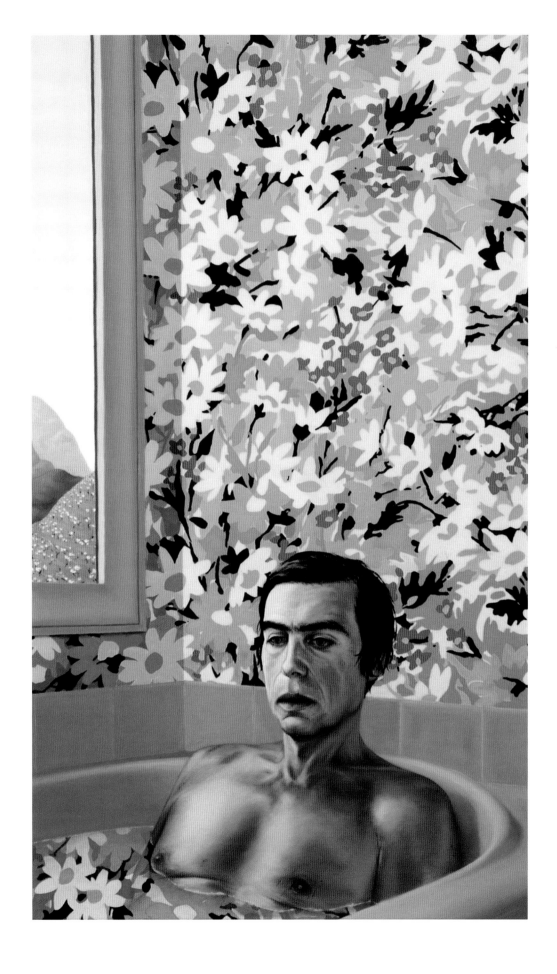

Mathew Cerletty
The Bath, 2002

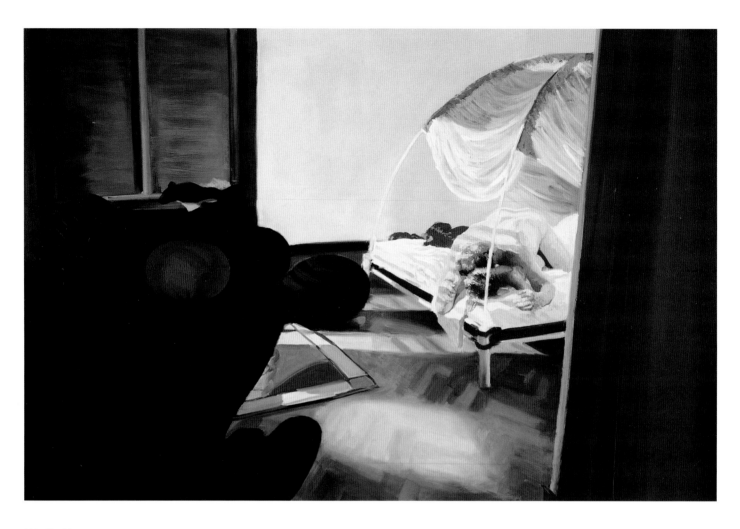

Eric Fischl
Bedroom Scene No. 8, 2004

Fischl was born in New York in 1948, but spent his childhood
in the 'safer' suburbs of Long Island. He cites his experience
of this distorted domesticity as a major influence on his
paintings, which continue to explore the sexual tensions
hidden behind closed suburban doors. In *Bedroom Scene No. 8*,
a faceless woman lies on her front, a man crouched close over
her. There's an element of Francis Bacon in the armature of
the bed, but none of his epic violence in the figures. This
appears as a private act on which we look as a voyeur, slyly
peering round the dark doorframe. In *Bathroom Scene No. 4*,
we are again privy to something that not even the woman's
partner can see, her leaning forward on the toilet expectantly,
make-up bag in hand. Fischl works on a cinematic scale (his
works are often two by three metres) and this painting makes
us feel as uncomfortable in its misplaced intimacy as Stanley
Kubrick's opening sequence of *Eyes Wide Shut*.

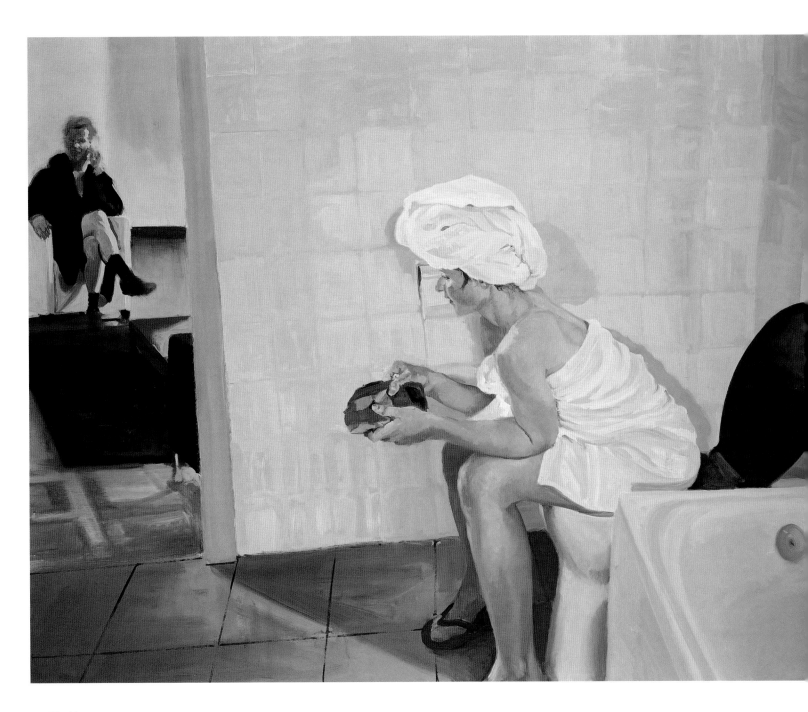

Eric Fischl
Bathroom Scene No. 4, 2005

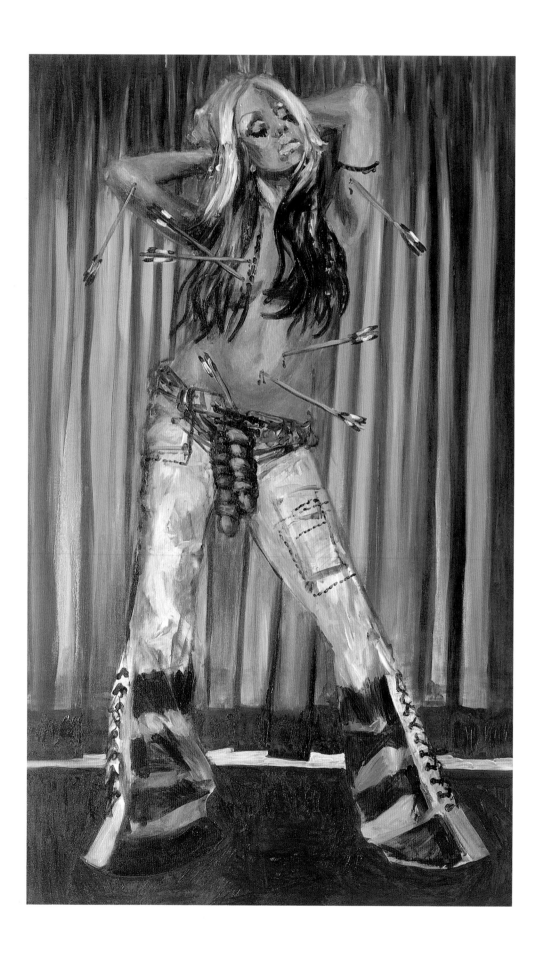

Dawn Mellor
Christina Wieners, 2004

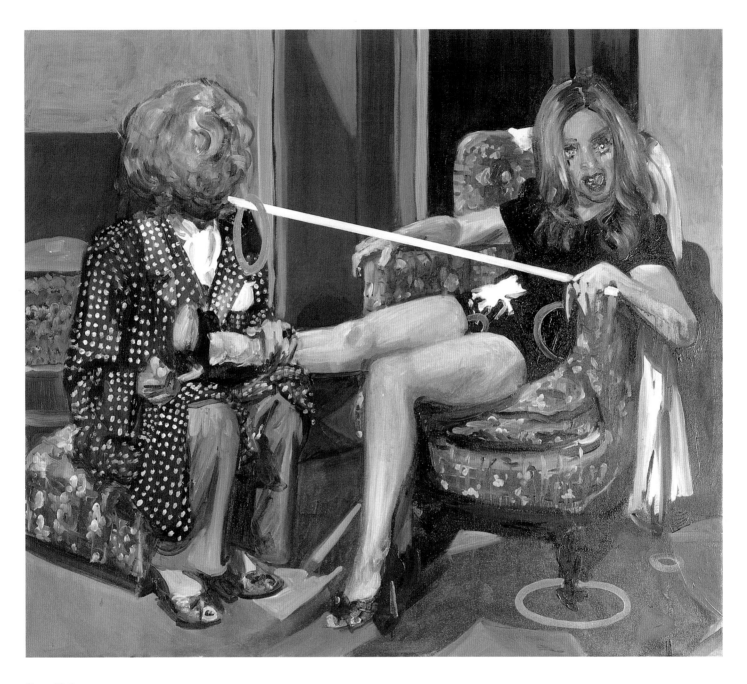

Dawn Mellor
Madonna Molotov, 2004

At the heart of Mellor's work is her belief in the destructive power of the media and our own obsession with celebrities. Her paintings feature the giants of Anglo–American stardom (reinvented by Mellor), from Gwyneth Paltrow – cuddling a big cat instead of her Oscar – to Liza Minnelli in an X-rated version of *Cabaret*.

Mellor's women often appear grotesquely caricatured, and yet there is an underlying sympathy for each character, almost like adulation from an obsessive fan. In *Christina Wieners*, Christina Aguilera appears ecstatic in her martyrdom, shot through with arrows like the tenacious St Sebastian. In *Madonna Molotov*,

Madonna's artful ability to reinvent herself despite fierce press criticism has everyone – even a hirsute British ex-prime minister – pandering to her every whim. The faceless Mrs Thatcher, prodded by Madonna's own white walking cane, emphasizes our blind belief in both the media and the celebrities who appear in it.

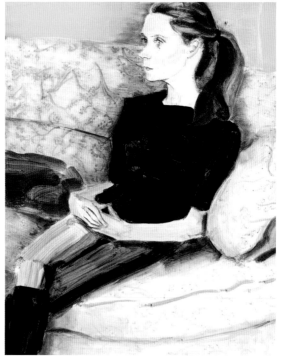

Elizabeth Peyton

Pauline, 2005 [above]
Peconic (Ben), 2002 [left]
Ken and Nick, 2005 [opposite]

Peyton's portraits capture the fragile beauty of her generation, the paleness of skin against oil-black thickets of hair or cherry-stained lips, the melancholy insouciance and vulnerability of singers like Jarvis Cocker and Pete Doherty. A sadness infuses her canvases, as if – like James Dean – the good looks of her models can only lead inevitably to their destruction. Peyton is often compared to David Hockney, translating his portrait classics such as *Mr and Mrs Clark and Percy* for the twenty-first century. Her works are painted in thin oil washes on gesso, the white ground giving the faces a ghostly luminosity. Her subjects are never active, but sit or lie, exhausted by their own slacker mentality, as decadent as Oscar Wilde's friend Lord Alfred 'Bosie' Douglas, himself an early subject of Peyton's.

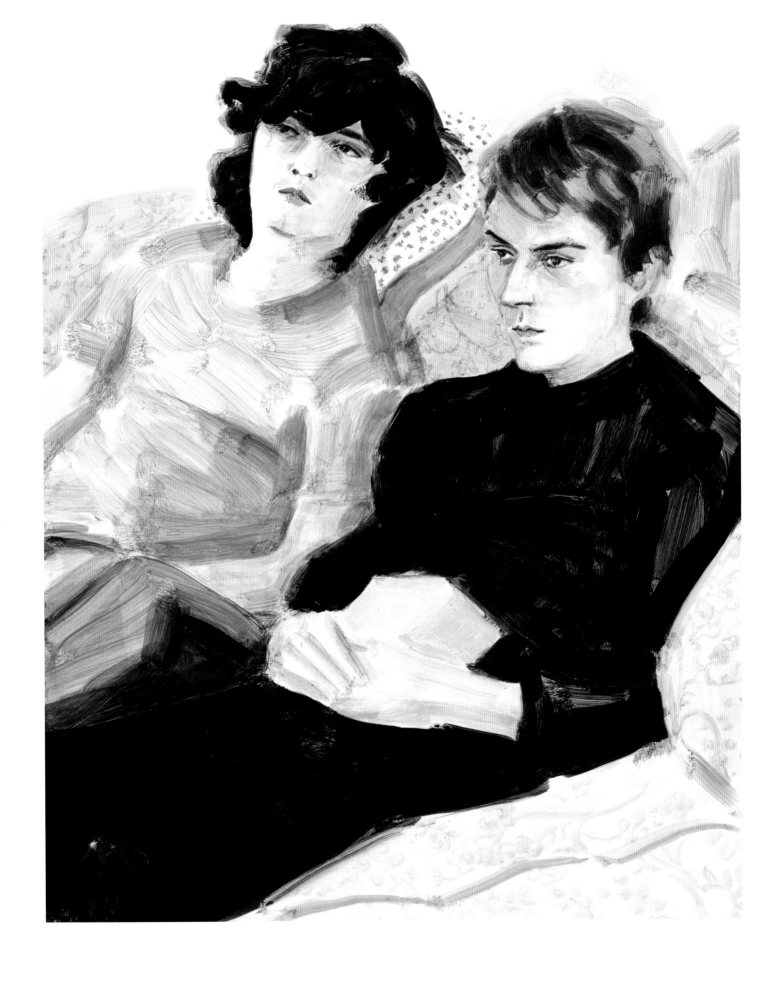

Muntean and Rosenblum

Untitled (Everything High Above...), 2003

While Markus Muntean and Adi Rosenblum work together
in a range of media, painting is central to their artistic practice.
Sourcing their nubile models from photographs in fashion
magazines, they replicate their mannered poses in a variety
of urban and suburban settings, from bland interiors to
basketball courts. In *Untitled (Everything High Above...)*, the
location is the edge of a reservoir, electricity pylons silhouetted
against the sunset. The teenage figures, inappropriately dressed
in the latest high street fashions, seem isolated, alienated, staring
out at you with a bored look of indifference. Underneath each
image runs a line or two of text, collaged from magazines into
cod-poetic epithets such as 'We look at each other without
seeing'. *Untitled (Everything High Above...)* draws on Piero della
Francesca's *The Baptism of Christ*, 1450s, with its pale sky and
grey tree bisecting the canvas. But as opposed to della Francesca's
painting, where Christ stands centre stage, here there is only
a watery void, because – for these youngsters – this is a Godless
age, where only brands matter.

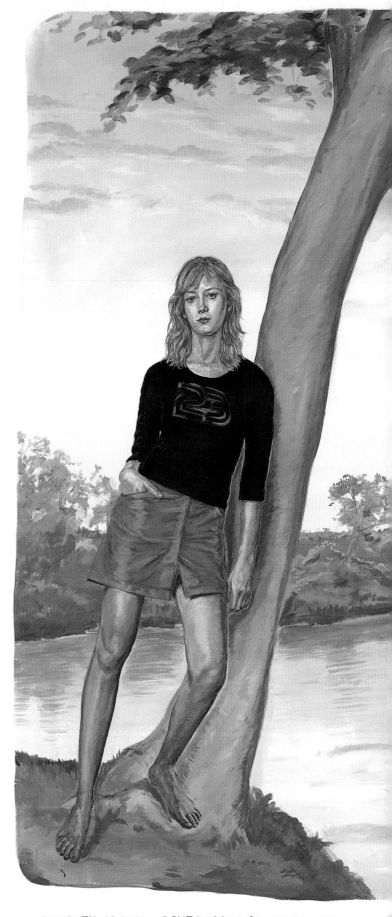

EVERYTHING HIGH ABOVE PASSES ON, JUST LIKE EVERYTH[

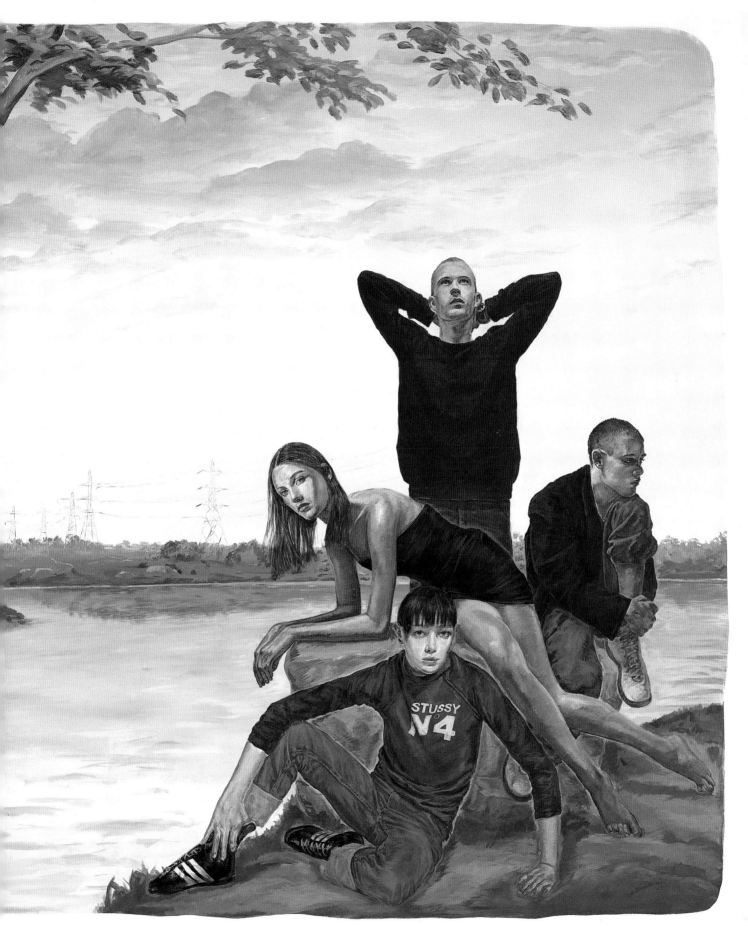

N BELOW, WITH NO CLOUD LEAVING BEHIND MORE THAN RAIN, NO TRUTH LEAVING BEHIND MORE THAN SORROW.

Jun Hasegawa
23 Figures, 2004

Hasegawa was born in Mie, Japan, and moved to London to study graphic design and, later, painting. Japanese *anime*, computer games and her graphics training have all influenced Hasegawa's painting style, where flat figures like cardboard cut-outs populate illusory spaces that look like simple stage sets, or basic computer game landscapes. She only paints women, first tracing their outlines from men's magazines. They appear self-sufficient, uncommunicative, meeting your gaze but never allowing you – or any of their neighbours – into their hearts or minds. They have been taken out of context and now occupy a fictional territory in which they seem both out of place and time, trapped in their sad bubble world, unable to make contact.

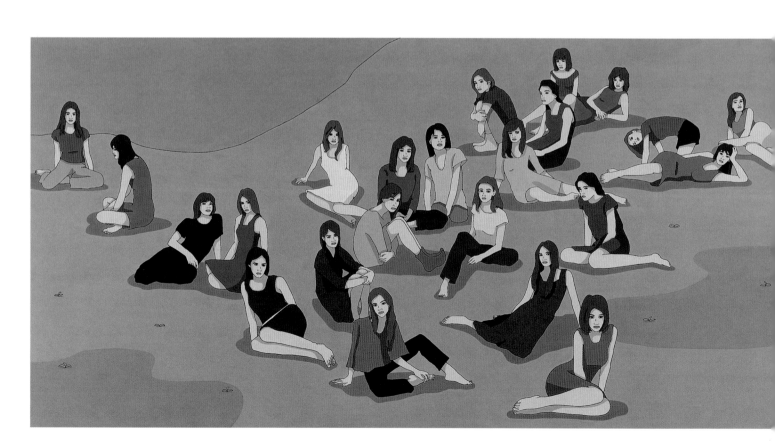

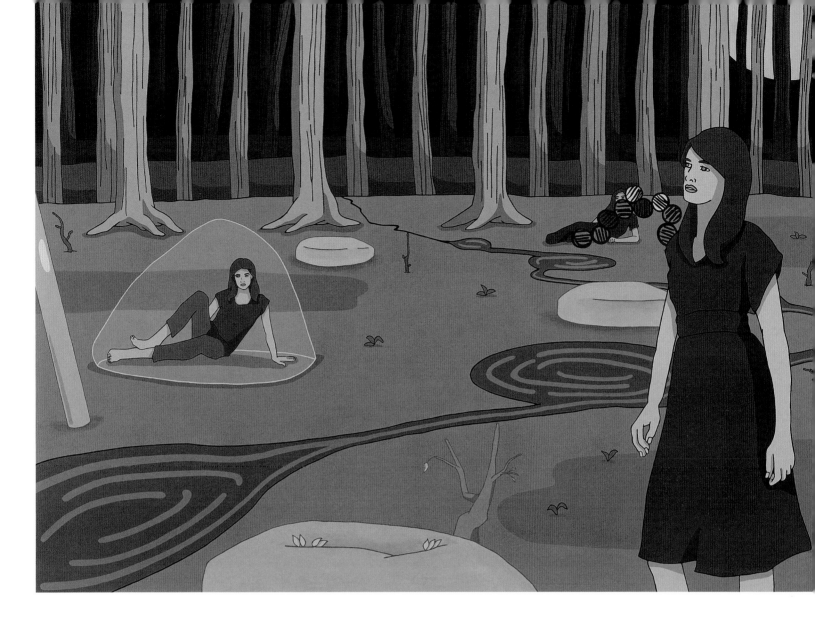

Jun Hasegawa
Untitled, 2004

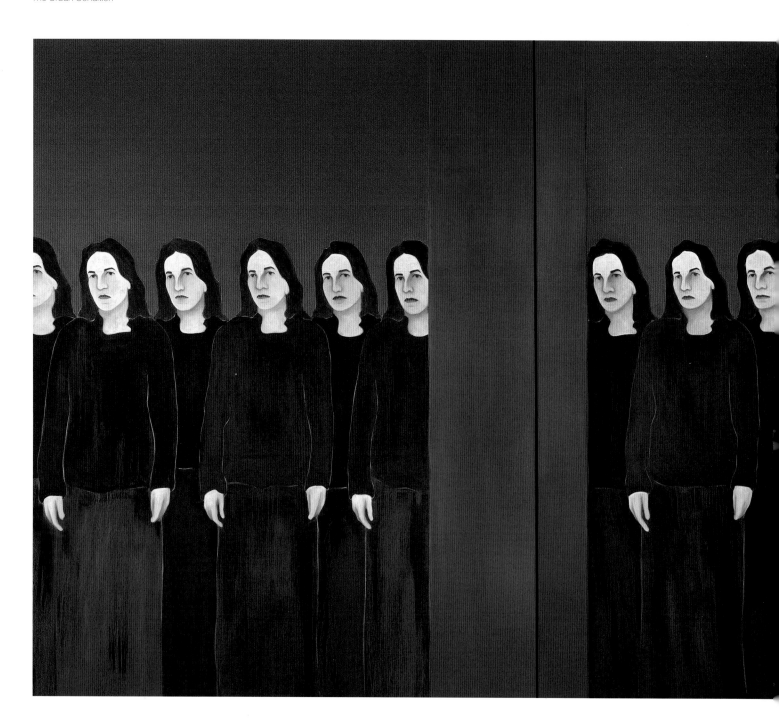

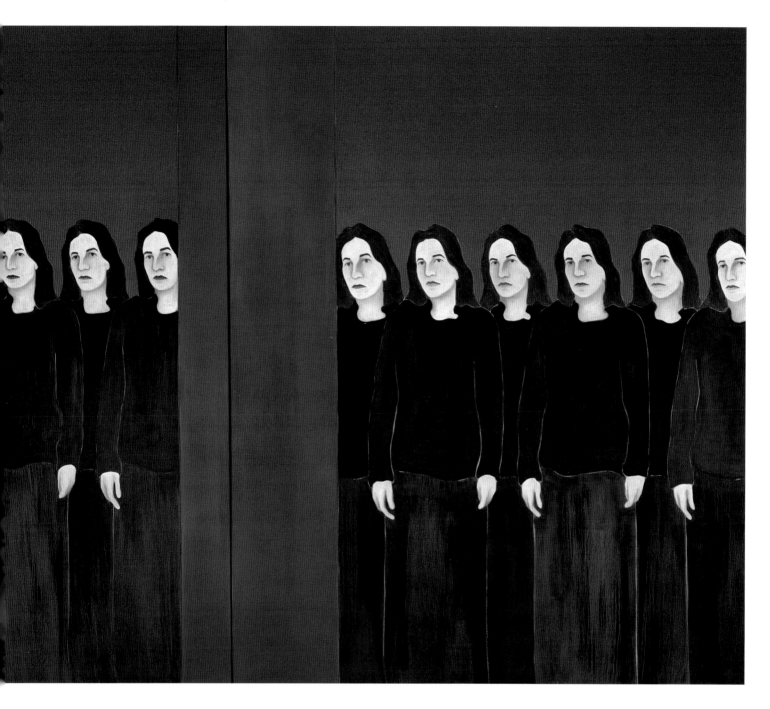

Djamel Tatah
Untitled, 2003

In 1986, while still at college, Tatah decided to pare his subject matter right down to a clothed figure or figures set against a near-monochrome background. Since then, he has stripped down the people he paints still further – now they have flat slabs of black paint for hair, wear shapeless clothes and have no distinguishing features. Despite there being eighteen women in this painting, their sense of solitude could not be more apparent. Each figure is painted from the same photograph of a model whose outline he initially projects life-size onto the canvas. Their grey–white skin and dark clothes suggest a repetitive and colourless urban existence where they are merely numbers, not individuals. In contrast, the smouldering red background surges at the viewer while the blue columns push the surface back, trapping the women in their featureless location from which there is no escape.

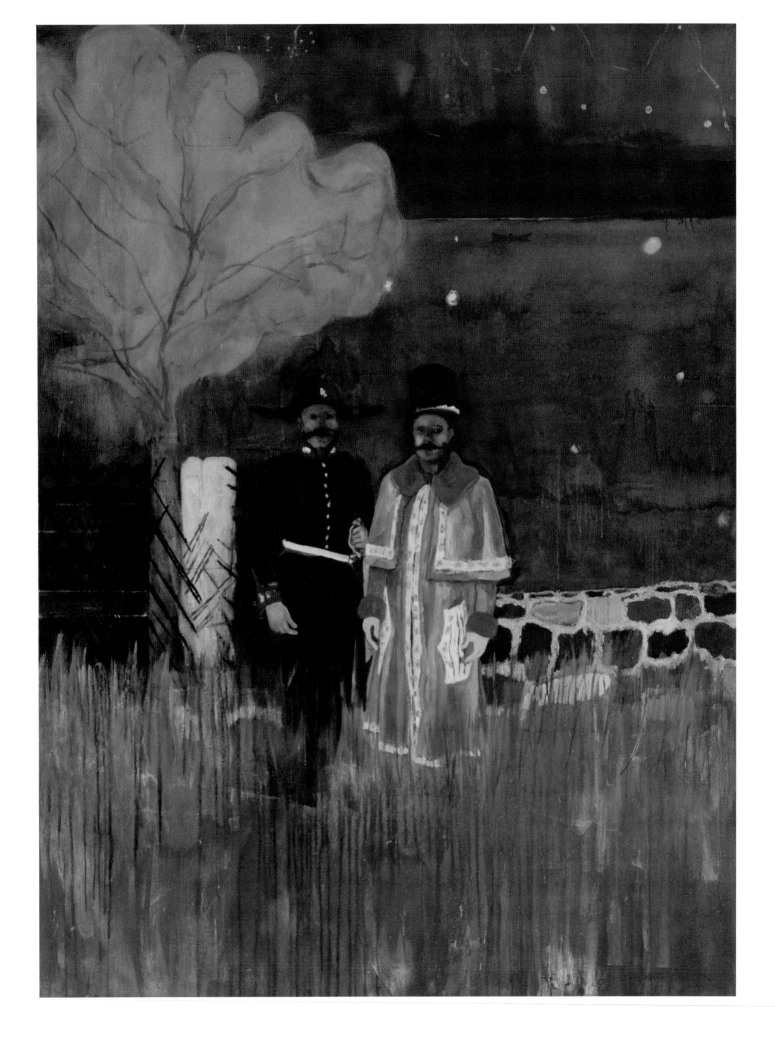

3 Other Worlds

Over the last few years, there has been a resurgence of interest in romanticism among artists, of the importance of the artist's personal response to the environment that surrounds them. When Peter Doig was shortlisted for the Turner Prize in 1994 he stood alone in the British contemporary art world, a solitary artist exploring what it was to be overwhelmed by the landscape. At the time, he painted skiers no bigger than flecks of paint, dwarfed by the enormity of the snow-encrusted mountain they raced down. Now he paints lone men in canoes who float on becalmed waters, insignificant and vulnerable below threatening skies, and others who wade through pools surrounded by tropical vegetation.

Doig's peripatetic lifestyle – which has seen him live variously in Scotland, Trinidad, Canada and England – continues to inform his paintings, as the chill arctic wind of a Canadian winter or the hot tropical ripeness of a Trinidadian afternoon form the backdrops for his investigations into our relationship with the world. Man is often shown alone, engulfed by the landscape, whether walking over thin ice, as in *Blotter*, 1993, or wading through a waterfall, as in *Pelican (Stag)*, 2003. The single figures signify the artist's own desire to be overwhelmed by nature, to enter into a shamanistic relationship with his environment. The resulting paintings appear as visions of somewhere familiar yet strange, uncanny shimmerings based on a careful study of our world that in turn suggest another.

A recurring motif for Doig is the canoe, long and low in the water, a traditional dug-out in which man never rows, never takes control of the direction he travels in but seems happy to follow the currents. Boats have long been connected with transition – from one country or continent to another; from this life to the next. As if offering transport across the river Styx as Charon provided for dead Greeks or the ferryman Mahaf offered

Takashi Murakami *Jellyfish eyes-MAX & Shimon in the Strange Forest*, 2004

Yoshitomo Nara *My 13th Sad Day*, 2002

ancient Egyptians as they moved to the afterlife, they float across the canvas, often separating two distinctly coloured bodies of water, or offering a visual stepping stone to the far shore. They are a vehicle in which to navigate between two worlds – a motif also favoured by German artist Henning Kles to suggest a journey beyond our known shores.

Doig also offers gateways within his paintings; less watery portals through which to enter and step beyond this world. In *Gasthof*, 2004, the costumed gatekeepers invite you to step past them, to follow the road out of the picture, to pass the distant canoe on the lake behind. In *Country Rock Version*, 2001–02 the figure has already disappeared from view, into the black rainbow-edged tunnel that has opened up at the side of the road. Kles often paints people on the brink of similar journeys – standing on the banks of rivers, walking through flimsy gateways. The sky appears coruscatingly alive with possibility, as it often does in Doig's paintings, and as can be seen in the work of David Harrison, with whom Doig studied in the 1980s and whose work also operates in similar territory.

In Rui Matsunaga's painting *Keeper of the Garden*, 2005, the gatekeeper stands foursquare looking out at you, the masked man in a velvet frock coat beckoning you to step beyond him, into his world where spheres of energy float from painting to painting, and characters are transformed in paint into mythological beings on the brink of further transformation. If artists such as Doig and Kles mythologize their characters and explore a romantic trajectory that has its starting point in nature, Kaye Donachie, by contrast, fills her paintings of isolated natural landscapes with teenage hippies from unknown cities. The adolescents sit awkwardly on rocks in ones and twos, waiting for the enlightenment that they feel will arrive now they have returned to nature.

Other artists are as happy locating their figures in urban shopping centres as they are in wooded glades. Daniel Richter paints clusters of people staring up at the sky in front of department stores or tower blocks, their skin glowing unnaturally, their forms dissolving into one another. As with Doig, the paint visibly forms a skin on the surface while the subject matter draws you into the painting, the woods and tower blocks dissolving into the figures who in turn bleed into the concrete pavements and arid ground. Your eye plunges

into each canvas only to be hauled back by flecks of paint or drips that sit resolutely on the surface.

While Richter's figures could be seen to be fluorescent mutations of our own, those of Wangechi Mutu have passed beyond such recognition. Mutu's figures are a collage of photographs from magazines, paint sprayed on to masked body parts and delicately painted grassy landscapes from which they seem to sprout. Explosions of colour burst up and down their skin, their bodies morphing as they are adorned with too-small shoes, giant rings, mechanical parts instead of limbs. They are fantastical and yet have a cohesion that brings them to life, tattooed ladies from another planet who don't seem out of place in ours. Raqib Shaw's figures don't even aim for a stylistic coherence, but offer an orgiastic splicing of people and marine creatures in his series, *Garden of Earthly Delights*.

Throughout the twentieth century, cartoon characters have undergone similar transformations. With the advent of computer games, and the rise

David Harrison *Miss Kitty in Paradise*, 2005

of Japanese genres of animation, manufactured characters have become part of the fabric of our global culture. No artist has been as influential in fusing the traditions of 'high' art with the 'low' art of *manga* as Japanese artist and impresario Takashi Murakami. He has invented his own cartoon character, Mr DOB, whose success funds a busy studio where protégés of his Kaikai Kiki school start their careers. One such protégée is Aya Takano, whose cartoon-like pre-pubescent girls float around their own little worlds in nothing more than squid helmets.

American artist Inka Essenhigh also draws heavily on the elastic capabilities of cartoon figures for her disturbing paintings of futuristic life, where women fresh from plastic surgery shop for vacuum-packed food or figures lay under a fierce sun and all but melt into their loungers. In contrast to the romantic visions of Doig and Kles, these artists – Richter and Essenhigh, Mutu and Murakami – show the flip side of the coin, when our increasing reliance on technology and DNA alterations threatens to become a reality.

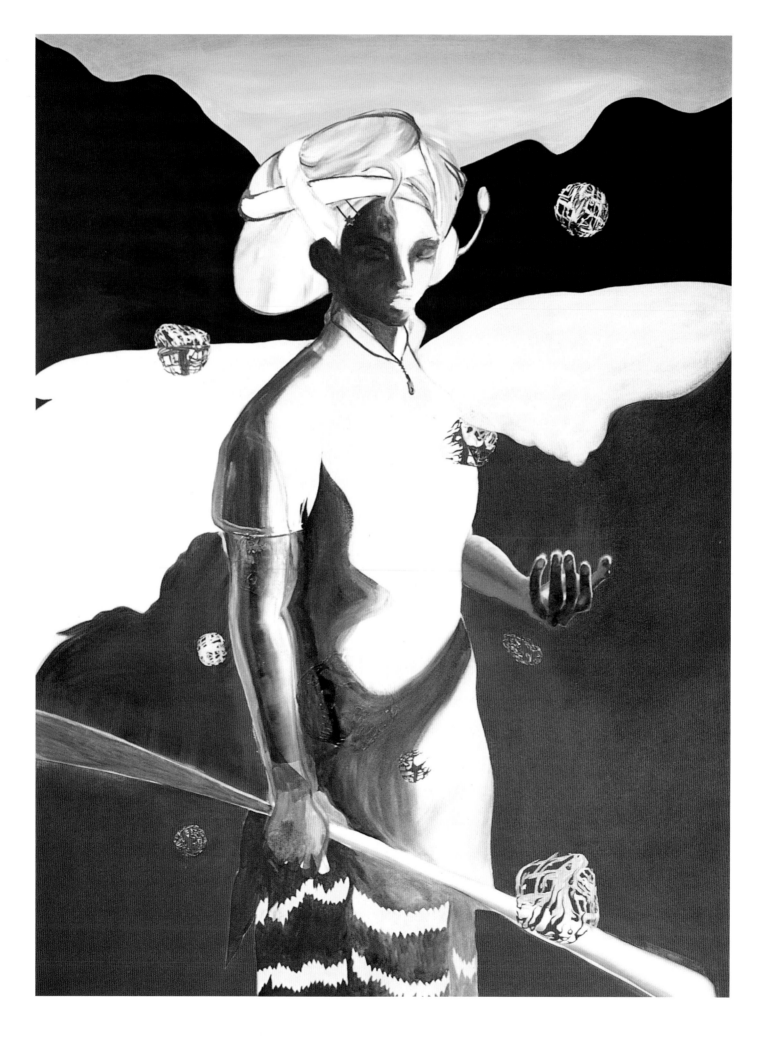

Rui Matsunaga

Light Sabre, 2005 [opposite]
Eternal Sunshine, 2005 [below]
Keeper of the Garden, 2005 [right]

All Matsunaga's paintings take us on a journey, out of our
own world and into that of her subjects who are on the move
themselves. In *Light Sabre*, an androgynous figure half-obscured
by shadow beckons us to join them. In their right hand they
clutch an oar, ready to paddle a boat away from this abstracted
land with you on board. In *Keeper of the Garden*, the costumed
gatekeeper sweeps his hand across the canvas in a gesture
of welcome, emploring you to join him as he gets set to step
into the acid-yellow light beyond. Matsunaga paints places from
her imagination, balls of energy floating in the sky, lurid colours
and flat tranches of paint denying any sense of specific location.
She bases her figures on magazine photographs, transforming
her subjects from actors and agents into mythological characters
of her (and our) invention.

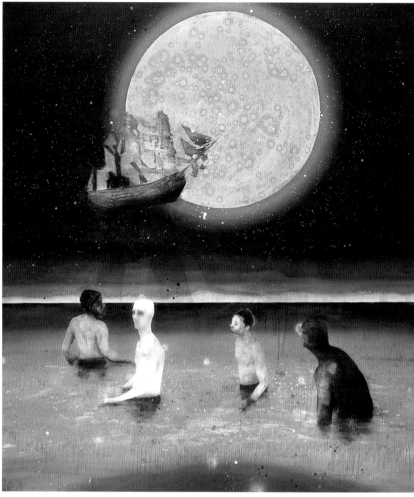

Henning Kles

Ludergrube II, 2004 [above left]
Bounty, 2005 [above right]
Bell Boy, 2004 [left]
Nachbarn, 2004 [opposite]

Kles's canvases feature a fantasy world of sky-divers and mutineers, explosions and fires. In *Bounty*, a ghost ship surfs the sky as Captain Bligh's naked crew watch from the phosphorescent water below. Kles seems to paint key moments whose significance we can't quite fathom. Often he features bridges or platforms, gateways to other worlds. In *Ludergrube II*, a hesitant boy stands by a makeshift crossing, fearful of slipping into the toxic water but seduced by the radiant figure on the far bank. In *Nachbarn*, a man looks through a guillotine-like door-frame strung with fairground lights, a ghostly vision in pinstripe trousers returning his gaze. Both the poisonous purple river in *Ludergrube II* and the deadly smoke in *Nachbarn* seek to deny the paintings the depth the story craves, and Kles is skilful in creating a Whistleresque surface over which the eye cannot help but linger.

Peter Doig
Metropolitain (House of Pictures), 2004 [left]
Pelican (Stag), 2003 [opposite]

Doig's figures reside out of time in magical landscape settings – a lake that reflects the twinkling sky, a tropical bower. In *Gasthof* (see p. 82), the men seemed dressed for a costumed party. In another version of this painting, the multicoloured stone wall extends over a bridge: these men are gatekeepers, markers between our world and theirs. Doig now lives on the Caribbean island of Trinidad, and much of its tropical landscape features in his latest work. Palm trees droop over the semi-naked man in *Pelican* (*Stag*) and crop up again in *Metropolitain* (*House of Pictures*). In both these pictures Doig revels as much in paint's own qualities as in each work's narrative possibilities. The blue scree of paint in *Pelican* (*Stag*) drips down the canvas like a waterfall; in *Metropolitain* (*House of Pictures*) the landscape in the paintings on display stains the wall and leaches between the frames. Paint rids the works of their internal logic, recasting them as dreamscapes.

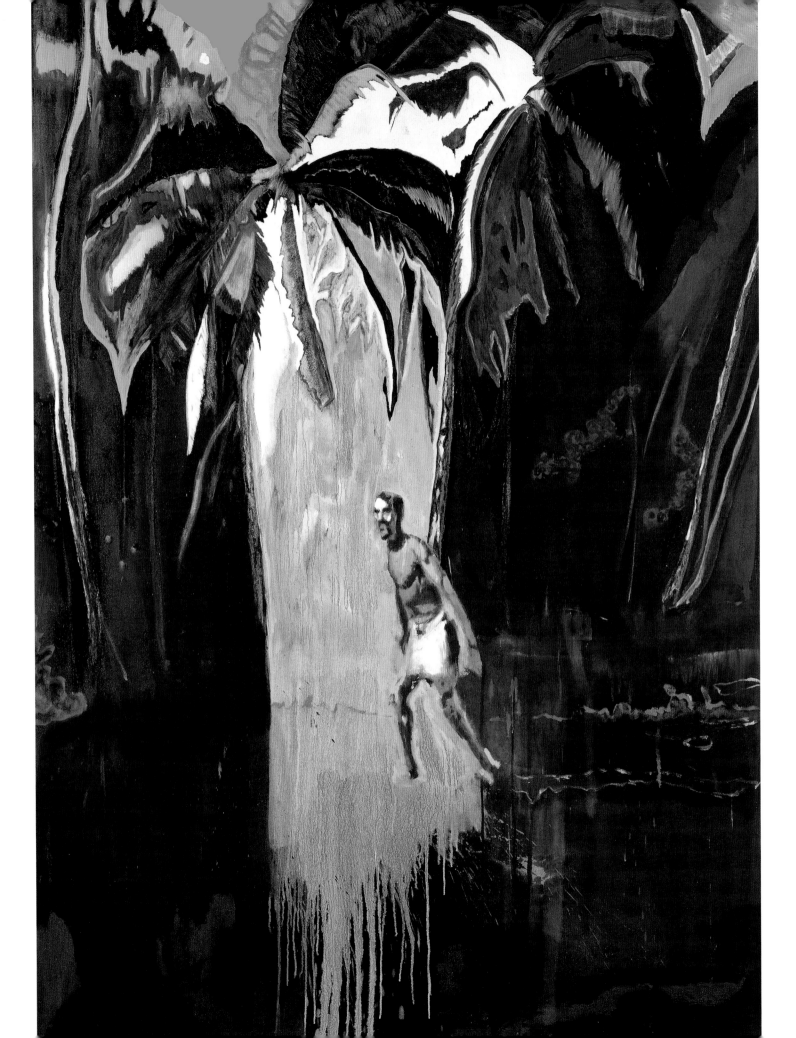

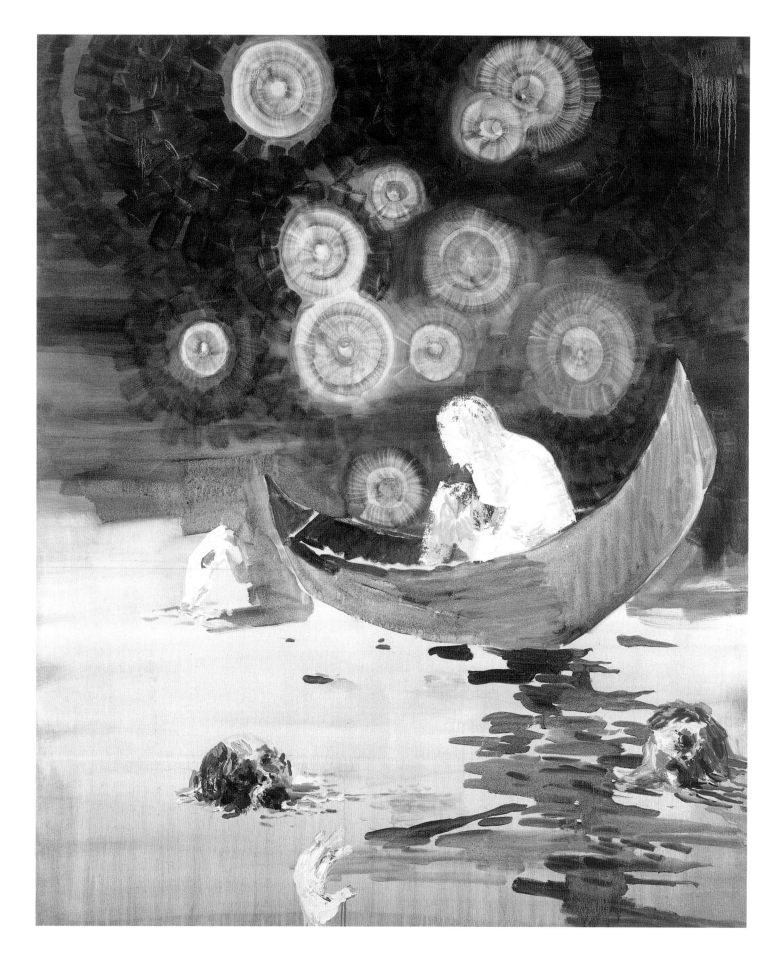

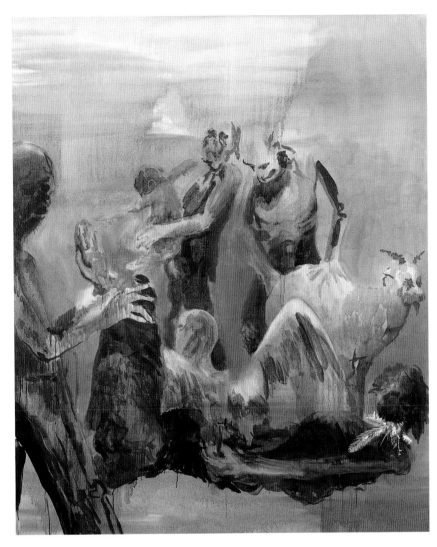

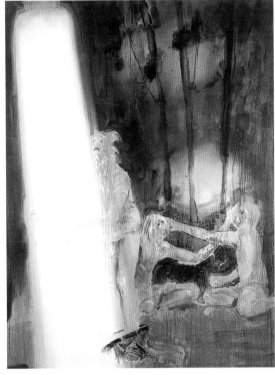

Andrew Guenther

Planetary Discipline, 2003 [opposite]
Welcome to the Earth, 2003 [above]
On Enlightenment, 2004 [above right]

Guenther's work is iconoclastic, demented, decadent.
Flesh-eating zombies have taken over his world, and skulls
and animals are bathed in hallucinogenic colours. Guenther
fuses the bleakness of Goya with the dark mysticism of
Blake and also the motifs of Peter Doig in his paintings.
In *Planetary Discipline*, a canoe floats in a sea of severed heads,
the stars above twinkling in a bloody sky. The figure sits
hunched in disbelief as his vessel negotiates the sullied water.
In *Welcome to the Earth*, a new species has arrived on our planet,
raping and pillaging the Earth's sunset years. God seems to
have forsaken these lands, and yet, deep down, all Guenther's
subjects are searching for a sense of belonging, a spirituality,
evoked by the white light that illuminates the forest dwellers
in *On Enlightenment*.

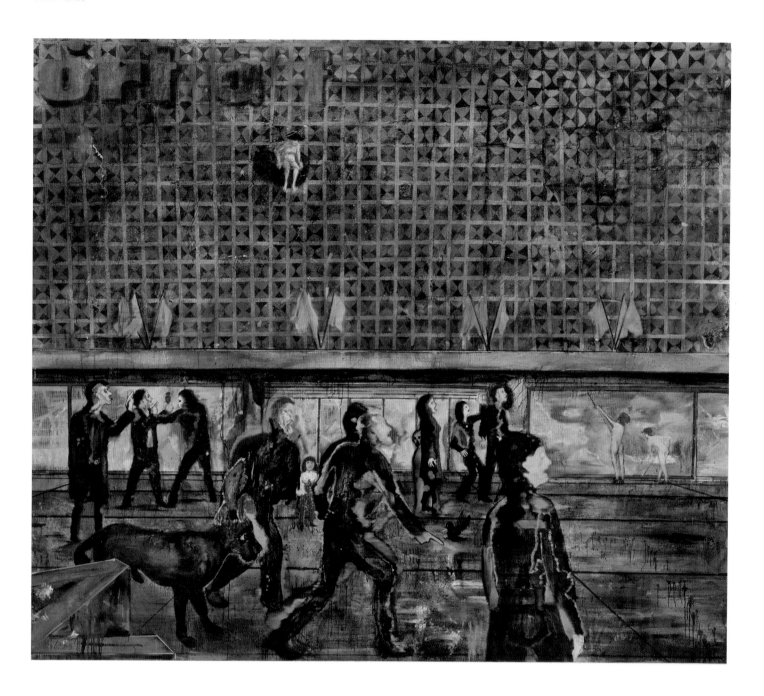

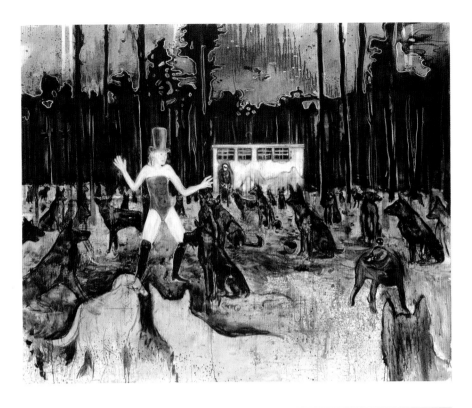

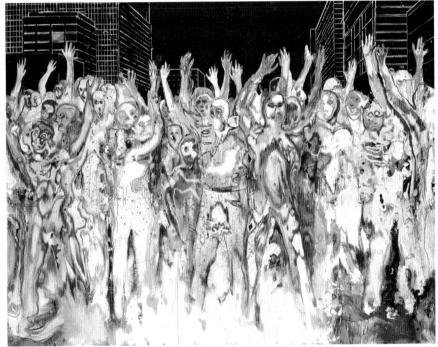

Daniel Richter

Gedion, 2002 [opposite]
Tuwenig, 2004 [above]
Duisen, 2004 [left]

Richter started out as an abstract painter, his
figures slowly emerging from a Kandinsky-like
jumble of shapes around the turn of the millennium.
Now they are centre stage, albeit often bleached
and burnt, naked and radiating a Technicolor glow.
In *Gedion*, Saturday shoppers stop to stare at the
sky, an ultraviolet haze enveloping their bodies.
Everybody is caught up in their own action –
staring, fighting, painting – except the little girl
in red, who looks at us with all the intensity of the
Grady daughters in Stanley Kubrick's *The Shining*.
In *Duisen*, the figures glow as if genetically modified
to change colour with heat. At an orgiastic rave
they seem hypnotized, eyes skyward, arms in the
air. But again, a child – this time green and unsure –
stares out at us, connecting us to events, turning us
into witnesses. They see us, but we are left curious
as to what the rest of them are looking at.

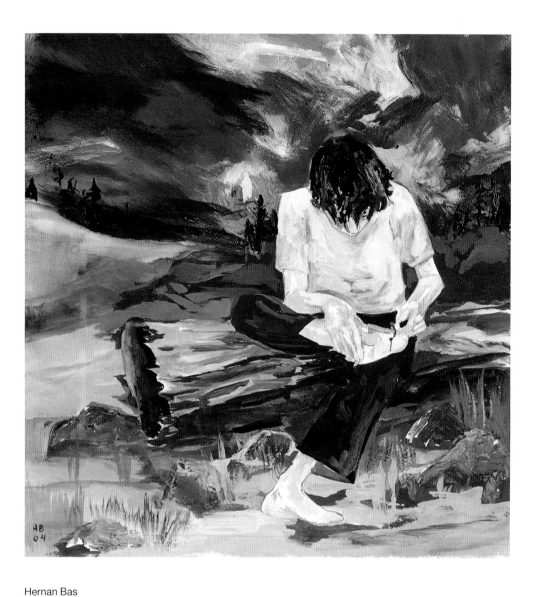

Hernan Bas

Boy Plucking Thorn from Foot, 2004 [above]
Well Aged, 2005 [opposite]

Bas's paintings on paper feature waif-like boys isolated in
woodland glades or framed by turbulent twilight skies.
There's more than a whiff of the nineteenth-century dandy
about them, albeit reflected through the 1990s model of pale
and sickly heroin chic. They are wrapped up in their own
world where seemingly trivial things can appear overwhelming,
intensified by Bas's often sublime backdrops and sometimes
deadly narratives. (He's tackled group suicide before now –
think Romeo and Juliet meets The Smiths.) Bas has said that
all these works reflect his own passions as a young gay man
painting in Miami. Skinny, dark-haired and in his twenties,
he paints stories of his search for a lover, or his memories
of a past one. And as each series he completes becomes another
chapter in his life, he gets to decide what happens next –
on paper, at least.

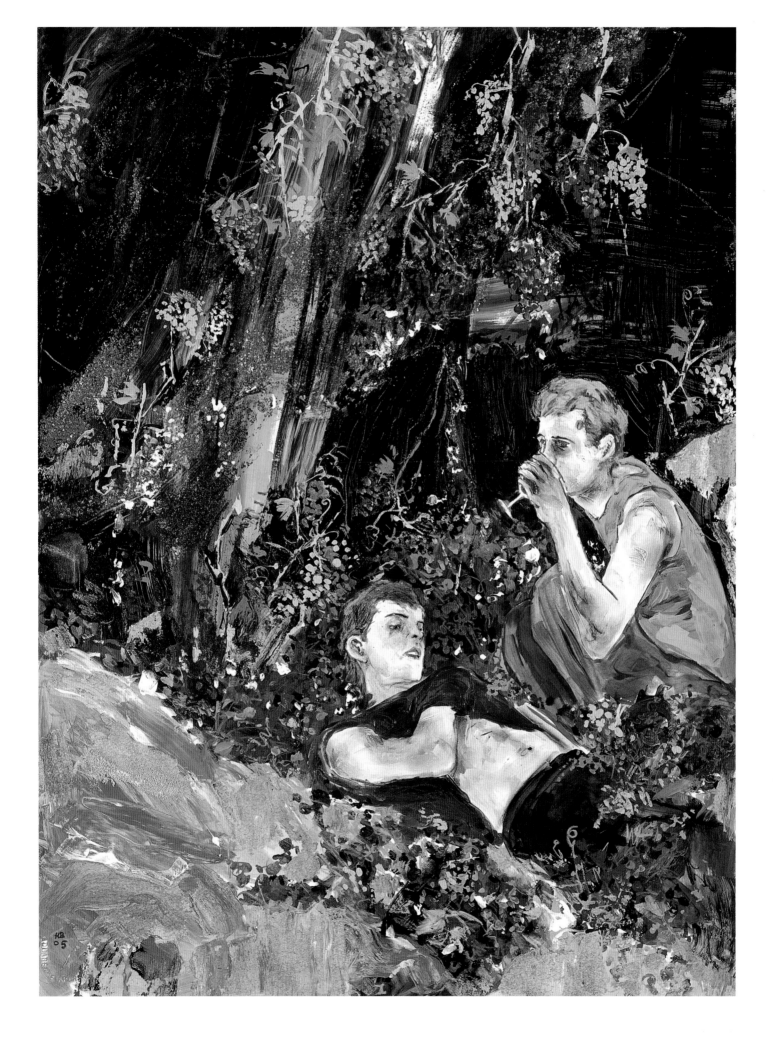

 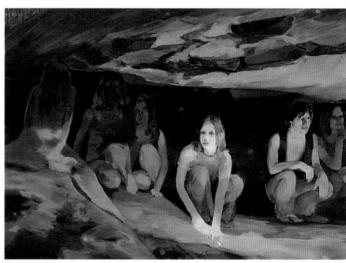

Kaye Donachie

All your life you were waiting for this moment to arise, 2004 [clockwise from top left]

Can't find nothin' I can put my heart and soul into, 2004

Every mornin' our love is reborn, 2004

Ah, you can have my world, 2003

In Donachie's recent paintings, teenagers sit in the dark recesses of forests and caves, waiting to be touched by the light. It's not clear if this is the recent past or the near future – young idealists have communed with nature for centuries – but it does seem apparent that these youths all strive for a greater understanding of their place in the world, fostering new-age spirituality through prayer, heads bowed and palms together. (The hippyish song-lyric titles of the paintings further emphasize their desire for new beginnings.) In many of the works their concentration pays off, and pale apparitions seem to radiate light from their bodies, haloes of luminosity illuminating the dark scene. Donachie paints tonally, often in yellow, the pale lemon highlights contrasted by earthy ochre shadows. Her focus on light and dark adds tension and impact to her narratives, as if we are seeing each scene through a drugged sleep, as intense and unnatural as a dream.

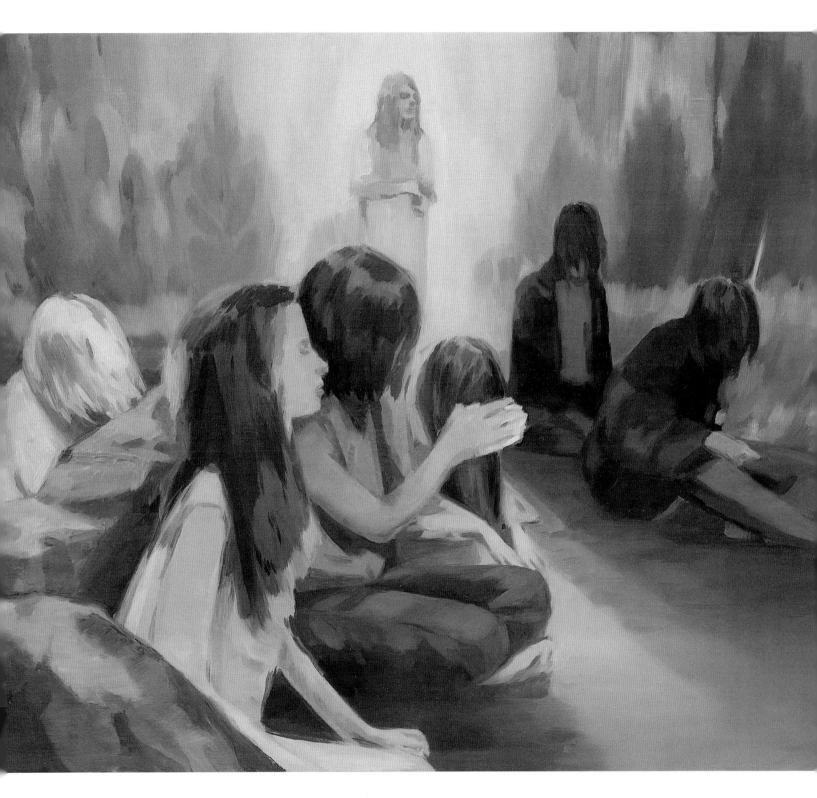

Kaye Donachie
Submission is a gift go give it to your brother, 2003

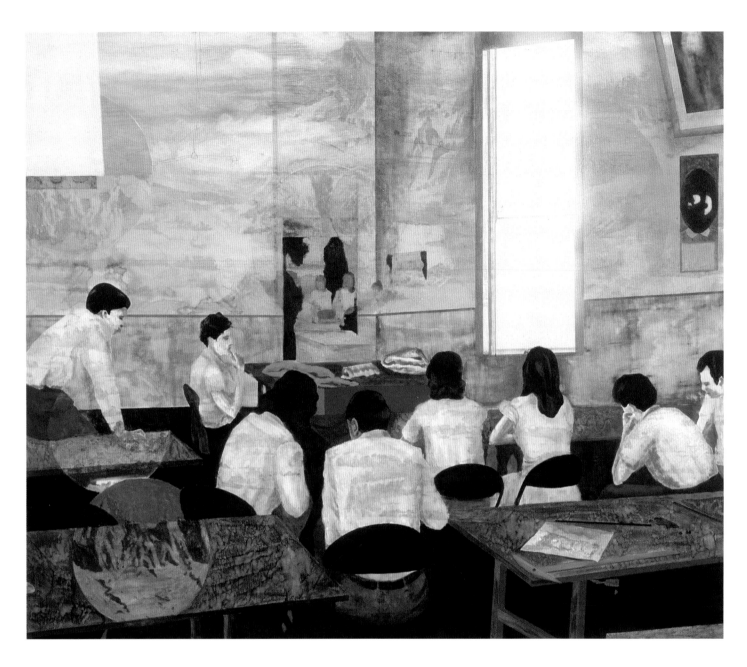

Mamma Andersson
Study Kit, 2004

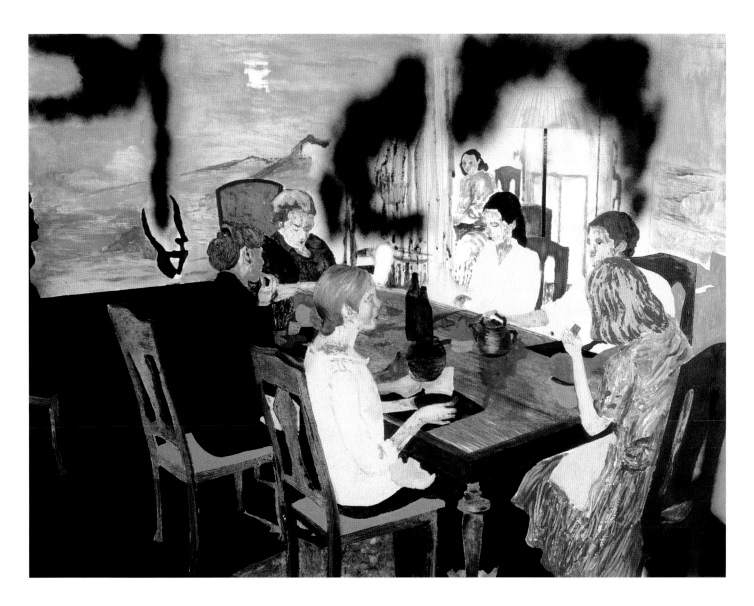

Mamma Andersson
Travelling in the Family, 2003

Andersson won the prestigious Carnegie Art Award in 2006, and
represented Sweden in the 2003 Venice Biennale. She paints vista
landscapes and domestic interiors, classrooms and public halls –
all are places we should be familiar with, yet in her work they
leave us on edge. She destabilizes each environment she paints,
improbably flattening perpendicular walls, as in *Study Kit*,
confusing windows with paintings and landscapes, as in *Travelling
in the Family*. She bases her figures on a broad range of sources
including Scandinavian folklore and Western art history, taking
them out of context and reinterpreting them, and her paintings
are all constructed to suggest we are onlookers to their parallel
world. Grafitti-like black paint hovers on the surface of many
of them, including *Travelling in the Family*, as if sprayed on to the
lens of a CCTV camera through which we secretly observe their
undecipherable rituals.

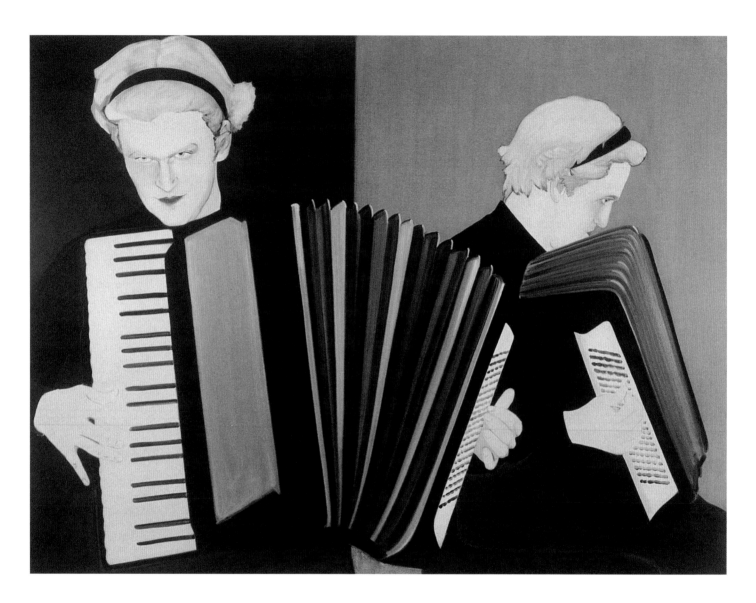

Milena Dragicevic

Reconstruction Isn't Easy, 2002

Dragicevic was born in Serbia in 1965, but grew up in Canada and now lives in London. She's a twin, and this biographical fact – along with her peripatetic existence – is at the heart of her painting practice. For much of her work features two people, near identical, occupying territory that often spans the Atlantic. The accordion players in *Reconstruction Isn't Easy* float on the surface like marquetry memories of an Eastern bloc bar. They are lost in thought, and we are lost trying to work out if the second figure is a reflection or a twin of the first. In *Seansa*, Dragicevic interprets the story of Englishman Archie Belaney who posed as a native Canadian to campaign on environmental issues in the early twentieth century. Here his dual identity is literally shown as two figures, the cloaked English bourgeois and the tanned Ojibway brave.

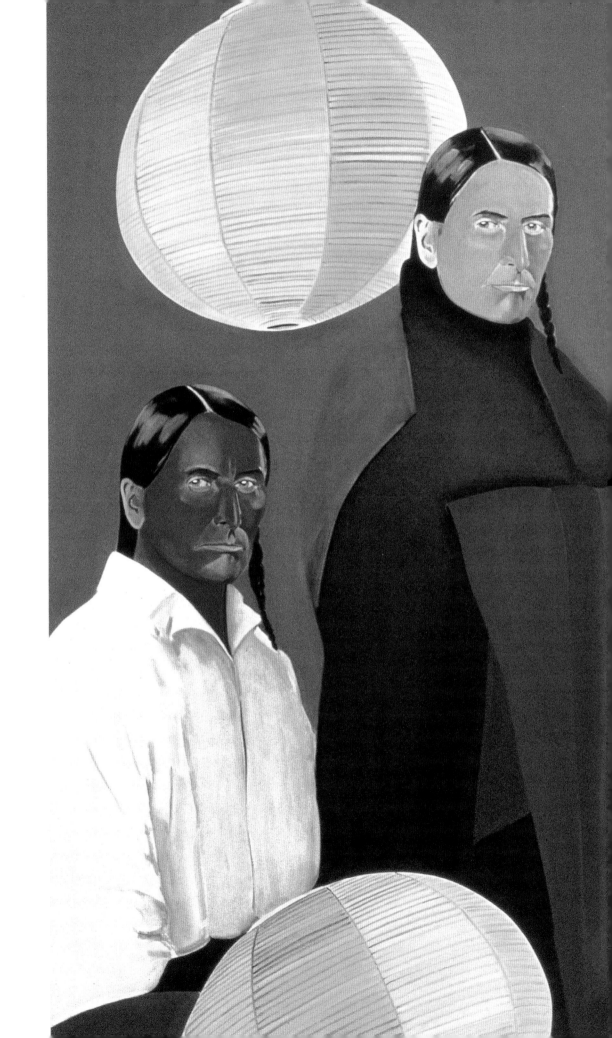

Milena Dragicevic
Seansa, 2004

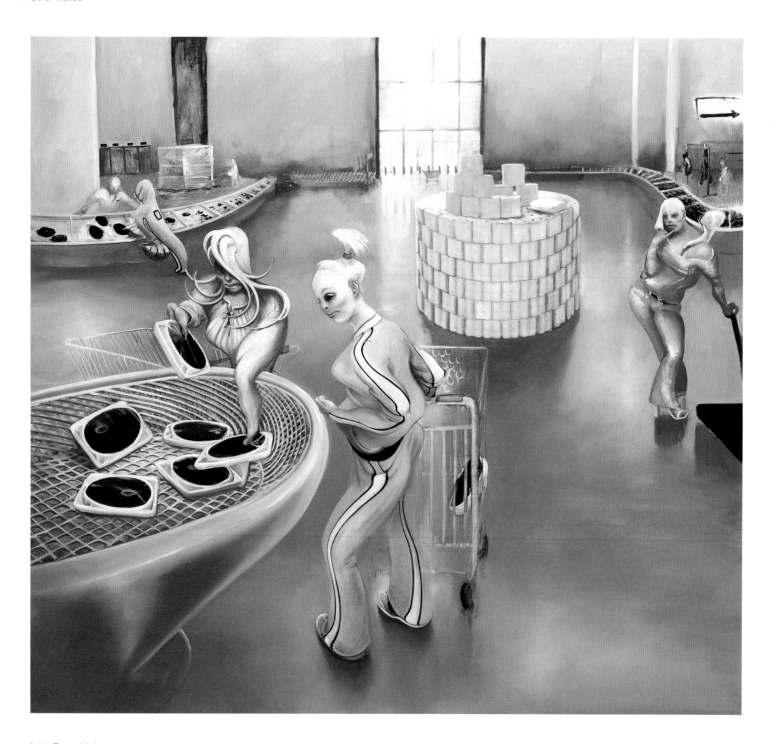

Inka Essenhigh
Shopping, 2005

Essenhigh started out as a classical figurative painter, and still regularly practices life drawing. But following an early job as a textile designer, creating repetitive motifs for boxer shorts, she abandoned realism and started to paint amorphous forms in enamel that hovered halfway between cartoon-like figuration and abstraction.

However, since switching to oil paint in 2001, she has become more interested in creating credible three-dimensional scenes where figures writhe, bend and dissolve. She works directly on the canvas with no preparatory sketches, the final image growing from surface doodles rather like the surrealists' automatic drawing.

In *Power Party*, figures fuse together in isolated clumps, a grey–green artificial light and empty skyscraper setting giving a sense of desolation. In *Shopping*, clones in grey tracksuits search out prime cuts as their trolleys glide silently over the polished concrete floor. The world seems a bleak and unforgiving place in her hands.

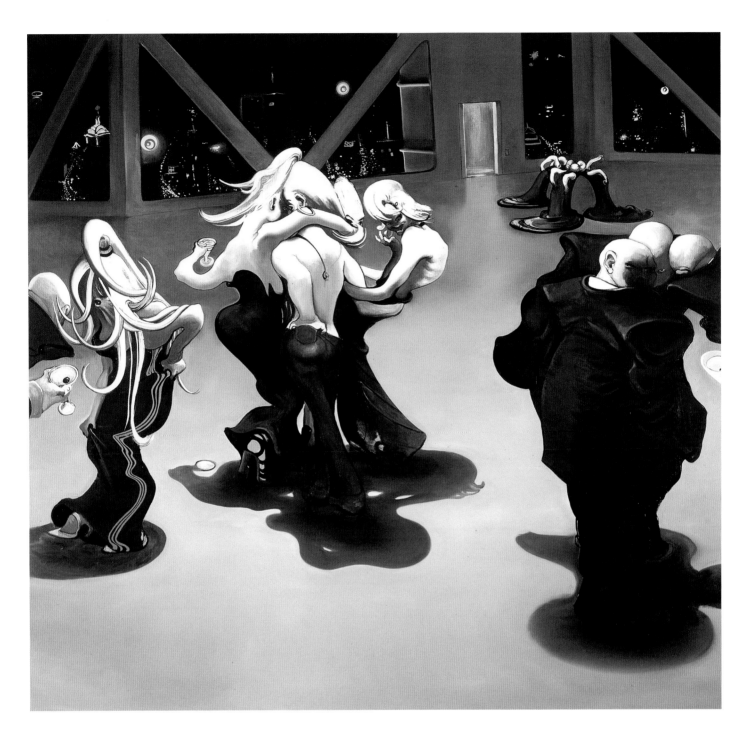

Inka Essenhigh
Power Party, 2003

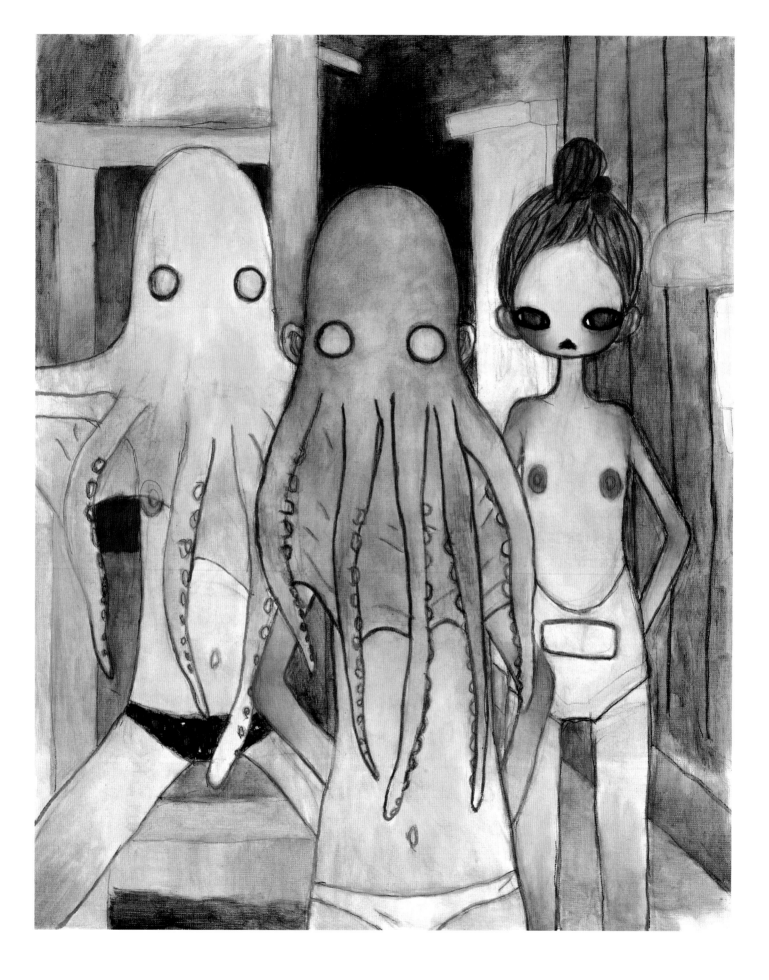

Aya Takano

If you're looking for that, it went over there, 2004 [opposite]

A cluster of fireworks, that girl, 2003 [above]

Survivor, 2004 [above right]

I like the hollows of the buildings, 2003 [right]

Takano is a member of Takashi Murakami 's Kaikai Kiki school, whose 'superflat' style fuses American pop with both Japanese contemporary culture, such as *manga* comics, and traditional prints. In her paintings, prepubescent waif-like girls stand almost naked, their bare flesh emphasized by adornments such as necklaces and boots. Masks feature regularly in her work – squid with eye-holes cut in, Western theatrical props, patches – as if her girls are concealing things, despite their innocent faces. This underlies a darkness that can be found in all her work. Her pre-teens in their skimpy pants, with rosebud mouths and huge lozenge eyes, may be painted in the *kawaii*, or cute, style known to lovers of Hello Kitty merchandise, but their sexual awareness is unnerving (look at the suggestive pose of the girl in *A cluster of fireworks, that girl*, for example). And their aptitude to get in the way of trouble – as suggested by the falling girl in *I like the hollows of the buildings*, or the battered pair in *Survivor* – suggests they are inhabitants of a far-from-perfect world.

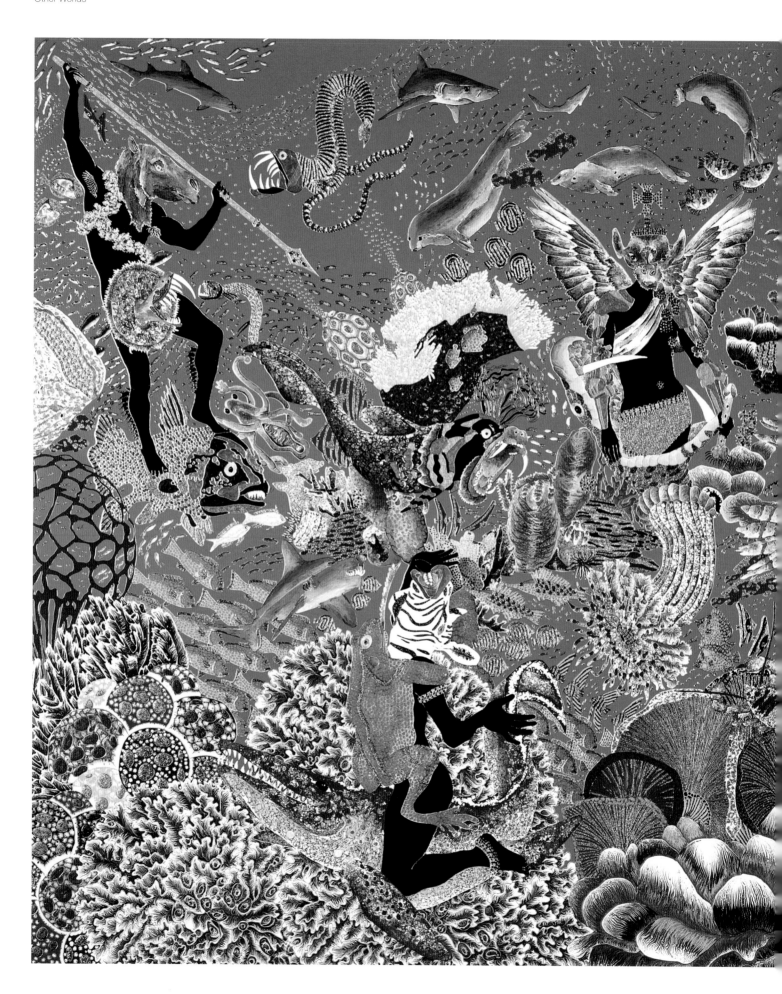

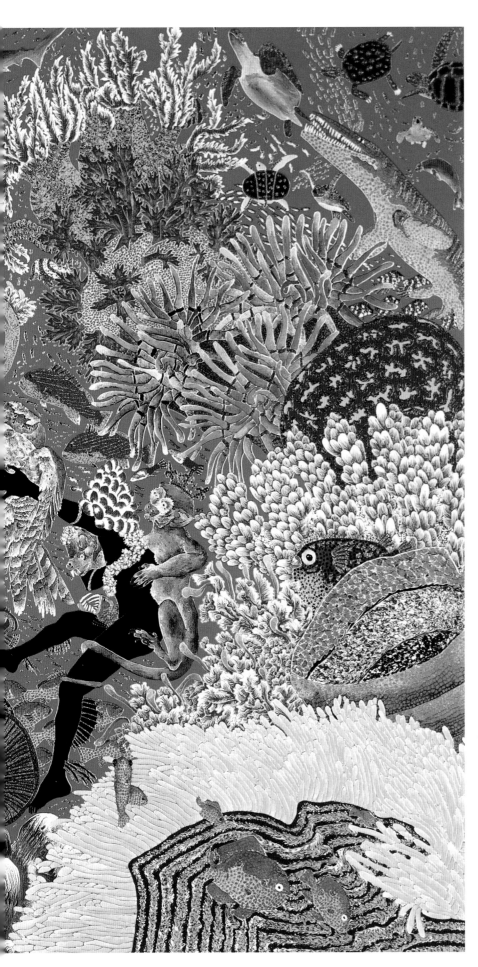

Raqib Shaw
Garden of Earthly Delights IV, 2004

Calcutta-born Shaw now lives in London, and his
paintings are as much a fusion of East and West as
he is. His ongoing series *Garden of Earthly Delights* –
inspired by Hieronymus Bosch's sixteenth-century
painting of this title – features hybrid creatures
part-man, part-fish, part-animal, in an underwater
fantasy land of floral fecundity. They are as
intricate as Bosch's own complex visions, and share
an anthropomorphic creativity, as duck-headed
females sit astride conga eels and red-skinned men
sprout tusks and langoustine erections. The all-over
patterning is reminiscent of textile design – Shaw's
family are carpet makers and shawl traders – and
he enhances this sense of flatness by working in
a cloisonné style, using enamel paints, glitter and
jewels to cover the surface. But his work in turn also
suggests the naïve junglescapes of Henri Rousseau,
the mille fleur patterns of medieval tapestries and
Aubrey Beardsley's erotic illustrations – Shaw casts
his net wide as he devises his obsessively intricate
underwater fantasies.

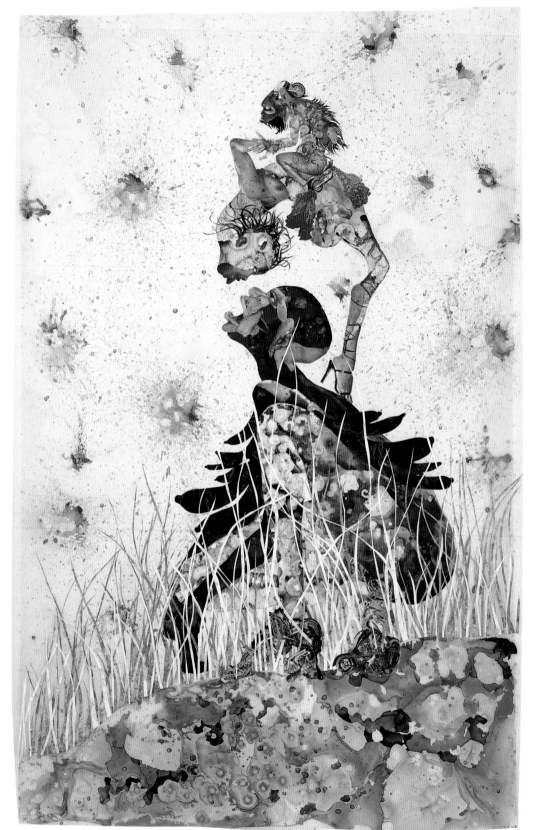

Wangechi Mutu

Misguided Unforgivable Hierarchies, 2005 [left]
She's Egungun Again, 2005 [opposite]

At first glace, Mutu's women seem powerful, striking, elegant and flamboyant. They are often naked, with thick tendrils of hair and firm bodies patterned with the cosmos. But look again, and this beautiful mirage begins to pale – limbs have been amputated and replaced with machinery, feet squeezed into improbable shoes, faces made up of photographs of bottoms and breasts. In *She's Egungun Again*, the figure's hair becomes a Medusa's tangle of kicking legs, and her hands and feet sprout Yeti-like fur. Mutu – born in Kenya and educated at Yale – explores Western stereotypes of African beauty. She implants her figures with idealized body parts cut from fashion magazines and parodies notions of exoticism such as tattooed skin, feathered costumes and masks, creating mutant creatures who force us to question our outdated Western ideology of beauty.

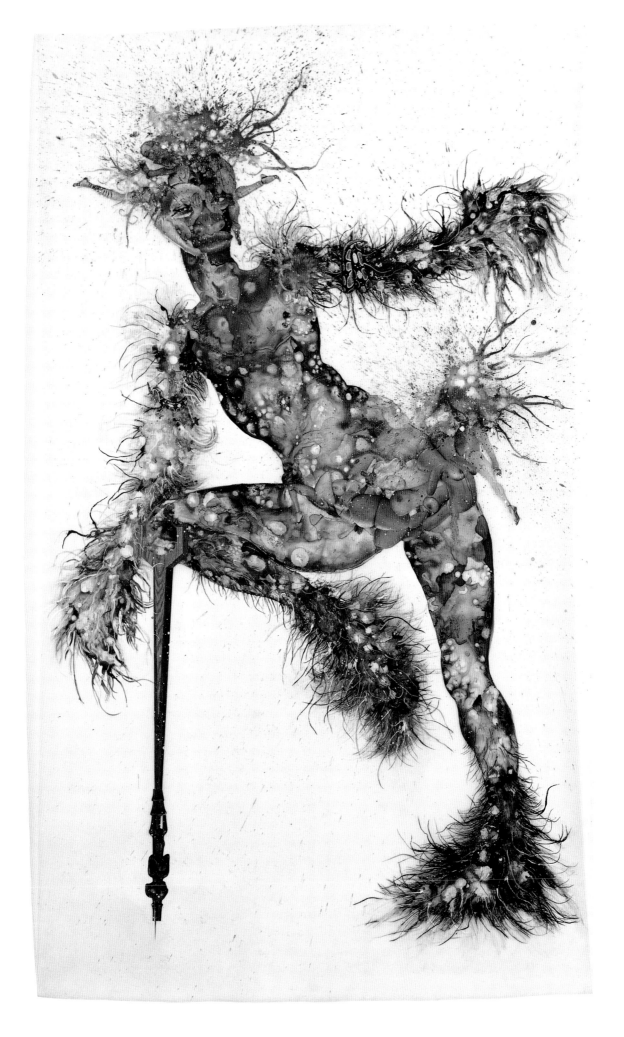

Chris Ofili

Afro Love and Envy, 2002–03 [left]
Blind Leading Blind, 2005 [opposite]

Ofili has often explored the territory between the sacred and the profane, from his *The Holy Virgin Mary*, 1996 – a black Madonna surrounded by naked bottoms from porn magazines – to his recent series of works that fuse the Biblical fall of man with Greek and Eygptian mythology. *Blind Leading Blind* knots Eve's silver serpent around two silhouetted naked figures as they stand under a ripe fruit tree. The blue tones transform the lush colours of Eden into a monochrome nocturnal scene, as if it's a dream. With the pyramid rising in the background and the hooded Cobra, this could be an Egyptian tale, or even a Trinidadian one – like Peter Doig, Ofili lives in Trinidad, and was in part inspired by the blue men who dance at the annual carnival. *Blind Leading Blind* is a fusion of myth, religion and the idea of paradise. Paradise was the subject of Ofili's ambitious 'Within Reach' exhibition at the Venice Biennale in 2003. *Afro Love and Envy*, one of the paintings in the show, reveals how Ofili explored the complex structure of paradise, mixing the palm fronds of a tropical island (holiday heaven), with true love and notions of belonging and identity, seen through both the Western dress of the lovers and the tri-colour palette, taken from the Pan-African flag.

4 Folk Tales

Increasingly, narrative painting is appearing as a dominant trend in both America and Europe. While it has maintained a strong presence in Asia and Africa, as seen in the work of Chéri Samba, for example, it has only recently resurfaced again as a suitable means of artistic expression in Western art schools and commercial galleries after a period of almost twenty years. Previously, individuals such as Paula Rego and Ana Maria Pacheco have managed to find an audience for their powerful paintings – contemporary reworkings of nursery rhymes and biblical stories, tales of backstreet abortions and gender reversals – but they have existed in isolation. Now, a growing number of artists are weaving stories in paint.

New York is increasingly becoming the centre for artists who are rejecting the Eurocentric fascination with media imagery as typified by Gerhard Richter, Luc Tuymans and their followers. While this style of painting remains in vogue (see Chapter 5), many painters have turned their back on this exploration of mass reproduction to produce work that embraces a sense of being homemade, of being individual, of having a unique story to tell, no matter how slight or inconsequential. Painting in a naïve style, these artists acknowledge folk art as a point of departure. They admire its focus on telling stories, its lack of concern for perspective and placement of figures when they get in the way of the narrative. Neo-folk art simulates the artistic naïvety of great American outsider artists such as Henry Darger and Howard Finster, and turns its back on world events and the latest aesthetic arguments. Neo-folk artists focus on incidental scenes of everyday domesticity – looking in a mirror, sitting on a bed, writing a letter – with awkward-looking figures living at one remove from society.

But despite their clunky appearance, these figures still have the power to make us consider the all-encompassing emotional states that occupy them. As with Darger's illustrative pictures of pre-pubescent girls fighting for their virtue in an evil world, darkness lurks behind their sugary palettes and cartoon-like figuration.

Neo-folk art is a reaction to the dominant painting style of the highly-influential Gerhard Richter, the artists who paint this way repeatedly asserting that Richter's analysis of mass imagery is no longer interesting to them, that it is as dead in the water as is the brash consumerism of such American artists as Jeff Koons or the vapid spot paintings of British artist Damien Hirst. If these artists cite visual influences, they are from the past, from the work of Piero della Francesca, for example, or that of early Freud and Hockney, or late Picabia.

Francis Picabia *Femmes au Bulldog*, 1941–42

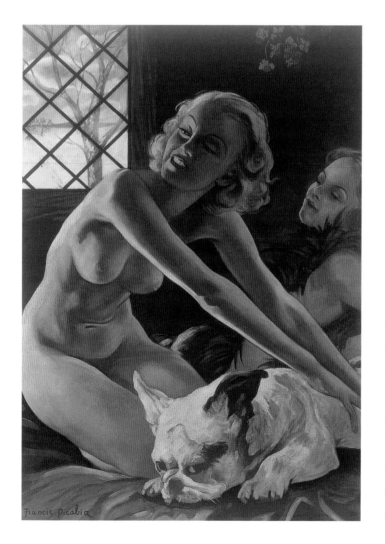

It is not really surprising that this style of painting, with its fascination with folk or outsider art, has sprung up now, and in New York. It is the first coherent artistic style to emerge from the city since the World Trade Center was attacked there on 11 September 2001. Since the end of the nineteenth century, artists have repeatedly turned to outsider art – the art of the untrained, of children, of patients locked up in prisons or asylums – in times of great upheaval. When centennial fever had nineteenth-century Parisian critics saying the world was in meltdown, artists such as Pablo Picasso were championing the work of the untrained customs officer, Henri Rousseau, and stock-broker turned artist, Paul Gauguin, who travelled to Tahiti in search of societal innocence. After the First World War, Picasso and others such as the Futurist Gino Severini turned their back on their avant-garde developments to 'return to order', with figurative paintings of women and nature existing harmoniously. Jean Dubuffet amassed a vast collection of outsider art or 'Art Brut' during and after the Second World War, which he exhibited from 1948. His own art and the broader movement 'Art Informel' grew out of Art Brut, as Dubuffet looked beyond the parameters of 'acceptable' art for inspiration.

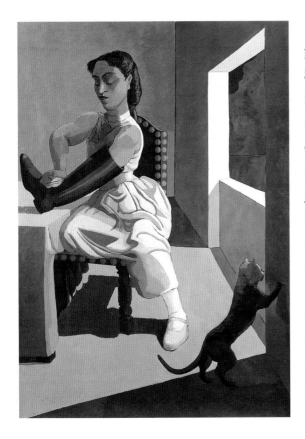

Paula Rego *The Dance*, 1988

Ana Maria Pacheco *Hades I*, 1998

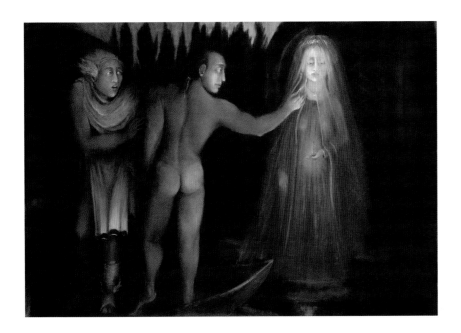

Contemporary neo-folk art takes its conceptual lead from the kind of paintings you find at car boot sales and thrift stores. (American artist Jim Shaw has amassed his own collection of such art that he regularly exhibits in America and beyond as 'Thrift Store Paintings', which has no doubt influenced many contemporary neo-folk artists.) Often painted in the style of early Freud – the wide-eyed luminescence of his *Girl with Roses*, 1947–48 for example, with her writhing hair alive against her flatly-painted neck and jumper – with more than a generous nod to Alex Katz, artists such as Ridley Howard and Jocelyn Hobbie paint people as wooden as bad actors on stage, stiffly posed or crying crocodile tears. And yet they portray real emotions, as do the long-faced slackers of West Coast artist Brian Calvin's world.

Amy Cutler's work is more in line with Darger's dark narratives of female persecution, her method reminiscent of book illustrators such as Arthur Rackham (whose delicate style brought Peter Pan to life). Although Cutler lives and works in New York, she developed her working practice while in Germany, realizing she had to pare down her style to let the stories she was keen to tell emerge.

Germany – more specifically, the former East Germany – is home to several artists whose work has connections with many of the New York neo-folk artists. While they share interests in artists such as Katz and Darger, their overwhelming influence is the social realism they grew up with, in the form of posters and advertising on every street corner, and through the art academies where social realism remained the dominant style until after the fall of the Berlin Wall in 1989.

These artists, often grouped together as the 'Leipzig School', include Neo Rauch and Jörg Lozek. Norbert Bisky, born in Leipzig but now living in Berlin, also uses social realist techniques to create unnerving paintings. Bisky's boys all appear as clones of each other, white-blond hair above perfect smiles and tanned, lean bodies. Their perfection is disquieting, as is their trained athleticism, and parallels to the ethos of Hitler Youth make these uncomfortable viewing.

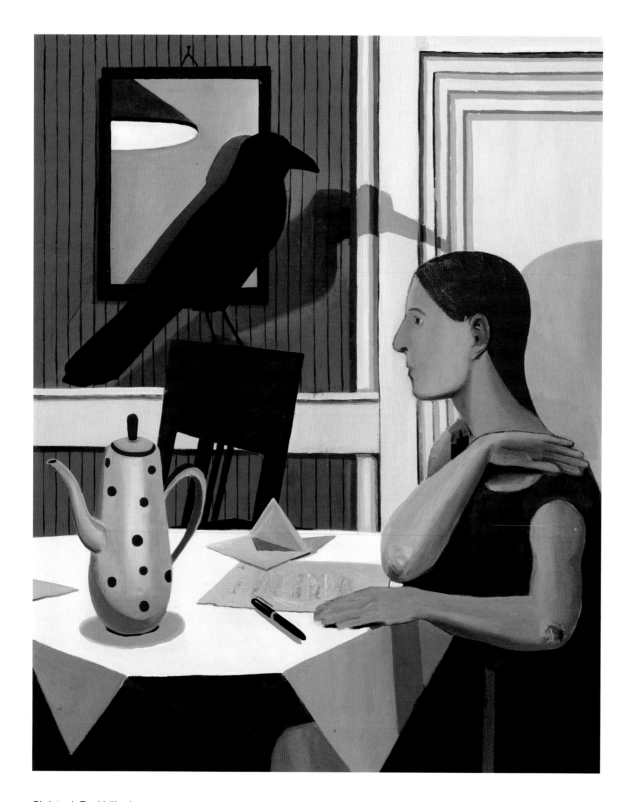

Christoph Ruckhäberle
Der Brief, 2004

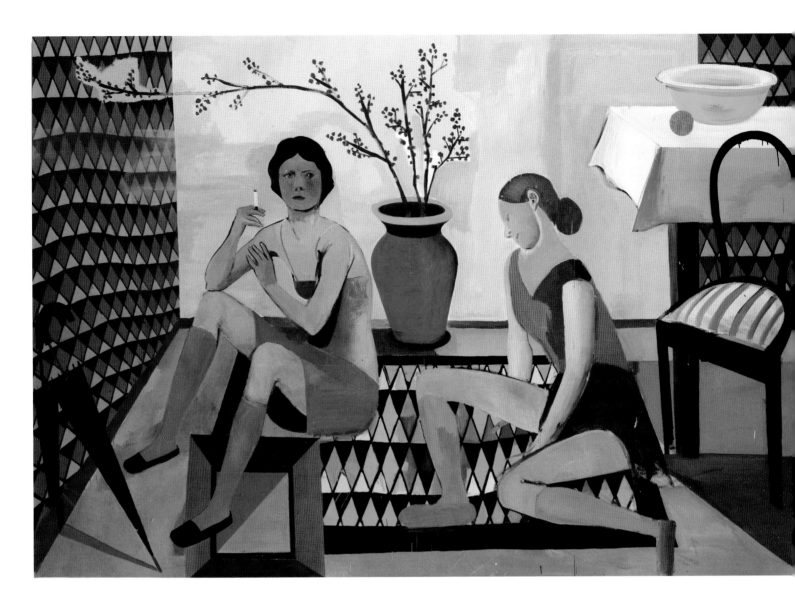

Christoph Ruckhäberle
Arrangement, 2004

Ruckhäberle's paintings have a tension built in to them through his use of claustrophobic settings, oversized inhabitants and furnishings that block people in. In *Der Brief*, the sense of unease is heightened by the harsh lighting that throws a predatory shadow behind an Edgar Allen Poe-style raven (previously used by Paul Gauguin in *Nevermore*, 1897, to symbolize foreboding). Ruckhäberle often visually quotes modern masters , such as Henri Matisse, Paul Gauguin and Edouard Manet. In *Der Brief*, as in

Manet's *A Bar at the Folies-Bergère*, 1881–82, the mirror is used to show elements – the lampshade and bulb – that should be present in the main scene but are strangely absent. Other elements add to the tense atmosphere: there's no coffee cup for her to drink from; the lid is on the pen yet a half-written letter lies open in front of her. As in all Ruckhäberle's paintings, what should be a placid domestic scene is electrified by his constricting architecture, awkward perspective, larger-than-life figures and juxtaposed props.

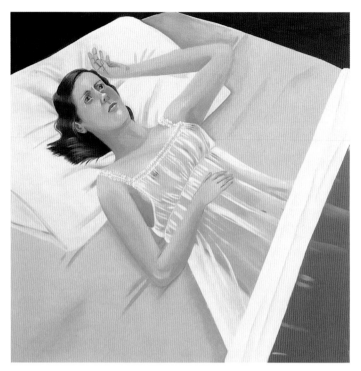 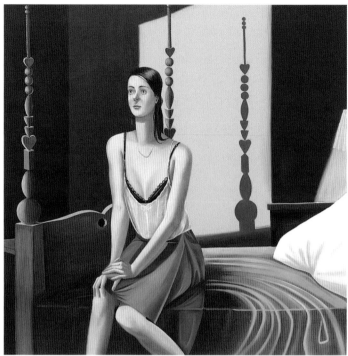

Jocelyn Hobbie
Pink Girl Crying, 2004 [above]
Single Bed, 2005 [above right]

Hobbie's women are always alone, and often in bedrooms. These are not comforting, individual spaces of refuge but places dominated by large beds with only one pillow. The women are in various states of undress, but their sexual partner – whether real or imagined – has stood them up, and they all sit or lie with their large eyes filled with glassy tears. We feel their heightened emotions as if they were Rapunzel locked in her tower, unable to reach her lover. These women strum melancholy laments, as in *Guitar Player*, or gaze at the moon as in *Single Bed*, looking for comfort. But in *Single Bed*, the moonlight has skewered the bedpost's heart against the wall, a symbol of heartbreak, and we can't help but feel that these girls' desires will never be fulfilled.

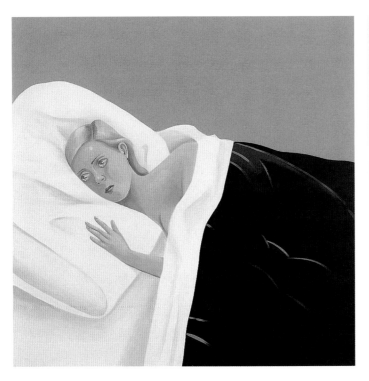 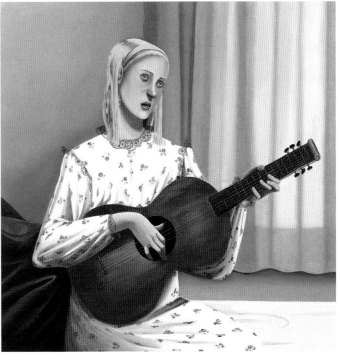

Jocelyn Hobbie
Girl Crying in Bed (Cartoon Emotions), 2004 [above]
Guitar Player, 2005 [above right]

Brian Calvin
In A Place, 2004

Calvin lives and works in Los Angeles, and his long-haired androgynous subjects inhabit worlds that have much in common with fellow Californian David Hockney's. Calvin's paintings also nod to another figurative great, Alex Katz, but Katz's stylized middle-aged women have been reinvented by Calvin as awkward, skinny slackers who wait and mope against cerulean skies. In *Unable to Fly*, a girl stands helplessly with stick arms bent, lank hair blowing in the slight breeze. The sun sets on the distant horizon, and she makes her hand into a limp gun, as if to end it all. This gesture is repeated in *In A Place*, the finger-gun cocked and pointing at the meditating girl. She is holding a set of beads, perhaps a rosary, and her eyes are shut in concentration. Calvin's figures share a melancholy sadness that, through his simplified painting style, is surprisingly moving.

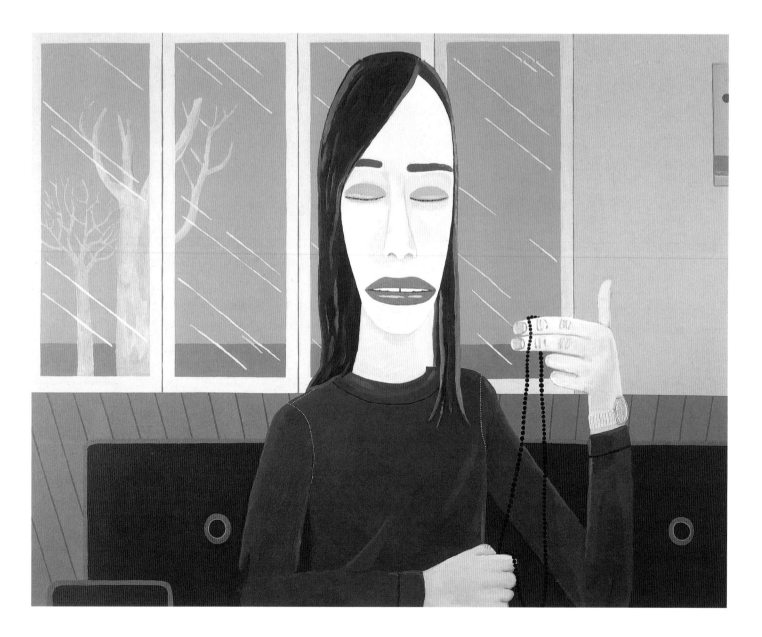

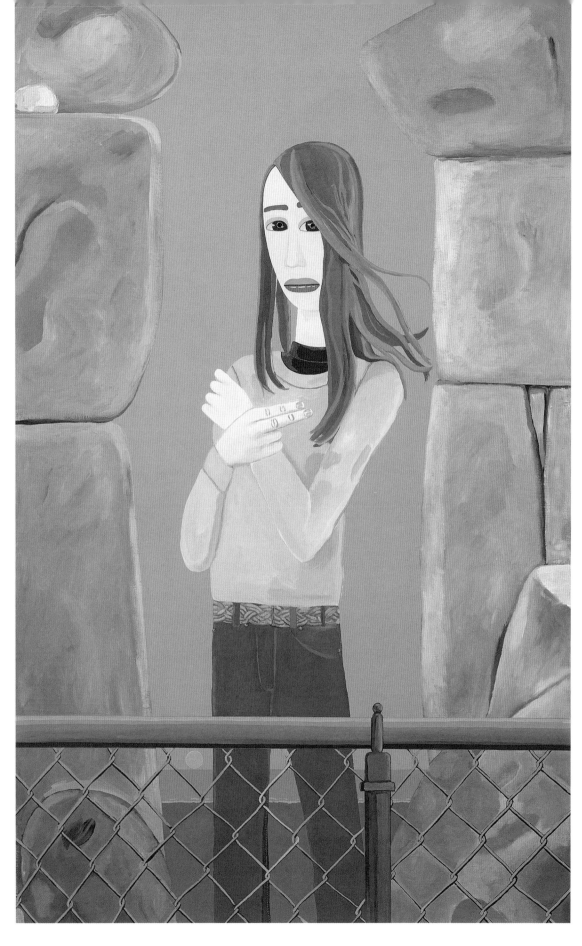

Brian Calvin
Unable to Fly, 2004

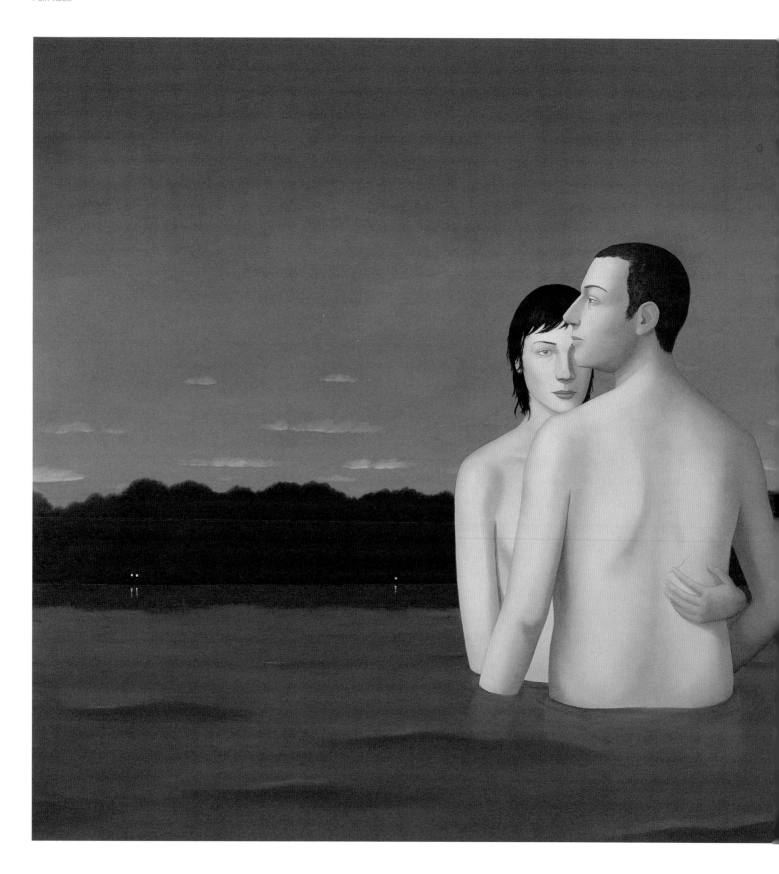

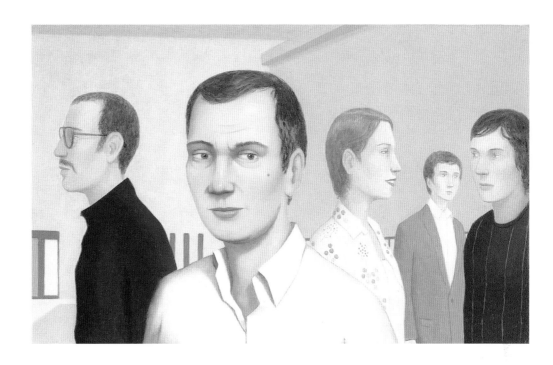

Ridley Howard
Violet's Effect, 2005 [left]
At the Forum, 2004 [above]

The women Howard paints appear vacant, lost in thought.
The men, on the other hand, appear angsty and nervous,
throwing questioning glances and looking around. All of them
seem frozen, posed, as if on a film set waiting for the clapper-
board to drop. Much of Howard's work is autobiographical,
and through it he relives memories that are freeze-framed in
his mind. In *At the Forum*, figures hang around awkwardly in
the vast, anaemic room. The title suggests a meeting should
be taking place, but no one can maintain eye contact let alone
speak. If this painting suggests Howard's primal dislike of
such events, *Violet's Effect* at first suggests a more pleasant
fantasy. But there's a sense of Magritte-like uncanniness to
it – the thin clouds still lit by the dying sun; the figures bathed
in full-moon light – and the couple, despite their nakedness,
are resolutely not close. Howard's painting style – meticulous
and yet pared down – emphasizes their isolation by denying
us any sense of intimacy with them.

Holly Coulis

Tiger Fight, 2005 [opposite]

Ring Man, 2005 [above right]

The Birdwatcher, 2005 [right]

Coulis's figures increasingly dominate the landscape they inhabit. In 2002 she was painting ghosts, whose insubstantial bodies floated over sickly forests and windswept plains. The landscape suggested the emotional tone, a painterly equivalent of Emily Brontë's *Wuthering Heights*. But now her figures are solid flesh and bone, stocky men in loud shirts or clingy running gear. However the landscape, while much reduced, still contributes to the picture, as in *Ring Man*. His naïve bravura in stripping down to his gold trunks for an early morning dip is emphasized by the cold clear day, the chilly-coloured sea and the barren tundra. We feel sorry for Coulis's oddball characters – *The Birdwatcher* in his inappropriately loud shirt; the fisherman in too-tight camouflage in *Mort* (see p. 114), who proudly displays a fish. Animals often feature in Coulis's work, and she examines our complex relationship with them, whether killing them for sport or taming them for companionship. They add a surreal dimension that her intentionally awkward painting style only serves to exaggerate.

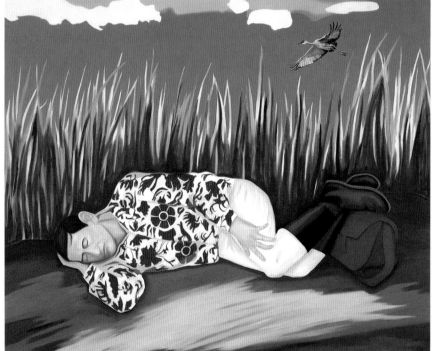

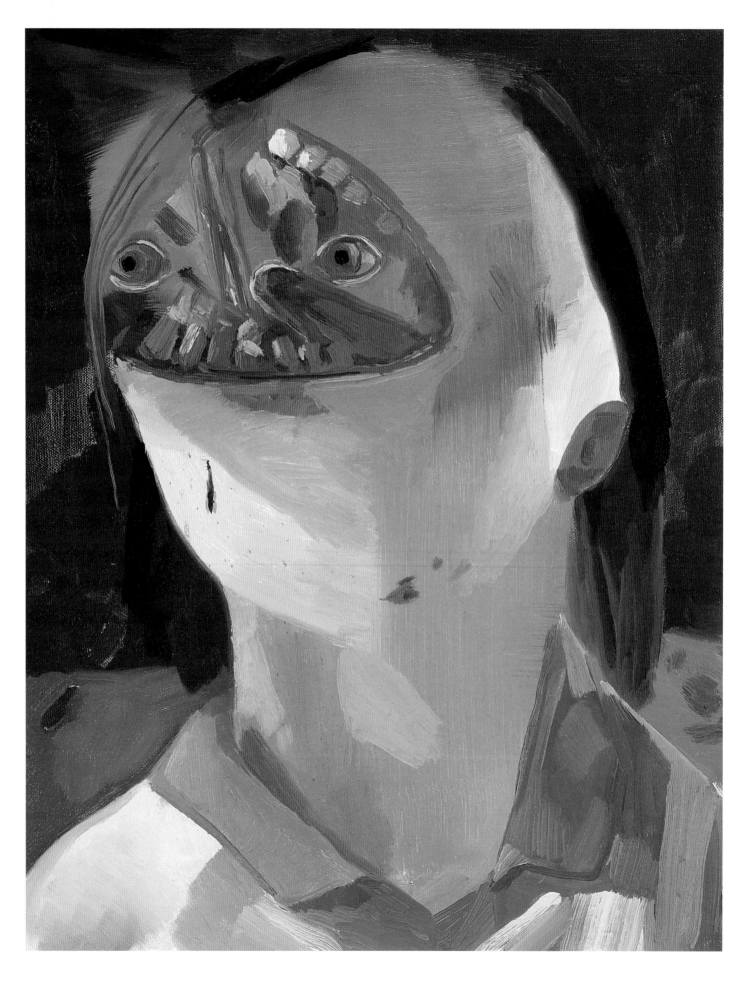

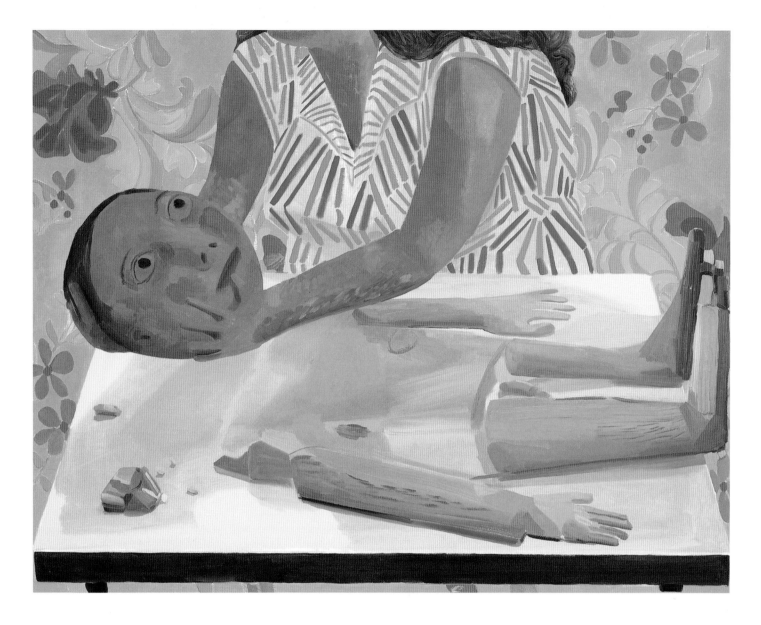

Dana Schutz

Boy, 2004 [above]
Face Eater, 2004 [opposite]

Using hot fleshy colours and exuberant brushstrokes, Schutz creates a crazed world where people devour themselves and others are rebuilt from spare body parts. In 2002 she painted a series of scenarios featuring Frank, the last man on earth. Now her world has been repopulated, but by mutant characters who prune their own dead wood so efficiently that the man in *Face Eater* is in the process of eating his own eyes and nose. Her obsession with deformity suggests links to post-First World War German artists such as Georg Grosz and Otto Dix, but Schutz's work is more often associated with the tropical palette of Paul Gauguin. Henri Matisse and Edouard Vuillard's patterning and Paul Cézanne's facets can also be detected, and Schutz blends these influences to create her own rich, disturbing world, confidently manipulating paint to support and empower her monstrous narratives.

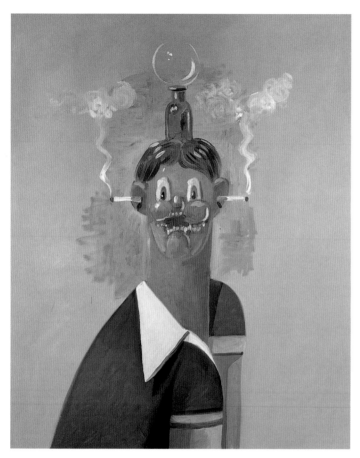 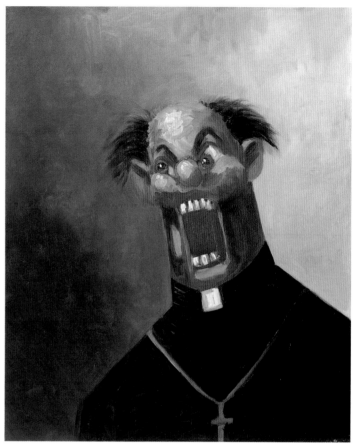

George Condo

Little Ricky, 2004 [above]

Screaming Priest, 2004 [above right]

The Housekeepers Family, 2004 [opposite]

Condo has been fascinated with portraiture for over twenty years. Recently he has used the genre to question the authority of traditional groups such as the family and the church. In *Little Ricky*, Condo's ongoing interest in Picasso can be seen in the displacement of the man's arms. But Condo's sphere of reference is vast, from Philip Guston to Velázquez, cartoons to thrift-store art. The boy sits in three-quarter pose, head turned to face the viewer, against a tonal background. But here any allegiance to tradition ends – he has cartoon features and smoking cigarettes in his ears. As with the three women in *The Housekeeper's Family*, who similarly have their ears blocked, *Little Ricky* is deaf to our nervous laughter (and to change). Condo picks holes in the supposed sanctity of church leaders in *Screaming Priest* – his trademark clown is transformed into a lunatic man of the cloth, proving nothing is sacrosanct in Condo's world.

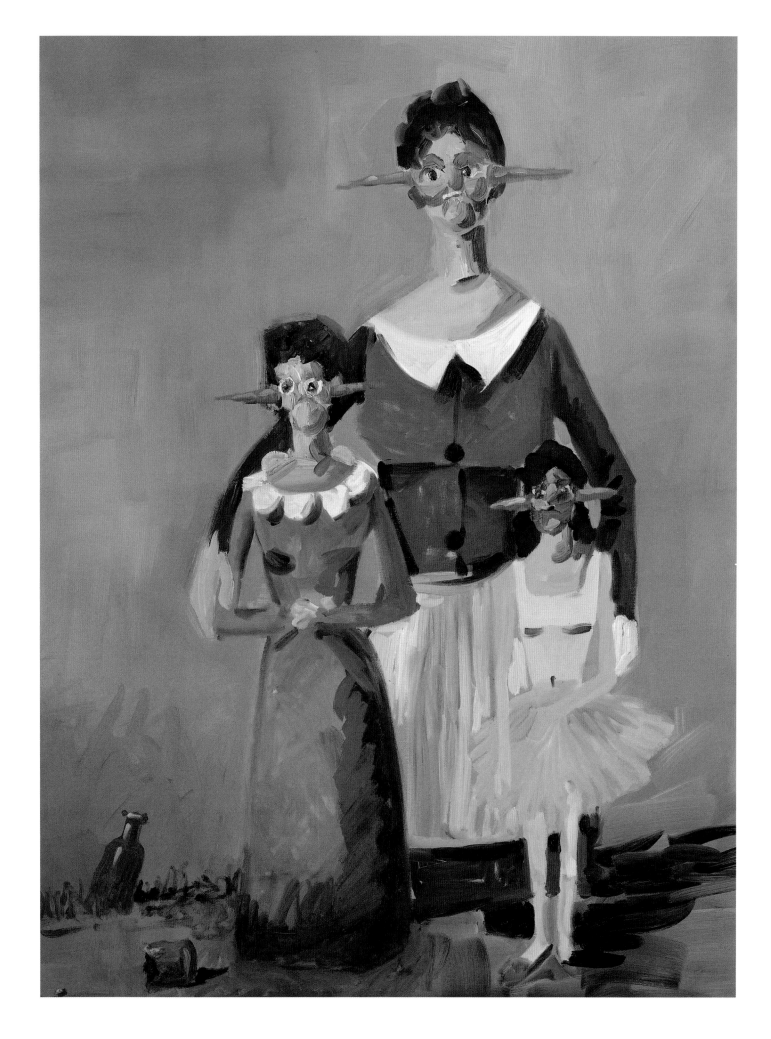

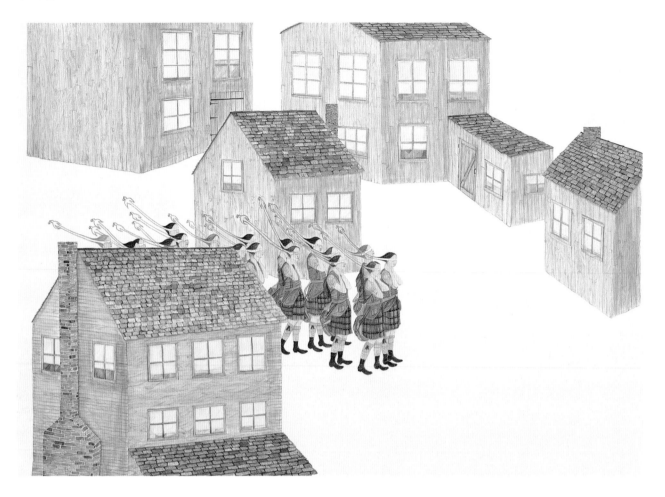

Amy Cutler
Souvenir, 2004 [above]
Army of Me, 2003 [right]
Tiger Mending, 2003 [opposite]

Cutler paints delicate gouache dreamscapes, fusing the
intricacies of Indian miniatures with the illustrative style
of Victorian artist Arthur Rackham and the surreal
juxtapositions of Giorgio de Chirico. In her work, what
should appear strange, such as women repairing living
tigers, is painted with such authority as to become credible.
Cutler mainly paints women, and often uses their historical
trappings, such as voluminous skirts or long braids of hair,
as areas of reinvention. So, hair becomes rope to move
buildings, or is held up in strange head-dresses that also
blind their owners, as in *Souvenir*. All the women she paints
are involved in some kind of work, but their attributes seem
to hinder them. In *Tiger Mending*, the patterned saris of the
seamstresses seem to fuse with the tigers' skins, adding
complexity to their already dangerous task. In *Army of Me*,
the women themselves have been fused — a single figure has
cloned herself into a miniature taskforce, and stands
addressing them as if at a rally.

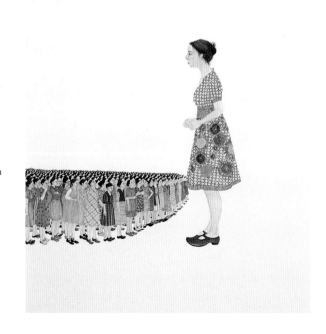

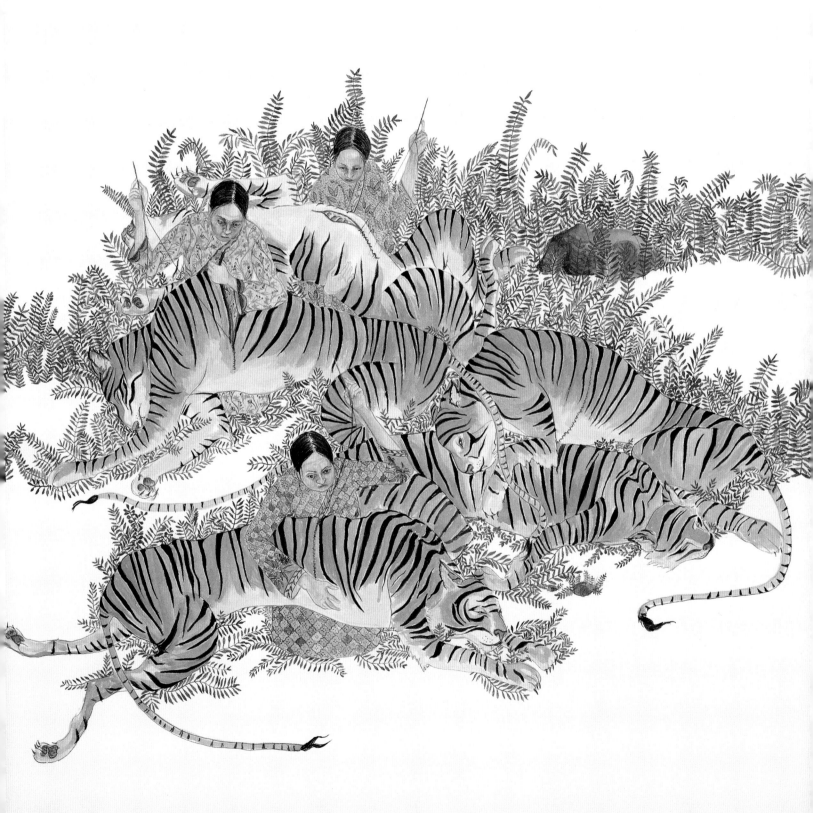

Chéri Samba
Problème d'eau. Où trouver l'eau? (The Water Problem.
Where to find water?), 2004

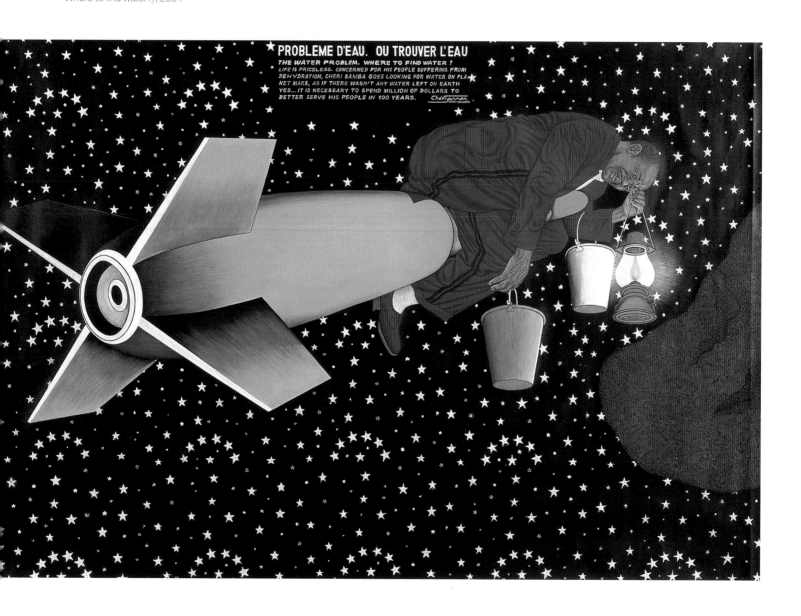

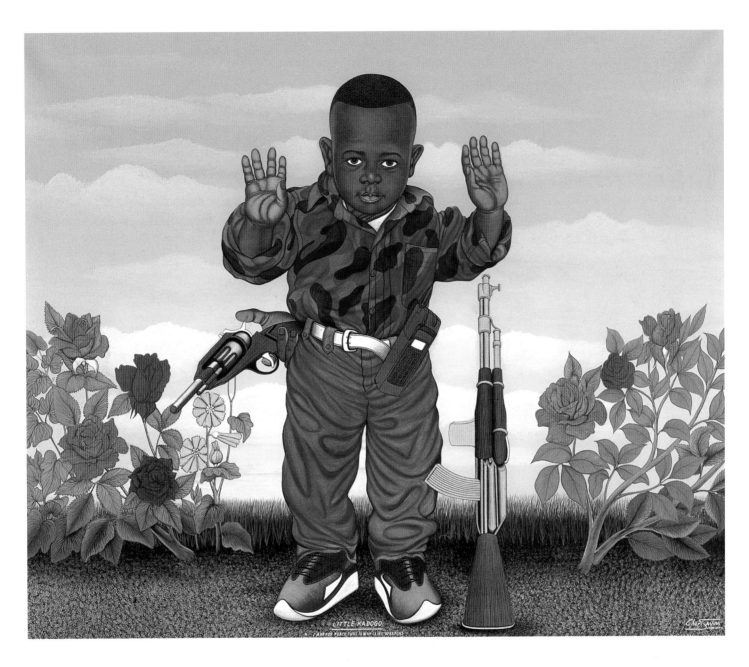

Chéri Samba
Little Kadogo, 2004

Samba trained with sign painters in Kinshasha, Congo, in the 1970s, and worked
as a street artist before concentrating on painting canvases (he now splits his time
between Kinshasha and Paris). His early training still feeds into his style, which fuses
folk art and a cartoon-like narrative with billboard scale. Through the figures and text
panels on his paintings, his often highly charged political narrative is driven home.
He spotlights inequality and corruption, the sex trade and child labour, as well as
the entrenched stereotypes of Africa such as witchcraft. But he interprets everything
through his own position as an artist, and often paints himself torn between his
needs, and those of others around him. In *Problème d'eau. Où trouver l'eau?*, Samba
appears in a red suit and shoes, carrying buckets as he soars into the heavens. He has
gone in search of aid, but, as the missile implies, at what cost?

Laylah Ali
Untitled, 2004 [left]
Untitled, 2004 [opposite]

Ali's gouache paintings explore societal violence and injustice, and are often based on blinkered stereotypes based solely on skin colour or street fashions. In her earlier work she painted cartoon-like stick figures with billiard-ball heads who carry out crimes against their own kind. The backgrounds to each lynching have been erased, leaving only the stark figures framed against a powder-blue sky, standing on a thin strip of unidentifiable land. But increasingly, Ali paints isolated characters, who stand in ornate head-gear and patterned garments. In these works she continues to explore prejudice and judgements based on clothes or race. In *Untitled*, 2004 (left), the figure's skin seems to have been flayed, the face raw and lurid, the prejudicial skin peeled back. These single figures appear in shock as if they were witnessing the crimes committed in the earlier works.

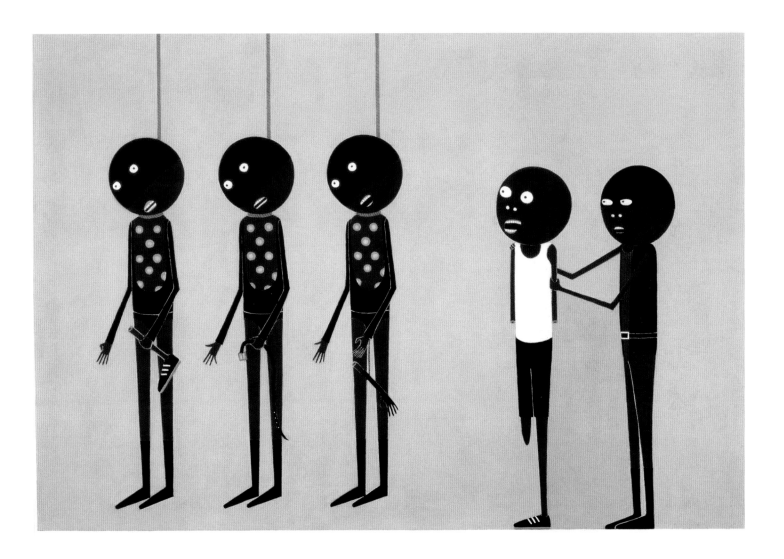

Marcel Dzama
Self Portrait No. 5, 2004

The kingdom of Dzama is a strange one. Figures dressed in khaki and black perform a variety of tasks from smoking to shooting. In his paintings, as in *Self Portrait No. 5*, hastily blocked-in landscapes locate them outdoors, but give no other indication as to where they are. His people's army exists out of time and place, in the realm of fictional characters that provide much of his inspiration (from Marvel comics to Beatrix Potter). In *Self Portrait No. 5*, the artist himself swells their ranks momentarily, before his naked alter-ego kills him off. In *10 Years of Revenge*, children whoop and jump as if it's the last day of school, but instead of swinging satchels they fire guns. These oddball scenarios, despite their darkness, have a clunkiness to them that is uplifting, and the paintings are as endearing as a homemade quilt made from flak jackets.

Marcel Dzama
10 Years of Revenge, 2004

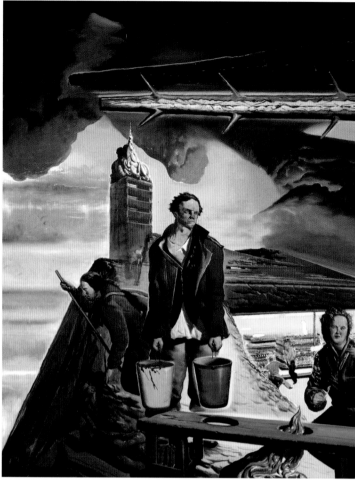

Neo Rauch
Lösung, 2005

Rauch's large canvases initially seem to offer
a coherent narrative of nostalgia but almost
immediately it starts to break down. Architectural
elements peter out; men in uniform from throughout
history intimidate men and women from other
centuries; great struggles occur but their reason is
never apparent; styles change at whim. This is the
stuff of dreams (or nightmares), conjured by
Rauch out of a melting pot of inspiration that
includes social realist painting (that of his mentors
at the Leipzig Academy), Communist graphic
design and socialist architecture. In many of his
works, a central figure struggles with creation,
an artist in turmoil that Rauch says illustrates
the continuing struggle between modernism and
realism. In *Höhe,* a dishevelled man in a soldier's
coat holds on to two buckets of paint as if they
were heavy burdens; in *Quiz,* the artist fails to
impress the panel and collapses, head in hand,
his inspiration spent.

Neo Rauch
Höhe, 2004
Quiz, 2002 [opposite]

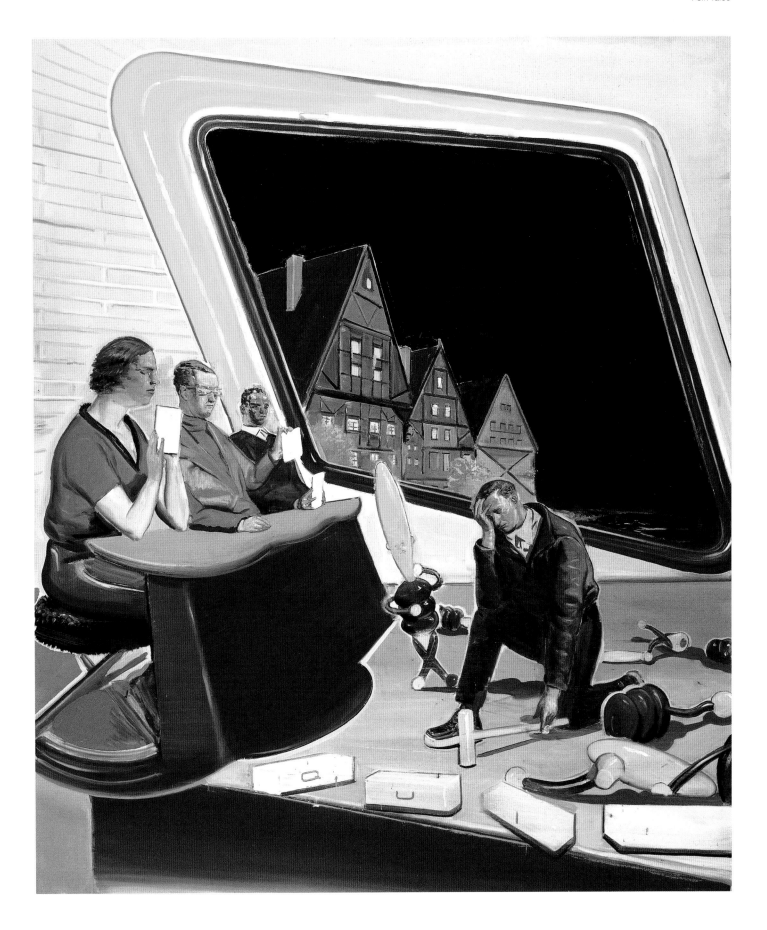

Norbert Bisky

Höllensturz II, 2004 [above]

Besteigung, 2004 [opposite]

Bisky's father was a prominent Communist official, and Bisky grew up under GDR rule in Leipzig. Communism was like a religion at home, so it is perhaps not surprising that the dominant art style of the party, socialist realism, has exerted such an influence over his own work. (It is the religious aspect of Communism that now interests Bisky, the desire for belief.) Drawing on the endless positive images produced in East Germany and Russia under Communism, Bisky's own paintings feature half-naked adolescent blonde boys endlessly pursuing leisure activities. Parallels have also been drawn between his art and that favoured by Adolf Hitler, who saw modern art as degenerate and preferred robust figurative art featuring well-toned Aryans. Bisky's work straddles these two opposing camps, and is further complicated by comparisons to the West's ongoing obsession with the body beautiful.

Jörg Lozek
Kinderstilleben I, 2001 [below]
Pflegen, 2002 [opposite left]

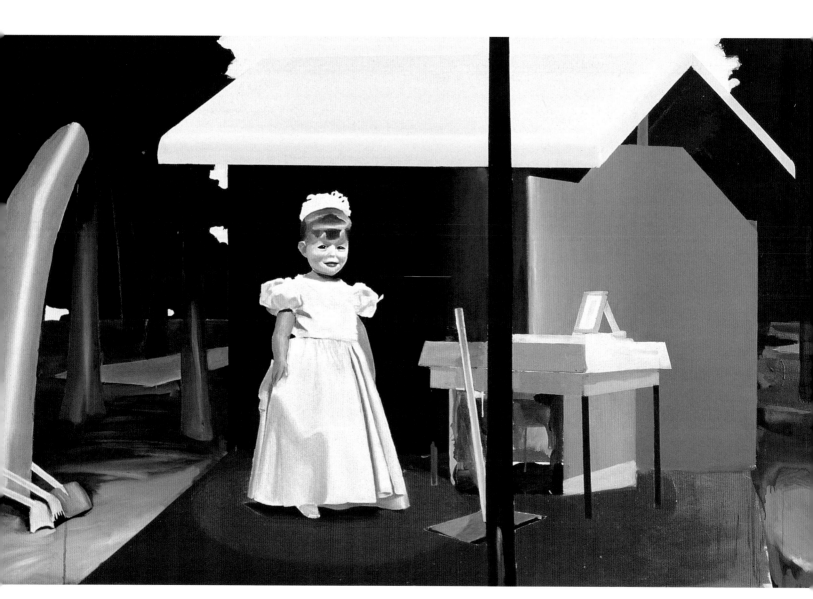

Lozek was born and grew up in Chemnitz, East Germany. He studied at the art school in Leipzig under aging socialist realist painters, whose figurative paintings have influenced a whole generation of young German artists such as Norbert Bisky and Neo Rauch. Lozek paints children, their portraits based on old newsprint photographs. In *Jüngling*, the boy's broad smile and narrowed eyes seems artificial, his slim tie and slicked-back hair aging him beyond his years. There's an uneasy fear that fills all of Lozek's work, much of which emanates from his incessant use of black that threatens to engulf his subjects. In the portrait, and in *Kinderstilleben I*, the blackness surrounds the stiffly posed girl, but she has her back to it, unaware of its closeness, innocent to its threat. In *Pflegen* it surrounds the children who study a plant, the blackness turning the shelves into blades that seem to be closing in on the guileless youths.

Jörg Lozek
Jüngling, 2004 [above]

5 The Past Deconstructed

Photography came into being in 1839, thanks to the scientific advances of Louis Daguerre and Henry Fox Talbot. In the aftermath of its invention, artists and critics worried about what the new genre of photography would do to painting (a question that is doggedly still raised today). But in truth, photography opened up more doors to painters than it closed. Eadweard Muybridge's time-lapse photographs of bodies in motion, for example, were echoed in cubism and works such as Marcel Duchamp's *Nude Descending a Staircase*, 1912. The decreasing cost of printing and the subsequent ability to print effectively in colour meant, for the first time, artists could see colour copies of masterpieces that previously they had journeyed around the world to see for themselves.

Artists have always used the latest developments to further their work – even Vermeer, in seventeenth-century Holland, is thought to have used a camera obscura to plot his compositions. Nowadays, the camera is as valid a tool for painters as a sketchbook and pencil, a way of recording thoughts and working out ideas. All of the artists in this book have used photography in some way to complete their work; for many of the artists in this chapter, photography has provided the subject matter too.

In 1977, Susan Sontag, in her highly influential book *On Photography*, wrote that photographs provide 'knowledge dissociated from and independent of experience'. They literally offer a snapshot of the past, a temporal fragment of an ongoing moment in which we can no longer see to the right or left of the frame, can no longer judge the scene for ourselves, first hand, can no longer experience the event in real time. Everything in the photograph carries the same importance; visual prioritization of what matters most to each viewer has been eliminated by the camera's objective eye. So, in a photograph, a smile can be as

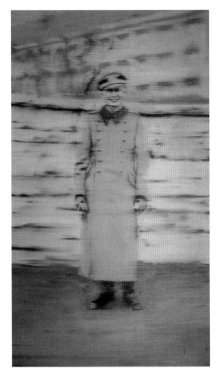

Gerhard Richter
Uncle Rudi, 2000 [above]
Uncle Rudi, 1965 [below]

important as a chimney stack or a reflection, a button given the same attention by the camera as an eye or a dapple of light. For German artist Gerhard Richter, a former photo-laboratory technician, who first started using photographs as source material for his paintings in the early 1960s, photography's sheer objectivity appealed to him. In conversation with author Peter Sager in 1972, he said: 'It (photography) has no style, no composition, no judgement. It freed me from personal experience. For the first time, there was nothing to it: it was pure picture.'

Photographs offered Richter a 'subject' that was devoid of meaning, one that he could manipulate to explore what it was to paint. Painting itself was his real subject, as he explored the relationship between the object depicted and the abstraction implicit in any kind of representation of it on canvas. In his 1965 painting of his Uncle Rudi, based on a family photograph of his mother's brother in Nazi uniform, Richter wanted the potentially loaded subject matter to be neutered by using a photograph that had already reduced the man to a flat image, and to be further leached of content by switching the focus from subject to process. The black and white painting, seemingly painted in a photorealist style and then 'blurred', refuses to deal with the person depicted (Uncle Rudi) and instead deals with issues of representation in paint. We, as viewers, feel frustrated that the painting is blurred, as if we are distanced from the original image by this device (which of course is his intention). But at the same time, Richter is implicitly pointing out that in fact a painting can never be blurry or second-rate: it simply is what it is. Unlike the photograph, its aim is not direct representation. A painting is not reality, he implies, and neither is a photograph. (Richter added another layer to this complex work when he photographed the painting of Uncle Rudi, and re-presented it as a Cibachrome editioned photographic print in 2000.)

Glenn Brown, who graduated from Goldsmiths College, London in 1992, has consistently worked from reproductions to question similar presumptions of viewing and authenticity. In his recent work he has bound together the subject from one masterpiece with the style from another. Seemingly impastoed figures painted in the style of Cobra artist Karel Appel and Vincent van Gogh are dressed in historical garb in poses taken from masterpieces by Jean-Honoré Fragonard and Anthony Van Dyck. Brown, prior to this fusion, spent much time reproducing other works

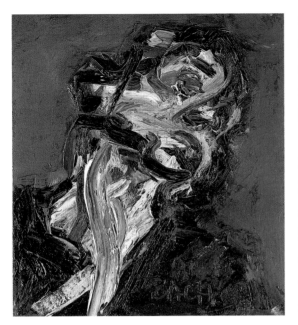

Frank Auerbach *Head of J. Y. M. II*, 1984–85

of art directly on to his canvas, exploring the gap between the reproductive copy and the original. In fact, he has achieved such success in this *trompe l'oeil* verisimilitude that, by a twist of fate, his painting *Beautification*, 1999, based on a Frank Auerbach portrait, sold for £200,000 at Sotheby's in February 2005 – twice the price of an 'original' Auerbach portrait.

Luc Tuymans also questions the trust we place in photographs. Like Richter, he uses found photographs to construct his muted paintings of Nazi sympathizers, Belgian politicians and fighter pilots. He studies news images – taken from magazines, newspapers and television reports – until, by the time he paints them, they are near-monochrome reductions of the original source material. He sucks out the colour from them, and in turn the content appears contextless, ahistoric, as adrift as an anonymous snapshot of an unknown person in your family album.

Over thirty years ago, John Szarkowski, then curator of photographs at the Museum of Modern Art, New York, surmised that there must already be more photographs in the world than bricks. By 1980, when Roland Barthes wrote *Camera Lucida* he concurred by saying: 'I see photographs everywhere, like everyone else, nowadays; they come from the world to me, without my asking; they are only "images", their mode of appearance is heterogeneous.' The power of photographs – as Warhol, Richter, Tuymans, and a cluster of younger artists such as Eberhard Havekost, Wilhelm Sasnal and Neal Tait have explored – is annihilated by their unchecked reproduction and their levelling of everything they depict, from a Nazi criminal to a bowl of fruit.

Other artists featured in this chapter use photographs as a means to access history. Photographs function like an image bank for artists such as John Currin, who repeatedly mines the past to create paintings that reinterpret old themes in today's visual language, or for Michaël Borremans, whose works seem rooted in the 1940s. Photography and images provide many artists with a convenient way of accessing the past. But this convenience – to tour galleries and private collections virtually, to compare works across centuries and continents at the touch of a button – comes at a price: visual and mental dislocation. Artists such as Rosson Crow and Richard Wathen delve into the past with alacrity, to create paintings that turn out to undermine our understanding of our own place in history.

Luc Tuymans
Gilles de Binche, 2004 [right]
Cockpit, 2003 [opposite]

Tuymans completes every painting in a day. Using
found imagery from magazines, newspapers and
television, he meticulously prepares for each
work, studying the image it will be derived from,
stripping out colour and meaning. Consequently
his figures often hover between realism and
abstraction, as in *Gilles de Binche*, the face no longer
visible, the body only intimated. It has the look
of an old photograph bleached by overexposure,
which allows the subject to become an apparition
and the eye to be seduced by the sketchy
brushstrokes, the muted colours. But, as with
all Tuymans's work, the subject is in fact the key.
Tuymans works in series, tackling such subjects
as the Holocaust, the bloody independence of the
Congo, 9/11. *Gilles de Binche* is based on a Belgian
carnival, where figures pelt the crowd with oranges
in a disturbing exaggeration of national pride.
Cockpit fits with a body of work made during the
build up to the Iraq war for a show in New York in
2003. The stories behind each painting irrevocably
alter how we look at these complex works.

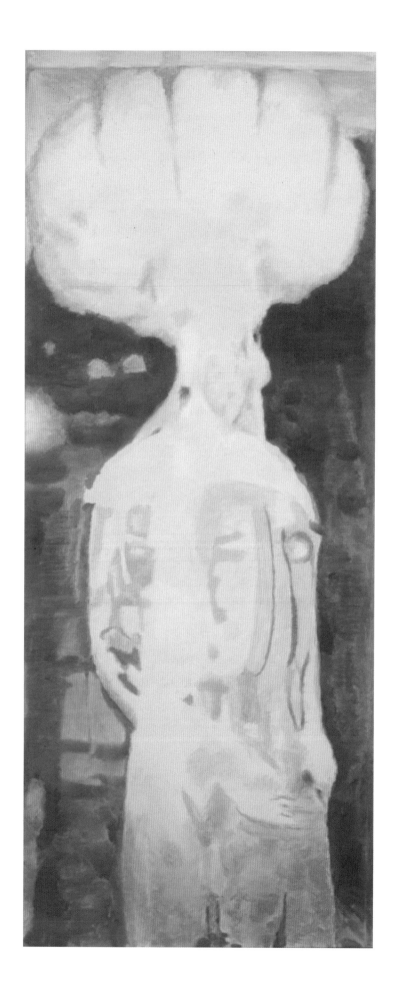

Wilhelm Sasnal
Untitled (a), 2004 [above]
Untitled (a), undated [opposite]

Sasnal's art defies categorization. He sashays between genres and styles, painting expressive abstract canvases one minute, and tightly controlled portraits the next. The figure often features, either by association – paintings of cars and buildings, things designed to accommodate us – or in the flesh, as it were. But despite this, there is a coherence to his practice. The world may be brimful of images but it is always Sasnal choosing what to paint and how. He is a cultural sieve, building his own personal lexicon of motifs and styles, repeatedly painting cars and forests and girls smoking, despite the apparent breadth of his range. His paintings reflect him, but also the art of painting itself, since he uses the images he has chosen to illustrate the limits of what paint can (and can't) do.

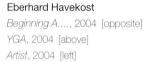

Eberhard Havekost

Beginning A...., 2004 [opposite]
YGA, 2004 [above]
Artist, 2004 [left]

At the heart of Havekost's work lies television. Our view of the world through news imagery and other footage is necessarily distorted, as scale becomes arbitrary (a mouse, man and mountain can be the same size on TV), colours shift and cinematic devices such as cropping and extreme camera angles can add drama to the most mundane views. Havekost uses similar techniques as he paints subjects that range from modernist apartment blocks to an anonymous man on the telephone. He crops images to add intrigue and tension – why do the figures climb the rockface in *Beginning A....*? How high is it (it is endless as far as we can see) and why are the pair climbing in trainers? Are they escaping something? What's going on? Havekost, like Tuymans before him, alludes to the inability of painting to tell the whole story. He paints people doing things – juggling, talking, climbing – without giving us the actual action. All we have is a split second freeze frame of something that is evidently ongoing. We can't hope to fully understand what is happening, and the image can therefore never be complete.

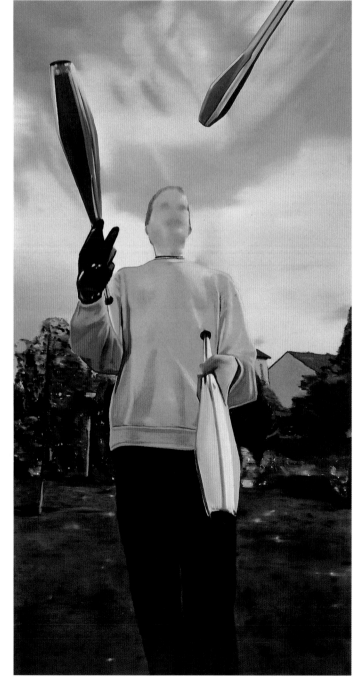

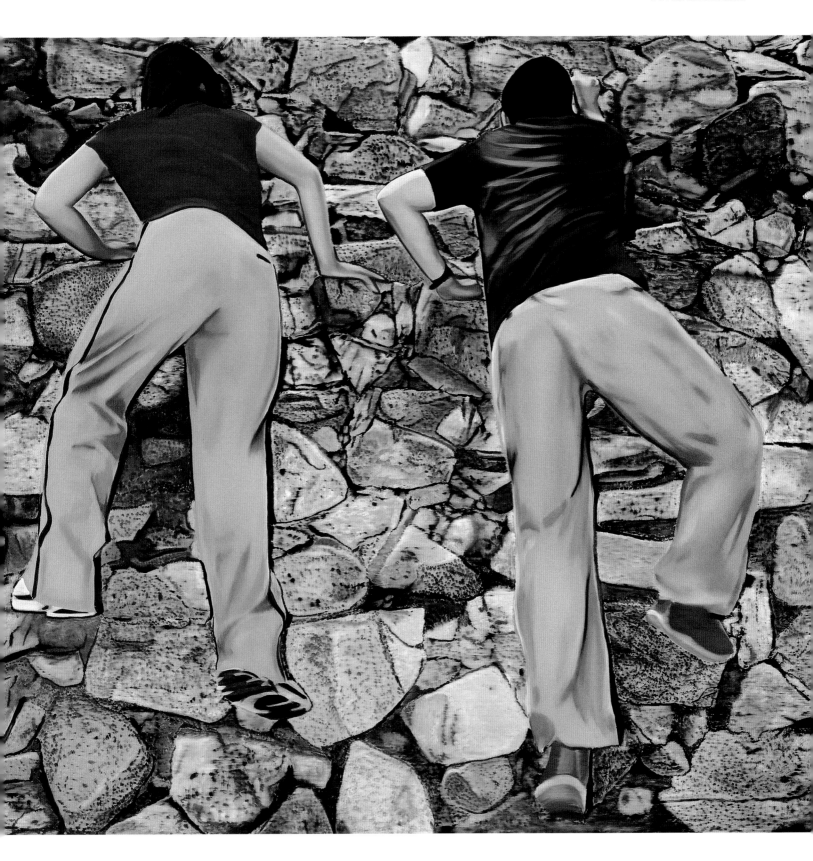

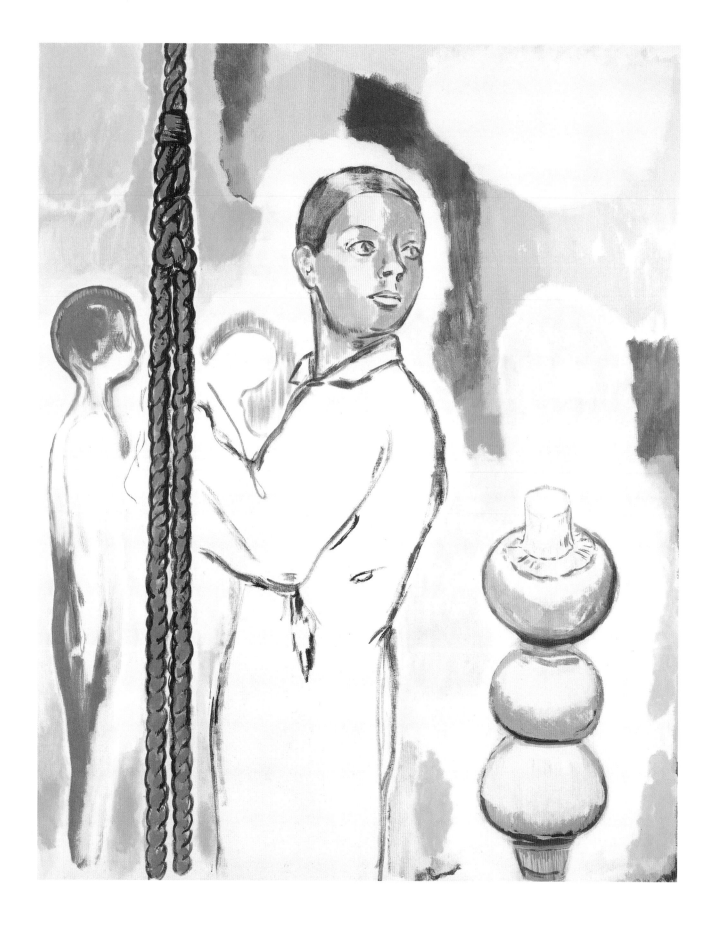

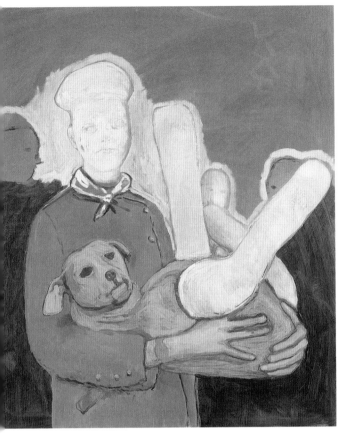

Neal Tait

Button Mushroom, 2003–04 [opposite]
Boy and Dog, 2003 [left]
Dancing Couple, 2003–04 [below]

Tait paints fragments of time, one moment from a complex
sequence. We can't hope to understand what is going on, but
we are curious to know, just as we start imagining possible
scenarios when we momentarily witness an event from a passing
car. Tait reinforces the futility of our efforts to get to grips with
his subjects through paint, which creates a patchy abstracted area
behind the woman in *Button Mushroom*, and almost obliterates
the face of the youth in *Boy and Dog*. His subjects often approach
abstraction, as in *Dancing Couple*, as he explores the boundaries
of representation. Tait employs a restricted palette, its aged
aesthetic reminiscent of Luc Tuymans. Both use found
photographs from which to compose their work but Tait uses
them to create work that is more poetic and personal, almost
dreamlike. Only the paint's coherence seduces us into believing
the disparate elements in *Button Mushroom* – bell rope, funghi,
a young woman in a lab coat – somehow belong together.

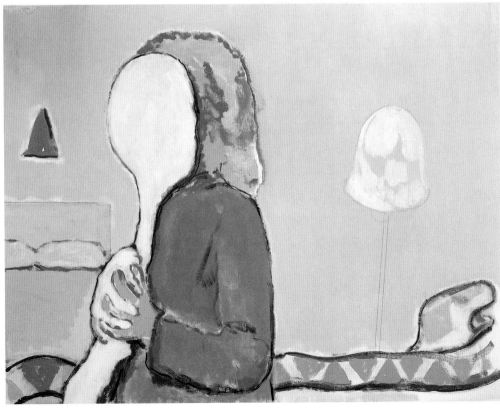

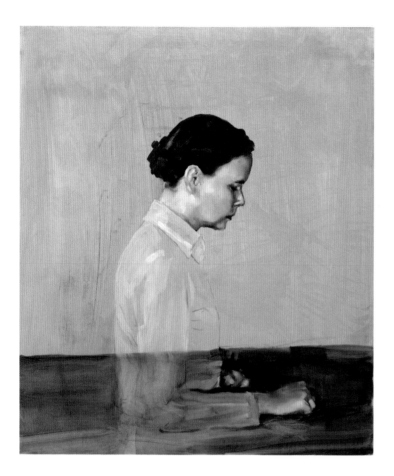

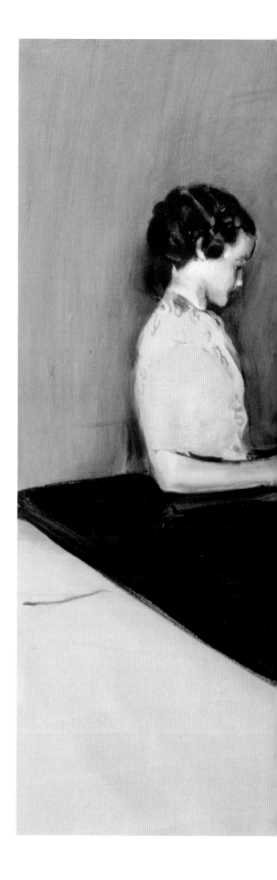

Michaël Borremans
One, 2003 [above]
Four Fairies, 2003 [right]

It's hard to believe Borremans's paintings were made this century. They feature men and women in 1930s and 1940s fashions, based on photographs and old illustrations, painted in a muted palette suggestive of postwar austerity. *The Marvel* (see p. 146) depicts an anonymous lady taken from a 1930s dressmaking pattern book; *Four Fairies* shows women in 1940s blouses. But while these works emanate nostalgia, they are also concerned with the strange possibilities of painting. In *The Marvel*, the white neck ribbon has become an abstract plane, in contrast to the fully-fleshed out face above. In *Four Fairies*, the painting has literally cut the women in half, a slab of oily paint reflecting the torsos of the women who seem to look down into it, lost in thought. The edges of the slab splash the raw canvas, pointing to the artifice of painting, emphasizing the contrast between the realistic modelling of the women's upper bodies and the physical reality of the flat surface.

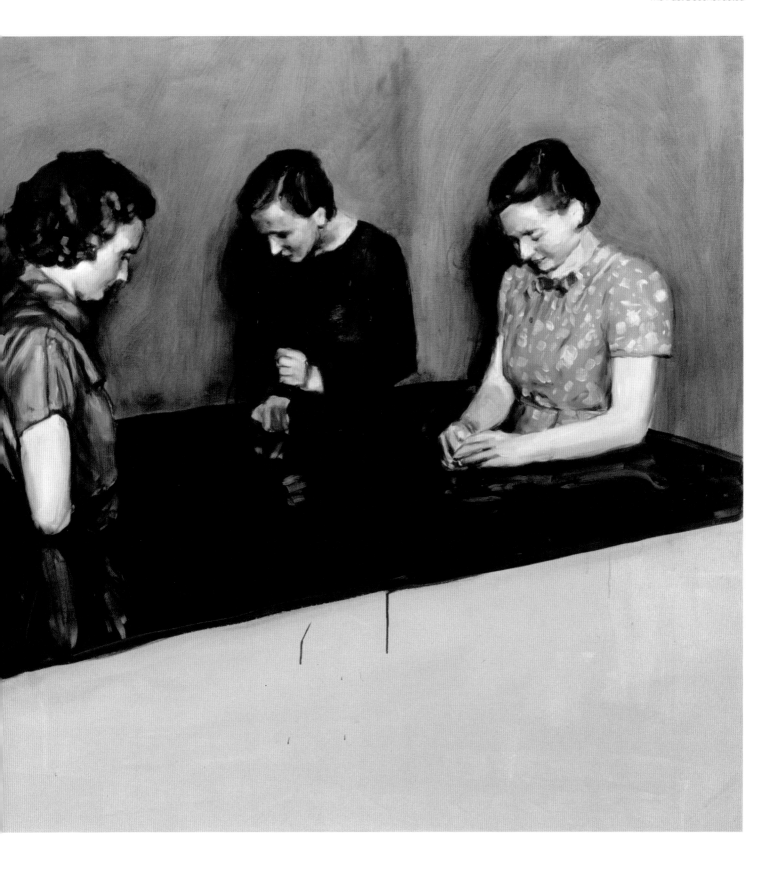

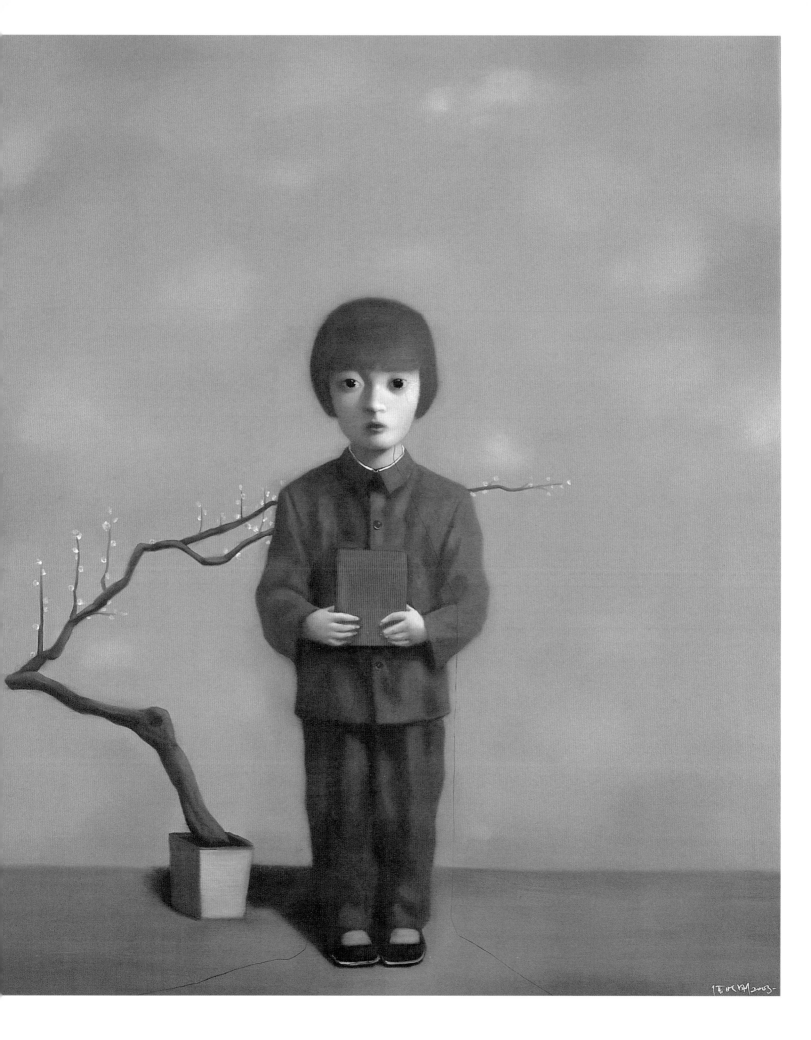

Zhang Xiaogang

Little Red Book, 2003 [opposite]

Comrade I, 2003 [right]

Comrade, 2002 [below]

Xiaogang was born in 1958, in Sichuan, China. His childhood
was shaped by the Cultural Revolution, and through his
paintings he now explores the personal legacy of this period.
Since 1993 he has worked on his *Big Family* series, creating work
based on photographs of his extended family taken during the
Cultural Revolution. When he first studied these images, he was
astounded by how depersonalized they were, how standardized
people had to be. He replicates this in his paintings, working in
a smooth, meticulous style, erasing imperfections. And yet, on
second viewing, tiny personal traits can be seen – a drooping
eyelid, a gap-toothed smile. Overlaying the portrait is often a red
watermark, seemingly randomly placed, like a birthmark for the
canvas. It is always red, the colour of Chairman Mao's canonical
Little Red Book (itself the subject of a painting by Xiaogang in
2003), and stains each work like a faded tattoo.

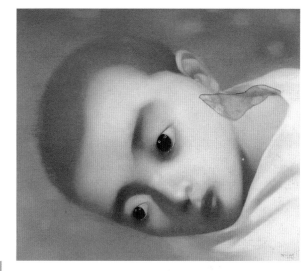

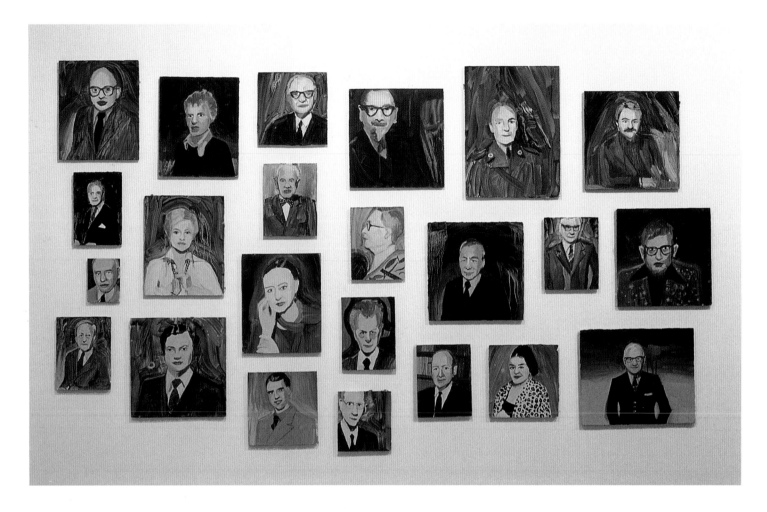

Anna Bjerger

23 paintings from the series *129 Swedes*, 2002
Bather, 2003 [opposite]

Bjerger paints photographs, both her own and found images. She reproduces the scene exactly as she finds it – the same crop, same figures, same setting. She wants to give faded photographs a sense of importance, a permanence. Often she paints her family and friends, but she doesn't want us to know who they are. By painting them she transforms them into a type – a mother, a naked bather, a traveller – whom she wants us to relate to generically. In *129 Swedes*, she copied portraits from a 1970s book of Swedish workers. Their awkwardness in front of the camera translates into paint, but their static poses are brought to life by her breathily expressive manner of painting (not unlike fellow Scandinavian Edvard Munch). She gives life back to people frozen by the camera, and her runny paint and brushy style fill her small, non-hierarchical paintings with a latent energy.

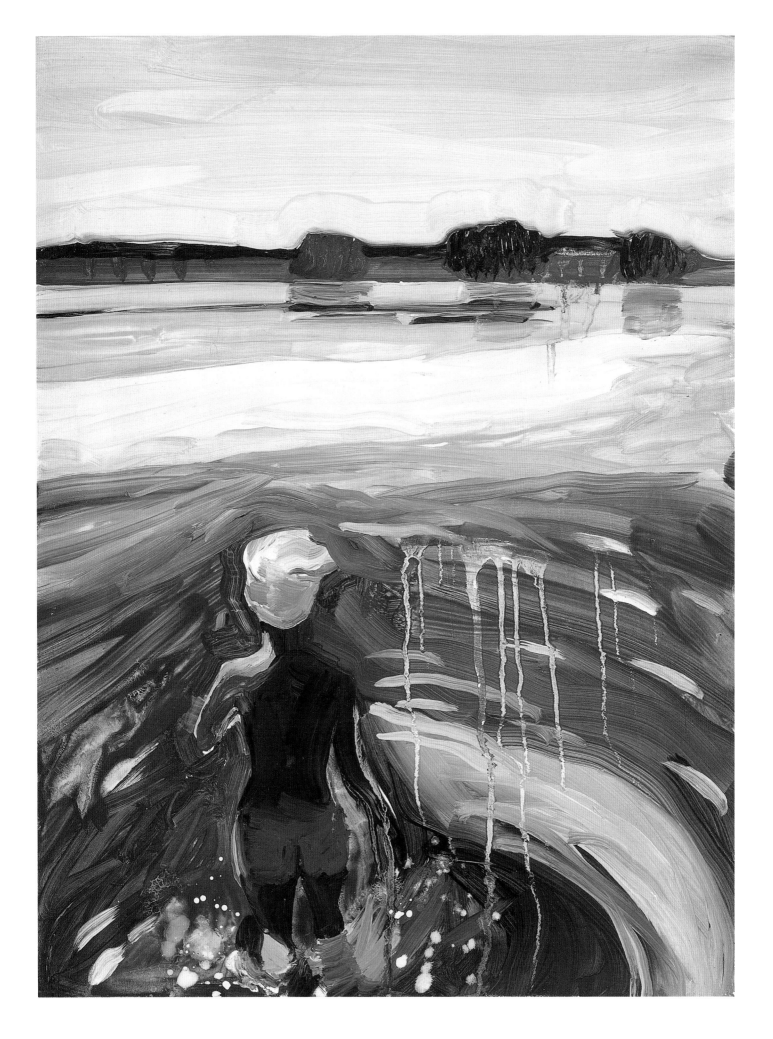

Glenn Brown

America, 2004 [below left]
The Riches of the Poor, 2003 [right]
Death Disco, 2004 [opposite]

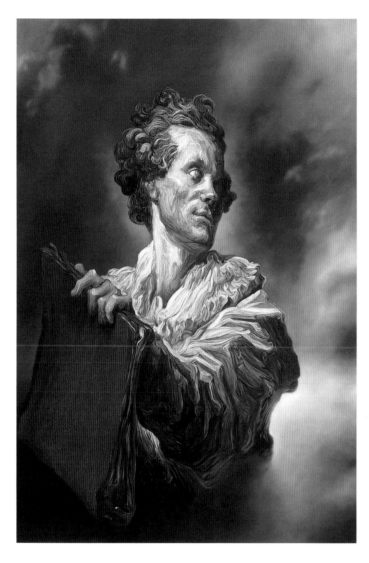

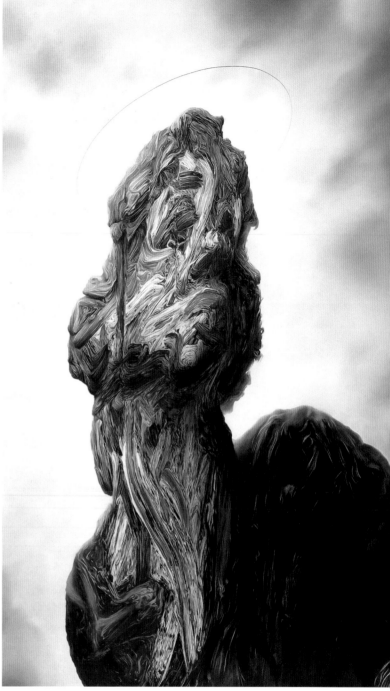

Brown's paintings reproduce iconic works of art by Rembrandt, Van Dyck, Fragonard and others. In *The Riches of the Poor*, he continues his exploration of the work of Frank Auerbach, using Auerbach's *Head of J. Y. M.*, 1973, as a template (see p. 149). But unlike the original, which is crusty with impasto, Brown's version has a glossy smooth surface, much like a photograph. All of Brown's paintings explore this transition – subtle or otherwise – between the authentic work or art and its reproduction. Paintings are photographed to allow their likenesses to be

disseminated, and it is this photographic reproduction of the original that Brown diligently works from, creating a copy of a copy. Increasingly, Brown is manipulating his subjects. *Death Disco*, based on Rembrandt's painting *Flora*, 1634, has stripped the woman of her contextual setting, elongated her and replaced tonal umber hues with lurid reds and blues. Flora now has bloodshot eyes; many of Brown's subjects have cataracts or eye problems, as if to say that when we look at reproductions of paintings we are not seeing the real thing, only a poor substitute.

Mathew Weir

Shit House, 2004–05 [right]
Dadd's Hole, 2004–05 [opposite]

In Weir's intricate paintings, Victorian figurines
of black boys and street performers stand in
bucolic landscapes, clusters of tea roses and
flowers copied from seventeenth-century Dutch
still life paintings smothering the ground. They
are painted with a Pre-Raphaelite intensity,
the glossy surfaces of the figurine contrasting
with the flat decorative detailing of the flora.
But all this painterly seduction is sharply
contrasted with the subject matter – Weir
paints ornaments that appear woefully dated
through their racist caricature. He further
complicates each scene by raising questions as to
where they are and why – have they been thrown
out, abandoned in some out-of-the-way field?
Do they pose and perform with no hope of an
audience? There's a strong sense of melancholy
to these works, a sadness made all the more
painful by Weir's loving attention to detail.

John Currin

Fishermen, 2002 [left]
Thanksgiving, 2003 [opposite]

Currin is a skilful painter, and he interweaves elements taken from historical paintings by Michelangelo, Manet and many others to create his detailed works. In the 1990s, his paintings were explicitly sexual – he attracted harsh feminist criticism for his grotesquely bosomed women – and his current work retains a sexual agenda, albeit a more discreet one. *Fishermen* appears as a homoerotic reposte to all the nude women in unlikely poses throughout history, while *Thanksgiving* abounds with symbolic references to deflowering (the single fresh rose; the turkey waiting to be stuffed; the open mouth). Recently, Currin has cast a critical eye over American suburbia, painting brunch parties, cocktail soirées and thanksgiving preparations. The three women in *Thanksgiving* are all based on Currin's wife Rachel, her body manipulated to create three graces who imitate Parmigianino's *Madonna of the Long Neck*, 1534. Rachel was also the subject for Currin's *Rachel in Fur*, 2002, featured on the cover of this book.

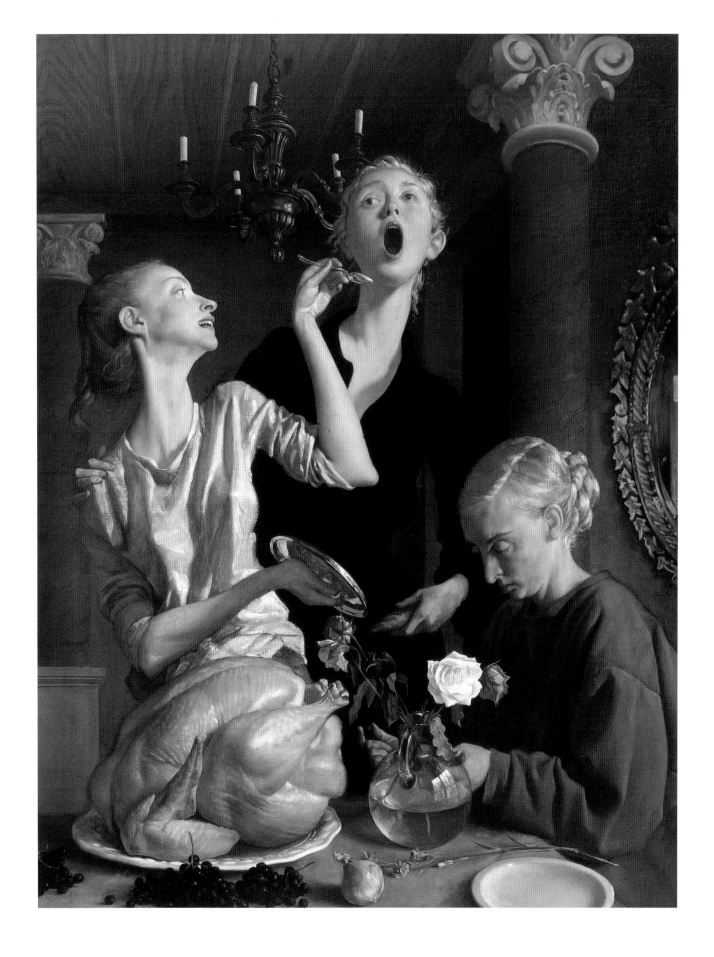

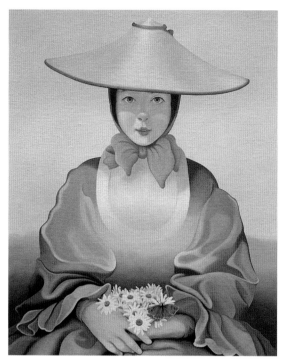

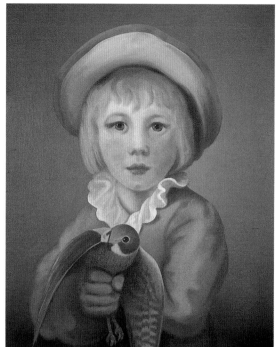

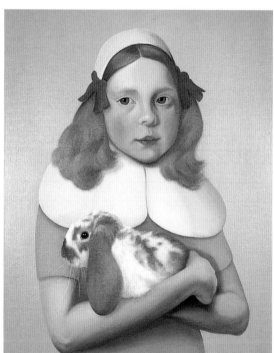

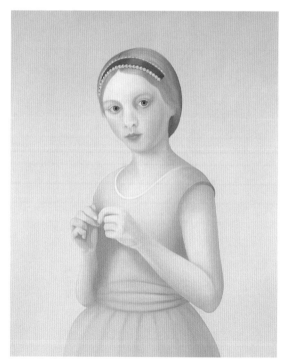

Richard Wathen

Over The Moor, 2003 [far left]
Casper, 2003 [left]
Gerty, 2004 [below far left]
Olivia, 2004 [below left]
Olive, 2004 [opposite]

Wathen creates complex portraits that at once look historical and yet contemporary. He raids the lexicon of traditional portraiture – ruffled collars, hats and backgrounds – so that each work has the initial appearance of a *memento mori* of a distant relative from an earlier century. But there's something not quite right about these portraits – the off-the-shoulder dress of *Olive*, and her grey cropped hair, tell us she is different, a hybrid of past styles and present beliefs; the red ribbons of *Gerty* jar with her puritanical collar and cap. Wathen says he uses the genre of historical portraiture to illustrate elements of himself, his childhood. But these works go beyond the purely personal, and point to our somewhat naïve belief in historical pictures to give us documentary evidence of the time. All portraits are a complex mix of tradition and modernity, politics and diplomacy, fact and fiction.

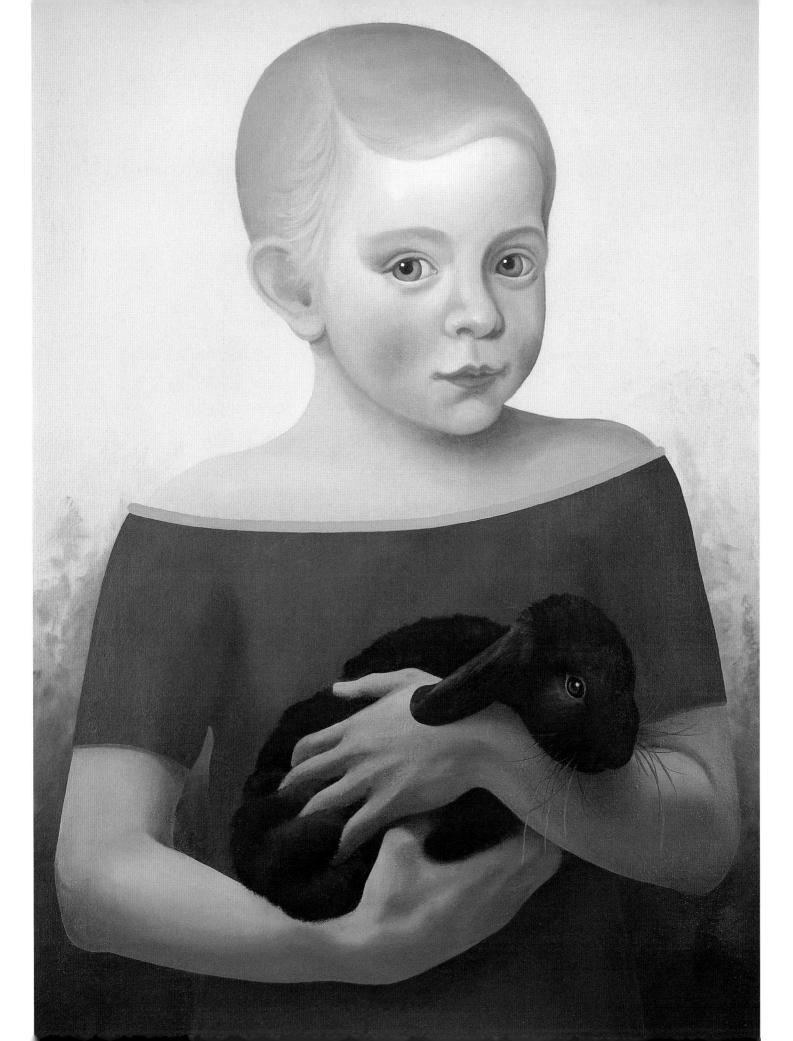

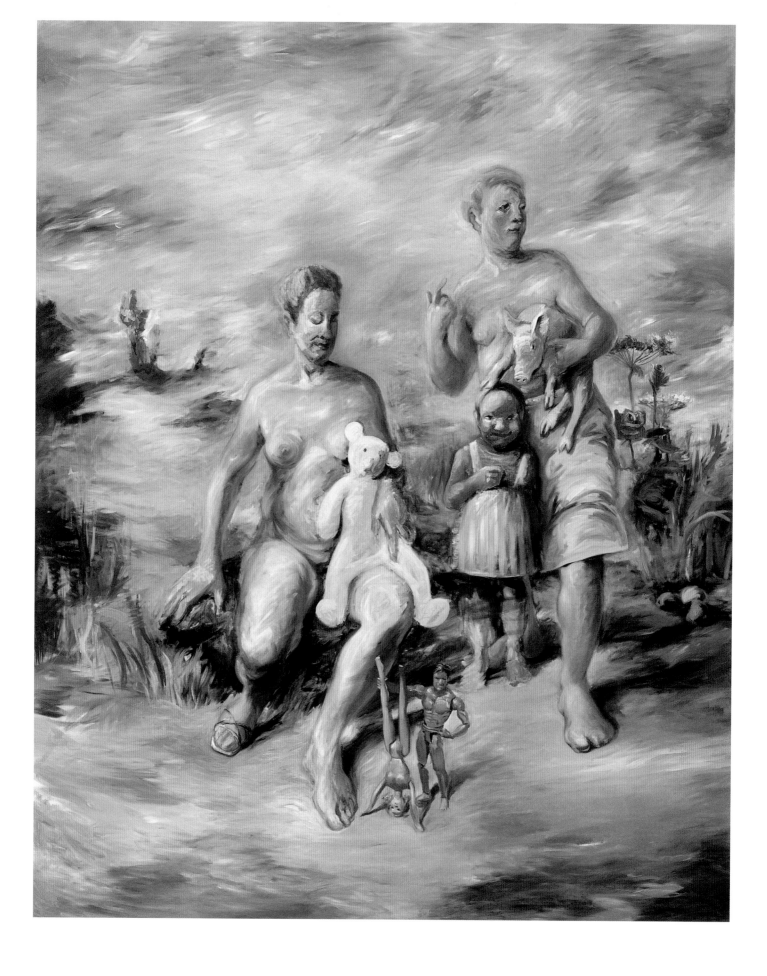

Bénédicte Peyrat

Teddy, 2003 [opposite]
Zum Lohn für deine Faulheit, 2003 [below]
Gilles, 2003–04 [below right]

Peyrat takes on the entire history of painting (and photography) in her large-scale
ambitious canvases. In *Zum Lohn für deine Faulheit*, a nude woman awkwardly poses,
club foot grazing the floor, chapped hand hanging down. It's as if she were posing
for a camera, and Peyrat's works have a feel of the old studio practices of early
photographers where abstract backgrounds would drop down behind the sitter,
artificial poses would be adopted and various props added to create the required
effect. In *Zum Lohn für deine Faulheit* art historic references also abound – the nude
is as fleshy as a Rubens, as feathery as a Renoir, and the backdrop as abstract as a
late Gainsborough. In *Teddy* the sky is a maelstrom of colour, swirling around the
stocky women who pose as a makeshift holy family, the white teddy a stand in for
baby Jesus.

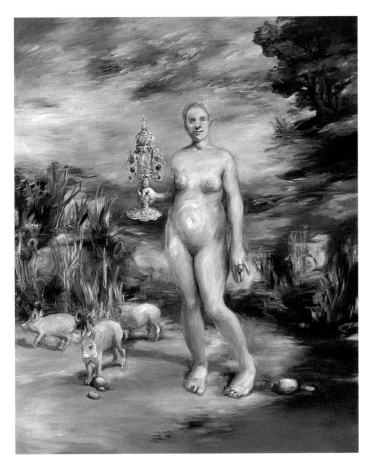

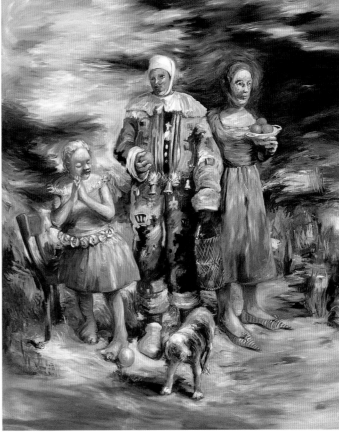

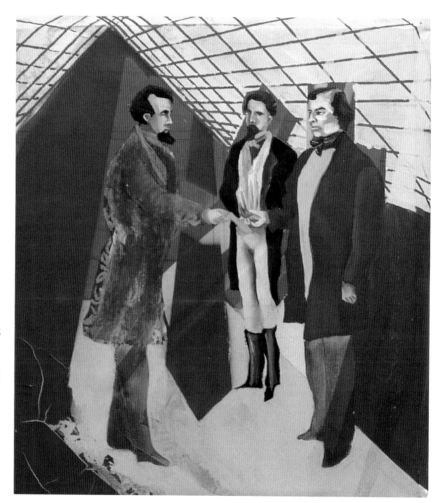

Rosson Crow

Vortex of Impeachment, 2004

Crow is still in her early twenties and completing an MFA at Yale, and consequently her work is in rapid development. She sandwiches centuries together in her architectonic paintings, layering costumes and characters from history with fabrics and wallpapers from other time periods, all held in stasis for just a moment on the canvas. In *Lord Nelson Surveying the Damage*, the rotund Captain stands in a coat seemingly made up of rigging, his own ships battered from war, gunpowder hanging in the air. The red chair under Nelson's left hand suggests he is inside, and conjuring the ships in his memory – nothing is as it seems in Crow's work. More recently, Crow's figures have reduced in size and at times disappeared altogether, the rooms they have vacated still cut through by various historical styles and decorations, reminiscent of the work of Dexter Dalwood and Ian Munroe.

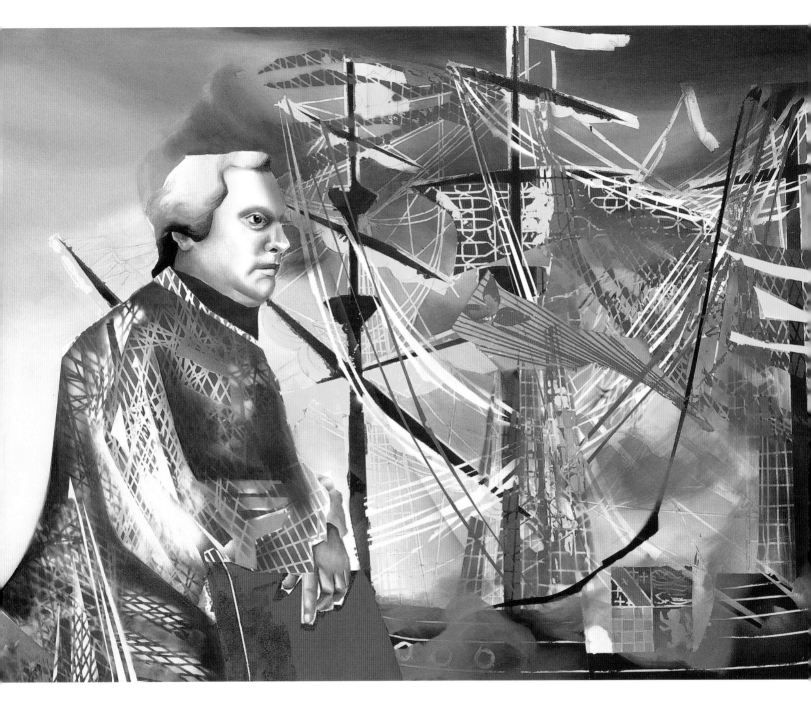

Rosson Crow
Lord Nelson Surveying the Damage, 2004

Artists' Biographies

| PHILIP AKKERMAN | ▶ 28

Born 1957, Vaassen, Netherlands
Lives The Hague, Netherlands
Ateliers '63, Haarlem, Netherlands, 1979–81
Royal Academy of Visual Arts, The Hague,
 Netherlands 1976–78

Select solo shows
2005 LAC, Sigeau, France
2004 Andrew Mummery Gallery, London
 André Simoens Gallery, Knokke
2002 Studio DVO, Brussels
2001 Gorney, Bravin + Lee, New York

Select bibliography
2005 Depondt, P., 'The Mirror Image and the
 Question: Is that me? Philip Akkerman and
 his Self-Absorbed Struggle with Portraiture',
 The Low Countries, Yearbook, no. 13
 Kipnis, J., 'Some thoughts on contemporary
 paintings in the hope that analogies to
 architecture might be drawn', *Hunch*, no. 9
2003 Van Alphen, E., 'Stylistic Travesties:
 Philip Akkerman's Obsessive Self-Portraiture',
 Berliner Theaterwissenschaft, Band 11

Contact
Andrew Mummery Gallery, London, England
www.andrewmummery.com

| LAYLAH ALI | ▶ 136

Born 1968, Buffalo, USA
Lives in Williamstown, Massachusetts, USA
MFA Washington University, St Louis, USA, 1994
BFA Williams College, Williamstown, USA, 1991

Select solo shows
2005 303 Gallery, New York
2004 Contemporary Art Museum, St Louis
2003 Albright-Knox Art Gallery, Buffalo
2002 Museum of Modern Art, New York
2001 Institute of Contemporary Art, Boston

Select bibliography
2005 Rockwell, J., 'Basketballs, Museum Galleries
 and Meaning,' *The New York Times*, 9 May, p. E5
2004 Whitney 2004 Biennial Edition, New York
 Weyland, J., 'American Splendor,' *Time Out New
 York*, 4–11 March, no. 440, pp.12–15

Contact
303 Gallery, New York, USA, *www.303gallery.com*

| MAMMA ANDERSSON | ▶ 100

Born 1962, Luleå, Sweden
Lives Stockholm, Sweden
Kungliga Konsthögskolan, Stockholm, Sweden
 1986–93

Select solo shows
2005 Stephen Friedman Gallery, London
2004 Galleri Magnus Karlsson, Stockholm
2002 Stephen Friedman Gallery, London
 Galleri Magnus Karlsson, Stockholm
2001 Konstens Hus, Luleå

Select bibliography
2005 Rubinstein, R., 'Person, Place and Thing',
 Art in America, Jan, pp. 104–09
2004 Dörrzapf, Von A., 'Fräulein Karins Gespür
 für Geschichten', art: *das kunstmagazin*, Mar,
 pp. 64–73
 Herbert, M., 'Emerging Artists Rewind:
 Mamma Andersson & Tal R go back to move on',
 Modern Painters, Dec/Jan, pp. 50–1

Contact
David Zwirner, New York, USA
www.davidzwirner.com

| JULES DE BALINCOURT | ▶ 60

Born 1972, Paris, France
Lives Brooklyn, New York, USA
MFA Hunter College, New York, USA, 2004
BFA California College of Arts and Craft,
 San Francisco, USA, 1998

Select solo shows
2005 Zach Feuer Gallery (LFL), New York
2003 Zach Feuer Gallery (LFL), New York
 Allston Skirt Gallery, Boston
2000 Space 743, San Francisco

Select bibliography
2005 Boucher, B., 'Jules de Balincourt at
 Zach Feuer', *Art in America*, May, p. 165
 Ratner, M., 'Jules de Balincourt',
 Frieze, May

2004 Nickas, B., *Collection Diary (Or How I Spent
 a Year)*, PS1 Contemporary Art Center/MoMA,
 New York (JRP/Ringier, Zurich)
2003 Johnson, K., 'Jules de Balincourt, LFL
 Gallery', *The New York Times*, 30 May
 Saltz, J., 'Burn, Baby Burn', *The Village Voice*, 3 Jun

Contact
Zach Feuer Gallery (LFL), New York, USA
www.zachfeuer.com

| HERNAN BAS | ▶ 96

Born 1978, Miami, USA
Lives Miami, USA
New World School of the Arts, Miami, USA, 1996

Select solo shows
2005 Victoria Miro Gallery, London
 Fredric Snitzer Gallery, Miami
2004 The Moore Space, Miami
 Daniel Reich Gallery, New York
2002 Museum of Contemporary Art,
 North Miami
2001 Frederic Snitzer Gallery, Miami

Select bibliography
2005 Güner, F., 'Gothic Worlds Collide', *Metro*,
 London, 29 Mar
 Douglas, S., 'Hernan Bas: Meet Me at the
 Cemetery Gate', *Flash Art*, Jan/Feb
2004 Ribas, J., 'The Other Side of Paradise',
 Art Review, Dec/Jan
 Schambelan, E., 'Hernan Bas: Daniel Reich
 Gallery', *Artforum*, Dec

Contact
Victoria Miro Gallery, London, England
www.victoria-miro.com

| NORBERT BISKY | ▶ 142

Born 1970, Leipzig, Germany
Lives Berlin, Germany
Universität der Künste Berlin, Germany, 1994–99

Select solo shows
2005 Galerie Tarasiéve, Paris
 Studio d'Arte Cannaviello, Milan
2004 Leo Koenig Inc., New York

2003 Galerie Michael Schultz, Berlin
 Galerie Rudiger Voss, Düsseldorf
2002 Galerie Terminus, Munich
2001 Galerie Michael Schultz, Berlin

Select bibliography
2005 Henry, M., *Norbert Bisky*, Leo Koenig Inc.,
 New York
2004 *New German Paintings*, Regina Gallery, Moscow
 Henry, M., 'Norbert Bisky at Leo Koenig
 (New York)', *Art in America*, Jun/Jul

Contact
Galerie Michael Schultz oHG, Berlin, Germany
www.galerie-schultz.de

| ANNA BJERGER | ► 162

Born 1973, Skallsjo, Sweden
Lives Stockholm, Sweden
MA Royal College of Art, London,
 England, 2001
BFA Central Saint Martins College of Art and
 Design, London, England, 1997

Select solo shows
2004 MW Projects, London
2003 Chapter Gallery, Cardiff (touring to Oriel
 Mwldan and Pumphouse Gallery, London)
2002 MW Projects, London

Select bibliography
2005 Leeson, D., 'Anna Bjerger – Angels In Your
 Beer', *Turps Banana*, no. 1, pp. 41–3
2004 Charlesworth, J. J., 'Fever', *Flash Art
 International*, Nov/Dec, no. 239
2003 O'Reilly, S., 'Selected Painting, MW Projects',
 Frieze, no. 79, Dec
2002 Ward, O., 'Anna Bjerger', *Art Review*,
 May, p. 59

Contact
Max Wigram Gallery, London, England
www.maxwigram.com

| MICHAËL BORREMANS | ► 158

Born 1963, Geraardsbergen, Belgium
Lives Ghent, Belgium
MFA Hogeschool voor Wetenschap en Kunst,
 Campus St Lucas, Ghent, Belgium, 1996

Select solo shows
2005 Cleveland Museum of Art, Cleveland USA
 Stedelijk Museum voor Actuele Kunst, Ghent
 (touring to Parasol Unit, London, The Royal
 Hibernian Academy, Gallagher Gallery, Dublin)
2003 David Zwirner, New York
2002 Zeno X Gallery, Antwerp, Belgium
2000 Stedelijk Museum voor Actuele Kunst, Ghent

Select bibliography
2005 Carrier, D., 'Michaël Borremans', *Artforum
 International*, Sept, pp. 308–09
 Ostrow, S., 'Strange Days: The Drawings of
 Michaël Borremans', *angle*, Sept/Oct, p. 5

Searle, A., 'Curiouser and Curiouser',
 The Guardian, 3 May, pp 12–13

Contact
David Zwirner, New York, USA
www.davidzwirner.com

| CECILY BROWN | ► 34

Born 1969, London, England
Lives New York, USA
BFA Slade School of Art, London, England, 1993

Select solo shows
2005 Modern Art, Oxford
2004 Museo Reina Sofia, Madrid
2003 Museo d'Arte Contemporanea, Rome
 Gagosian Gallery (Beverley Hills), Los Angeles
2002 Hirshhorn Museum and Sculpture Garden,
 Washington, DC
2001 Contemporary Fine Arts, Berlin

Select bibliography
2005 Wood, G., 'I like the cheap and nasty',
 The Observer, 12 Jun
2002 Landi, A., 'Action! Drama! Love! Adventure!',
 Artnews, Jun, p. 96–9
 Chambers, C., 'Cecily Brown', *Flash Art*,
 May/Jun, p. 133
2000 Leffingwell, E., 'Cecily Brown at Gagosian',
 Art in America, Jul

Contact
Gagosian Gallery, New York, USA
www.gagosian.com

| GLENN BROWN | ► 164

Born 1966, Hexham, England
Lives London, England
MA Goldsmiths College, London, England, 1990–92

Select solo shows
2004 Serpentine Gallery, London
 Gagosian Gallery, New York
2002 Galerie Max Hetzler, Berlin
2001 Patrick Painter Inc, Los Angeles
 Künstlerverein Malkasten, Düsseldorf
2000 Domaine de Kerguéhennec, Centre d'Art
 Contemporain, Bignan

Select bibliography
2005 Mark, L. and Schimmel, P. (eds), *Ecstasy:
 In And About Altered States*, Museum of
 Contemporary Art, Los Angeles
2003 *Biennale di Venezia: Dreams and Conflicts.
 The Dictatorship of the Viewer. 50th International
 Art Exhibition*, Skira Editore
2001 *Azerty. Un abécédaire autour des collections du
 FRAC Limousin*, Centre Pompidou, Paris
2000 Collings, M., *This is Modern Art*, Weidenfeld
 Nicholson, New York

Contact
Galerie Max Hetzler, Berlin, Germany
www.maxhetzler.com

| BRIAN CALVIN | ► 122

Born 1969, Visalia, California, USA
Lives Los Angeles, USA
MFA School of the Art Institute of Chicago,
 USA, 1994
BFA University of California, Berkeley, USA, 1991

Select solo shows
2005 Corvi-Mora, London
2004 Anton Kern, New York
2003 Corvi-Mora, London
2002 Gallery Side 2, Tokyo
2001 Corvi-Mora, London

Select bibliography
2005 Pagel, D., 'Sober, steady, yet electrifying',
 Los Angeles Times, 13 May, p. E24
2004 Wilson, M., 'Brian Calvin', *Artforum*, Dec, p. 195
2003 Harrison, S., 'Brian Calvin', *Time Out London*,
 17–24 Sept, p. 62
2001 Hainley, B., 'Brian Calvin', *Artforum*,
 Feb, pp. 140–41
 Higgie, J., 'Brian Calvin', *Frieze*, Sept, pp. 89, 96

Contact
Marc Foxx, Los Angeles, USA, *www.marcfoxx.com*

| MATHEW CERLETTY | ► 68

Born 1980, Milwaukee, USA
Lives New York, USA
BFA Boston University, Boston, USA, 2002

Select solo shows
2004 Rivington Arms, New York
2003 Rivington Arms, New York

Select group shows
2005 Gavin Brown's Enterprise, Passerby, New York
2004 Andrea Rosen Gallery, New York
 Peres Projects, Los Angeles
2003 Hiromi Yoshii Gallery, Tokyo and John
 Connelly Presents, New York
2002 Rivington Arms, New York

Select bibliography
2005 Kunitz, D. and Ribas, J., 'Emerging US
 Artists', *Art Review*, Mar, p. 114
2004 Krudy, C., 'Buying Into the Pleasure
 Principle', *Columbia Daily Spectator*, 9 Feb
 Bollen, C., 'Mathew Cerletty', *ArtForum*,
 Apr, pp. 148–9
2003 Bollen, C., 'Today's Man', *Time Out New York*,
 11 Sept, p. 88
2002 Cotter, H., 'I Kept All Your Letters',
 The New York Times, 24 May, p. B37

Contact
Rivington Arms, New York, USA
www.rivingtonarms.com

| YI CHEN | ► 24

Born 1974, Beijing, China
Lives New York, USA

MFA Purchase College, State University
of New York, USA, 2003
BFA Nova Scotia College of Art and Design,
Halifax, Canada, 2000

Select solo shows

2005 Kavi Gupta Gallery, Chicago
University of Connecticut Contemporary
Art Gallery, Storrs, Connecticut
2004 Plum Blossoms Gallery, New York
2003 Gallery 456, New York
Regent Wall Street Hotel, New York
2002 Purchase College, Purchase, New York
2000 Anna Leonowens Gallery, Nova Scotia College
of Art and Design, Halifax

Select bibliography

2004 Heartney, E., 'Ying-Yueh Chuang and Yi Chen
at Plum Blossoms', *Art in America*, Jun/Jul

Contact

Marianne Boesky, New York, USA
www.marianneboeskygallery.com

| CHUCK CLOSE | ▶ 22

Born 1940, Monroe, USA
Lives New York, USA
BA University of Washington, Seattle, USA
BFA Yale University School of Art and
Architecture, New Haven, USA, 1963
MFA Yale University School of Art and
Architecture, New Haven, USA, 1964

Select solo shows

2005 Walker Art Center, Minneapolis
Pace Wildenstein, New York
2004 Metropolitan Museum of Art, New York
2003 Pace Wildenstein, New York
2001 Worcester Museum of Art, Massachusetts

Select bibliography

2005 Rosenblum, R., 'Chuck Close's Facts and
Fictions', *Recent Paintings*, Pace Wildenstein
2002 Varnedoe, K., *Chuck Close: Recent Works*,
Pace Wildenstein

Contact

Pace Wildenstein, New York, USA
www.pacewildenstein.com

| GEORGE CONDO | ▶ 130

Born 1957, Concord, New Hampshire, USA
Lives New York, USA
BFA Lowell University, Massachusetts,
USA, 1976–78

Select solo shows

2005 Museum of Modern Art, Salzburg
2004 Galerie Sprüth Magers Lee, London
2003 Caratsch de Pury & Luxembourg,
Zürich
Galerie Sprüth Magers Cologne
2002 Luhring Augustine, New York
2001 Galerie Jérôme de Noirmont

Select bibliography

2005 Kellein, T., *George Condo. One Hundred Woman*,
Hatje Cantz
2001 *George Condo: Physiognomical Abstraction*,
Galerie Jérôme De Noirmont, Paris

Contact

Sprüth Magers Lee, London, England
www.spruethmagerslee.com

| HOLLY COULIS | ▶ 126

Born 1968, Toronto, Canada
Lives Brooklyn, New York, USA
BFA Ontario College of Art and Design,
Toronto, Canada, 1995
MFA School of the Museum of Fine Arts,
Boston, USA, 1998

Select solo shows

2004 Groeflin Maag Galerie, Basel
Greener Pastures Contemporary Art, Toronto
2003 LFL Gallery, New York

Select bibliography

2004 'Coulis in der Galerie Groeflin/Maag',
Basler Zeitung, 9 Sept
2003 'From Perky to Unsettling',
The Los Angeles Times, 4 Jul
2003 Smith, R., 'Holly Coulis',
The New York Times, 28 Mar
2002 Smith, R., 'Holly Coulis/Dana Schutz',
The New York Times, 8 Feb

Contact

Groeflin Maag Galerie, Basel, Switzerland
www.groeflinmaag.com

| ROSSON CROW | ▶ 174

Born 1982, Dallas, USA
Lives New Haven, USA
MFA Yale, New Haven, USA, 2004–06
BFA School of Visual Arts, New York,
USA, 2000–04

Select solo shows

2005 Galerie Nathalie Obadia, Paris
2004 CANADA, New York

Select bibliography

2005 Geneies, B., 'Une Revelation Americiane',
ParisObs, Nov
Debeilleux, H. F., 'Rosson Crow frappe fort',
Liberation, Nov
2004 Cena, O., 'Marche de Dupes',
Artchronique, 24 Nov
LaVallee, A., 'Young Artists Get Personal',
New York Arts, Dec
LaRocca, B., 'Rosson Crow', *The Brooklyn Rail*, Nov

Contact

CANADA, New York, USA
www.canadanewyork.com

| JOHN CURRIN | ▶ 168

Born 1962, Boulder, Colorado, USA
Lives New York, USA
MFA Yale University, New Haven, USA, 1986
BFA Carnegie Mellon University, Pittsburgh,
USA, 1984

Select solo shows

2003 Sadie Coles HQ, London
Museum of Contemporary Art, Chicago
(touring to Serpentine Gallery, London and
Whitney Museum of Art, New York)
Des Moines Art Center (touring to Aspen Art
Museum and Milwaukee Art Museum)
2002 Regen Projects, Los Angeles
2001 Andrea Rosen Gallery, New York

Select bibliography

2005 Honour, H. and Fleming, J., *A World History
of Art*, Laurence King, London
2003 Fleming, J., *John Currin – Works on Paper*,
Des Moines Art Center, Des Moines
Dailey, M., *Curve: The Female Nude Now*,
Universe Publishing, New York
2002 *The Honeymooners*, Sadie Coles HQ, London

Contact

Sadie Coles HQ, London, England
www.sadiecoles.com

| AMY CUTLER | ▶ 132

Born 1974, Poughkeepsie, USA
Lives New York, USA
MFA The Skowhegan School of Painting and
Sculpture, Skowhegan, USA, 1999
BFA Cooper Union School of Art, New York,
USA, 1997

Select solo shows

2004 Kemper Museum of Contemporary Art, Kansas
Leslie Tonkonow Artworks + Projects, New York
2003 The Kohler Art Center, Sheboygan
2002 Walker Art Center, Minniapolis
Institute of Contemporary Art, Philadelphia

Select bibliography

2005 Kunitz, D., 'Meet the New Folk,'
Art Review, Apr
2004 Douglas, S., 'Amy Cutler: Girls in Flammable
Skirts,' *Flash Art International*, Nov/Dec
Harris, J., 'Amy Cutler,' *Time Out New York*,
27 May–3 Jun
Jones, K. M., 'Amy Cutler,' *Frieze*, Sept
2003 Fogle, D., 'Strange Women and Lonesome
Cowboys,' in: *Dialogues: Amy Cutler/David
Rathman*, Walker Art Center, Minneapolis
2002 Caniglia, J., 'Amy Cutler,' *Artforum*,
Apr, p. 138
2000 Lloyd, A. W., 'Amy Cutler at Miller Block,'
Art in America, Dec

Contact

Leslie Tonkonow Artworks + Projects,
New York, USA
www.tonkonow.com

| PETER DOIG | ▶ 90

Born 1959, Edinburgh, Scotland
Lives Trinidad
BA Central Saint Martins College of Art
 and Design, London, England, 1983
MA Chelsea School of Art, London, England, 1990

Select solo shows
2005 Museum Ludwig, Cologne
 Dallas Museum of Art (touring to The Gallery
 at Windsor, Florida and Art Gallery of Ontario)
2004 Pinakothek Der Moderne, Munich (touring
 to Kestnergellschaft, Hannover)
2003 Bonnefanten Museum, Maastricht (touring
 to Carré d'Art contemporain de Nîmes)
2002 Victoria Miro Gallery, London
2001 Morris and Helen Belkin Art Gallery,
 The University of British Columbia, Vancouver
 (touring to National Gallery of Canada, Ottawa
 and The Power Plant, Toronto)

Bibliography
2005 Wege, A., 'Peter Doig', *Artforum*, Nov
 Lubbock, T., 'The triumph of painting?
 That's a pretty rich claim', *The Independent*, 25 Jan
2004 Ruhle, A., 'Overexposed Memories',
 Suddeutsche Zeitung, 7 May
2003 Higgs, M., 'Peter Doig: Arts Club
 of Chicago', *Artforum*, Oct
 Herbert, M., 'Unraveling the enigma',
 Tema Celeste, Sept/Oct
2002 Searle, A., 'Wide blue yonder',
 The Guardian, 16 Apr

Contact
Victoria Miro, London, England
www.victoria-miro.com

| KAYE DONACHIE | ▶ 98

Born 1970, Glasgow, Scotland
Lives London, England
MA Royal College of Art, London, England, 1997
BA University of Central England, Birmingham,
 England, 1992

Select solo shows
2005 peres projects, Los Angeles
 Maureen Paley, London
2004 Artists' Space, New York
 Maureen Paley, London

Select bibliography
2004 Price, M., 'Mixed Paint: A Survey
 of Contemporary Painters: Kaye Donachie',
 Flash Art, Nov/Dec, p. 90
 Coomer, M., 'The Young and the Restless',
 Elle (UK edition), March
2003 Kent, S., 'Yes! I am a Long Way from Home',
 Time Out London, 9–16 Apr
2002 Suchin, P., 'At the beginning of the movement
 was a scandal', *Frieze*, Oct

Contact
Maureen Paley, London, England
www.maureenpaley.com

| MILENA DRAGICEVIC | ▶ 102

Born 1965, Knin, Yugoslavia
Lives London, England
MA Royal College of Art, London, England,
 1990–92
BFA York University, Toronto, Canada, 1985–89

Select solo shows
2005 IBID PROJECTS, London
2003 Akrobatski, Galerie Martin Janda, Vienna
 Skulptura [skoolp-too-ra] ARTLAB 25, Imperial
 College, London
2002 IBID PROJECTS, London

Select bibliography
2005 Herbert, M., 'Milena Dragicevic',
 Artforum, May
 Boase, G., 'Milena Dragicevic', *Flash Art*,
 Mar/Apr
2004 Morton, T., 'Double Life', *Frieze*, Apr
2003 Harris, M., 'Milena Dragicevic at ArtLab
 at Imperial', *Art in America*, Dec

Contact
IBID Projects, London, England
www.ibidprojects.com

| MARLENE DUMAS | ▶ 44

Born 1953, Cape Town, South Africa
Lives Amsterdam, Netherlands
Psychological Institute, University of Amsterdam,
 Netherlands, 1979–80
Atelier '63, Harleem, Netherlands, 1976–78
BA University of Cape Town, South Africa,
 1972–75

Select solo shows
2005 Taidehalli Helsinki Kunsthalle, Helsinki
2004 Frith Street Gallery, London
2003 Stadtische Galerie Ravensburg
 Museum of Modern Art, Arken
 Art Insitute, Chicago
 Suspect, Fondazione Bevilacqua la Massa, Venice
2002 Zeno X Gallery, Antwerp

Select bibliography
2005 Jones, J., 'The Triumph of Painting',
 The Guardian, 27 Jan
 Kino, C., 'And Then Her Number Came Up',
 The New York Times, 27 Mar
2003 Snodgrass, S., 'Marlene Dumas at the Art
 Institute of Chicago', *Art in America*, Sept
 Schwabsky, B., 'Marlene Dumas', *Artforum
 International*, Vol. 38, Jan

Contact
David Zwirner, New York, USA
www.davidzwirner.com

| MARCEL DZAMA | ▶ 138

Born 1974, Winnepeg, Canada
Lives New York, USA
BFA University of Manitoba, Canada, 1997

Select solo shows
2005 David Zwirner, New York
 Centre d'art Santa Monica, Barcelona
 (touring to Le Magasin Centre National d'Art
 Contemporain, Grenoble)
2004 Christophe Daviet-Thery Livres et Editions
 d'Artistes, Paris
 Timothy Taylor Gallery, London
2003 Richard Heller Gallery, Santa Monica
2002 Sies + Höke, Düsseldorf
2001 Mendel Art Gallery, Saskatoon,
 Saskatchewan (touring to Olga Korper Gallery,
 Toronto, Saidye Bronfman Center for the Arts,
 Montreal, Agnes Etherington Art Gallery,
 Kingston, Art Gallery of Calgary, Calgary,
 Susan Whitney Gallery, Regina, Saskatchwan,
 Laforet Galleries, Tokyo)

Select bibliography
2005 Meno, J., 'Marcel Dzama', *Punk Planet*, no. 70,
 Nov/Dec, pp. 52–6
 Solomon, D., 'Drawn to Trouble: Marcel
 Dzama's twisted fairy-tale world comes to life',
 The New York Times Magazine, 4 Sept,
 pp. 4, 42–45
2003 Dzama, M., 'The Language of Freedom',
 Blackbook, Oct/Nov, pp. 152–56
 Dunn, M. and Gute, C., 'The Royal Art Lodge:
 Ask the Dusk', *Flash Art*, Vol. 36, Mar/Apr, p 55
2002 Enright, R., 'Canada: The Next Generation',
 Time, 14 Oct, p. 65

Contact
David Zwirner, New York, USA
www.davidzwirner.com

| THOMAS EGGERER | ▶ 58

Born 1963, Munich, Germany
Lives Los Angeles, USA
Vermont College, USA, 1994–95
Art Academy, Munich, Germany, 1988–94

Select solo shows
2004 Friedrich Petzel Gallery, New York
2003 Richard Telles, Los Angeles
 Kunstverein Brauschweig, Braunschweig
2002 Wadsworth Atheneum Museum of Art,
 Hartford, Connecticut
 Galerie Daniel Buchholz, Cologne
2001 Richard Telles, Los Angeles

Select bibliography
2005 Joselit, D., 'Terror and Form', *Artforum*,
 Jan, p. 45
 Ferguson, R., 'Lost in Space', *Artnews*,
 Jan, p. 70
2004 Smith, P. C., 'Thomas Eggerer at Friedrich
 Petzel', *Art in America*, Nov, p. 117
2001 Subotnick, A., 'Snapshot: New Art from Los
 Angeles', *Frieze*, no. 62, Oct, pp. 99–100

Contact
Friedrich Petzel Gallery, New York, USA
www.petzel.com

| INKA ESSENHIGH | ▶ 104

Born 1969, Belfonte, Pennsylvania, USA
Lives New York, USA
BFA Columbus College of Art and Design,
 Columbus, Ohio, USA, 1992
MFA School of Visual Arts, New York, USA, 1994

Select solo shows
2005 DA2 Domus Artium 2002, Salamanca
 Victoria Miro Gallery, London
2004 Michael Steinberg Fine Art, New York
2003 Museum of Contemporary Art, Miami
 Fruitmarket Gallery, Edinburgh
2002 Victoria Miro Gallery, London
 303 Gallery, New York

Select bibliography
2005 Williams, E., 'Inka Essenhigh', *Flash Art*,
 Jul/Sept
2003 Levine, C., 'Inka Essenhigh at 303 Gallery',
 Art in America, May
 Schwabsky, B., 'Entering the Labyrinth',
 Tema Celeste, Mar/Apr
2002 Norton, D., 'Inka Essenhigh at Fruitmarket',
 Circa, no. 104

Contact
Victoria Miro, London, England
www.victoria-miro.com

| GERAINT EVANS | ▶ 62

Born 1968 Swansea, Wales
Lives London, England
BA Manchester Polytechnic, England, 1990
Royal Academy Schools, London, England, 1993

Select solo shows
2004 Wilkinson Gallery, London
2003 Berwick Gymnasium Art Gallery, Berwick
 Centro de Arte de Salamanca, Salamanca
2001 Chapter, Cardiff (touring to Glynn Vivian,
 Swansea)
2000 Anthony Wilkinson, London

Select bibliography
2004 Usherwood, P., 'Weekending, Newcastle',
 Art Monthly, 1 Jan
 Lack, J., 'Solo Show: Wilkinson Gallery',
 The Guardian Guide, 24 Jan
2000 Farquharson, A., 'Solo Show, Anthony
 Wilkinson', *Art Monthly*, 1 Sept
 Searle, A., 'So you want to be an artist?
 Get a life', *The Guardian*, 4 Jul
 Kent, S., 'Geraint Evans', *Time Out London*, 28 Jun

Contact
Wilkinson Gallery, London, England
www.wilkinsongallery.com

| ERIC FISCHL | ▶ 70

Born 1948, New York, USA
Lives New York, USA
BFA California Institute for the Arts, USA, 1972

Select solo shows
2005 Jablonka Galerie, Cologne
2004 Fondazione Cassa Di Risparmio in Bologna
 Museum Haus Esters, Krefeld
 Kunstmuseum Wolfsburg, Wolfsburg
2003 Mary Boone Gallery, New York
2002 Mary Ryan Gallery, New York
2001 Jablonka Galerie, Köln

Select bibliography
2004, Yablonsky, L., 'How Far Can You Go?',
 Art News, Jan, pp. 104–09
2003 Eichler, D., 'Eric Fischl: Paintings and
 Drawings 1979–2001', *Modern Painters*, Dec, p. 128
 Gisbourne, M., 'Eric Fischl', *Art Review*,
 Dec, p. 101
 Kino, C., 'Eric Fischl at Mary Boone',
 Art in America, Nov, p. 167
2001 Leffingwell, E., 'Eric Fischl at Mary Boone',
 Art in America, Mar, p. 131
2000 Smith, R., 'Eric Fischl', *The New York Times*,
 15 Dec, p. E41

Contact
Jablonka Galerie, Cologne, Germany
www.jablonkagalerie.com

| LUCIAN FREUD | ▶ 36

Born 1922, Berlin, Germany
Lives London, England
Central School of Arts and Crafts, London,
 England; East Anglian School of Painting
 and Drawing, Dedham, England, 1938–42

Select solo shows
2005 Museo Correr, Venice
2004 Wallace Collection, London
 Acquavella Galleries, New York
2002 Tate Britain, London (retrospective
 touring to Fundacio La Caixa, Barcelona and
 Museum of Contemporary Art, Los Angeles)
2000 Acquavella Galleries, New York

Select bibliography
2005 Freud, L., *Lucian Freud: 1996–2005*,
 Alfred A. Knopf, New York
2004 Hughes, R., 'The master at work',
 The Guardian, 6 Apr
 Gayford, M., 'Captured by Lucian Freud,
 The Daily Telegraph, 2 Aug
2002 Rosenblum, R., 'English channels: Robert
 Rosenblum on Lucian Freud's Constable',
 ArtForum, Sept

Contact
Acquavella Galleries, New York, USA
www.acquavellagalleries.com

| BARNABY FURNAS | ▶ 50

Born 1973, Philadelphia, USA
Lives New York, USA
MFA Columbia University, New York, USA, 2000
BFA School of Visual Arts, New York,
 USA, 1995

Select solo shows
2004 Modern Art Inc., London
2003 Marianne Boesky Gallery, New York
2002 Marianne Boesky Gallery, New York

Select bibliography
2004 Kunitz, D., 'Institutional Exhibitionism',
 The New York Sun, 6 May
 Nichols, M. G., 'Barnaby Furnas: review',
 Art in America, Feb
 Mar, A., 'Barnaby Furnas: review', *The New York
 Sun*, 24 April
2002 Eleey, P., 'Barnaby Furnas', *Frieze*, Sept
 Kantor, J., 'Barnaby Furnas', *Artforum*, Sept

Contact
Marianne Boesky Gallery, New York, USA
www.marianneboeskygallery.com

| ANDREW GUENTHER | ▶ 92

Born 1976, Wheaton Illinois, USA
Lives Brooklyn, New York, USA
MFA Mason Gross School of the Arts,
 Rutgers University, New Brunswick,
 USA, 2000
BFA Lawrence University, Appleton, Wisconsin,
 USA, 1998

Select solo shows
2005 Greener Pastures Gallery Contemporary Art,
 Toronto, Ontario
2004 Perry Rubenstein Gallery, New York
2003 Daniel Silverstein Gallery, New York
2002 Daniel Silverstein Gallery, New York

Select bibliography
2005 Schwabsky, B., *The Triumph of Painting*,
 Random House/Saatchi Gallery, pp. 286–87
2004 Smith, R., 'Colony', *The New York Times*,
 9 Apr, p. E37
2003 Robinson, W., 'New Art Rules at Scope',
 www.artnet.com, 10 Mar
 Dannatt, A., 'Words Ideas and Etymology',
 The Art Newspaper, Mar, Vol. XIII, no. 134, p. 28
2002 Dannatt, A., 'Spelling it Out', *The Art
 Newspaper*, Oct, Vol. XIII, no. 129, p. 33

Contact
Perry Rubenstein Gallery, New York, USA
www.perryrubenstein.com

| JUN HASEGAWA | ▶ 78

Born 1969, Mie, Japan
Lives London, England
BA Goldsmiths College, London, England, 1993–95

Select solo shows
2005 20.21 Galerie Edition Kunsthandel, Essen
2002 Taro Nasu Gallery, Tokyo
2001 Galleria S.A.L.E.S., Rome

Select bibliography
2002, Clark, R., 'Review: Intimacy', *Art Review*,
 Apr, p. 84

Matsui, M., 'Review', *Flash Art*, Mar/Apr, p. 110
Judd, B. and Wood, C., 'Letter from Tokyo',
Art Monthly, Apr, p. 44

Contact
20.21 Galerie, Essen, Germany, *www.2021art.de*

| EBERHARD HAVEKOST | ▶ 154

Born 1967, Dresden, Germany
Lives Dresden and Berlin, Germany
Hochschule für Bildende Künste, Dresden,
 Germany, 1991–96

Select solo shows
2005 Roberts & Tilton Gallery, Los Angeles
 Kunstmuseum Wolfsburg, Wolfsburg
2004 Anton Kern Gallery, New York
 Galerie Gebruder Lehmann, Dresden
2003 White Cube, London
2002 Anton Kern Gallery, New York
2001 Galerie Gebruder Lehmann, Dresden
 Museu Serralves, Porto
 Galerie Johnen + Schottle, Cologne

Select bibliography
2005 Lütgens, A. and Havekost, E., *Eberhard
 Havekost: Harmonie, Bilder/Paintings 1998–2005*,
 Hatje Cantz, Germany
2004 Jordan K., 'The Tuymans Effect', *Artforum*, Nov
2003 Reust, H. R., 'A Test Card for Reality',
 Flash Art, Nov/Dec
2002 Loock, U., 'Eberhard Havekost',
 Flash Art, May/Jun
 Kantor, J., 'New York Critic Picks Eberhard
 Havekost', *Artforum*, May/Jun
2001 Gioni, M., 'Painting at the Edge of the World',
 Flash Art, May/Jun

Contact
Anton Kern, New York, USA
www.antonkerngallery.com

| JOCELYN HOBBIE | ▶ 120

Born 1968, Northampton, USA
Lives New York, USA
BFA Rhode Island School of Design, USA, 1991

Select group shows
No solo shows since 1997 (Jack Tilton, New York)
2005 Bellwether Gallery, New York
2004 K.S. Art, New York
2003 Fish Tank Gallery, Brooklyn, NY
2001 Geoffrey Young Gallery, Great Barrington, MA
2000 Tilton/Kustera Gallery, New York

Select bibliography
2005 Finch, C., 'More More More!', *www.artnet.com*,
 3 Oct
2000 Johnson, K., 'Art in Review', *The New York
 Times*, 29 Dec

Contact
Bellwether, New York, USA
www.bellwethergallery.com

| RIDLEY HOWARD | ▶ 124

Born 1973, Atlanta, USA
Lives Brooklyn, New York, USA
MFA Tufts University/School of the Museum
 of Fine Arts, Boston, USA, 1999
BFA University of Georgia, Athens, USA, 1996

Select solo shows
2005 Zach Feuer Gallery (LFL), New York
2004 Zach Feuer Gallery (LFL), New York
2002 Fredericks Freiser Gallery, New York
2000 Howard Yezerski Gallery, Boston

Select bibliography
2005 Miller, F. K., 'Ridley Howard',
 Tema Celeste, Jul/Aug, p. 70
 Kunitz, D., 'Meet the new folk',
 Art Review, Apr, pp. 44–5
2002 Roth, A., 'Ridley Howard',
 The New Yorker, 7 Oct
 Johnson, K., 'Ridley Howard',
 The New York Times, 4 Oct
2000 Koslow-Miller, F., 'Ridley Howard',
 Artforum, summer, pp. 187–88

Contact
Zach Feuer (LFL), New York, USA
www.zachfeuer.com

| CHANTAL JOFFE | ▶ 40

Born 1969, St Albans, England
Lives London, England
BA Glasgow School of Art, Glasgow, Scotland, 1991
MA Royal College of Art, London, England, 1994

Select solo shows
2005 Victoria Miro Gallery, London
2004 Il Capricorno, Venice
2003 Victoria Miro Gallery, London
2001 Galerie Jennifer Flay, Paris
2001 Monica de Cardenas, Milan

Select bibliography
2005 Hubbard, S., 'Sisters Under the Skin',
 The Independent 13 Dec
 Januszczak, W., 'The picture of health?',
 The Sunday Times, 27 Nov
2004 O'Reilly, S., 'Chantal Joffe: Bloomberg',
 Time Out London, 23–30 Jun
2003 Geldard, R. 'Chantal Joffe: Victoria Miro',
 Time Out London, 23–30 Apr
2001 Ratnam, N., 'Painting is dead: long live
 painting', *The Face*, no. 50, Mar
2000 Burn, G. 'Off the scrapheap',
 The Guardian, 13 Apr

Contact
Victoria Miro, London, England
www.victoria-miro.com

| MIKA KATO | ▶ 26

Born 1975, Mie Prefecture, Japan
Lives Mie, Japan

MFA Aichi Prefectual University of Art, Japan, 2001
BFA Aichi Prefectual University of Art, Japan, 1999

Select solo shows
2005 White Cube, London
2001–02 Contemporary Art Gallery Art Tower
 Mito, Ibaragi
2000 Tomio Koyama Gallery, Tokyo

Select bibliography
2005 Darwent, C., 'Deadpan Dolls', *Modern Painters*,
 Apr, pp. 46–7
2001 Johnson, K., 'West Side: The Armory Show on
 the Pier Just Keeps Growing', *The New York Times*,
 23 Feb
2000 DiPietoro, M., 'True gem in the rough
 of Aichi', *The Japan Times*, 23 Jul

Contact
Tomio Koyama Gallery, Tokyo, Japan
www.tomiokoyamagallery.com

| HENNING KLES | ▶ 88

Born 1970, Hamburg, Germany
Lives Hamburg, Germany
Hochschule für bildende Künste Hamburg,
 Germany, 2000–05
Hochschule für angewandte Wissenschaften, FB
 Gestaltung, Hamburg, Germany, 1993–98

Select solo shows
2005 Arndt & Partner, Zurich
2004 Hamburg Blaue Kugel, Hamburg
2002 Westwerk, Hamburg

Select bibliography
2005 Heinrich, C., 'In den Dämpfen der
 Ludergrube', *Geschichtenerzähler*, pp. 40–3

Contact
Arndt & Partner, Zurich, Switzerland and Berlin
Germany, *www.arndt-partner.de*

| REZI VAN LANKVELD | ▶ 52

Born 1973, Amsterdam, Netherlands
Lives Amsterdam, Netherlands
Jan van Eyck Akadamie, Maastricht, Netherlands,
 1997–99
Gerrit Rietveld Akademie, Amsterdam,
 Netherlands, 1993–97

Select solo shows
2005 The Approach, London
 Diana Stigter Galerie, Amsterdam
2003 The Approach, London
2002 Loerakker Gallery, Amsterdam

Select bibliography
2005 Gronlund, M., 'Rezi van Lankveld', *Frieze*, May
 Hubbard, S., 'Rezi van Lankveld at The
 Approach', *The Independent*, 4 Apr
2003 Higgie, J., 'Rezi van Lankveld', *Frieze*, Oct
 Herbert, M., 'Rezi van Lankveld', *Tema Celeste*,
 no. 99

Contact
The Approach, London, England
www.theapproach.co.uk

| JÖRG LOZEK | ▶ 144

Born 1971, Chemnitz, Germany
Lives Leipzig, Germany
Kunsthochschule, Leipzig, Germany, 1995–2002

Select solo shows
2004 Rhodes + Mann, London
2003 Galerie Binz & Krämer, Cologne
2002 Galerie Liga, Berlin
2001 Objekt Holzmarktstrasse, Berlin
2000 VITA-Haus, Chemnitz

Select bibliography
2005 Politi, G. and Kontova, H., *Prague Biennale Two: Expanded Painting* (Giancarlo Politi Editore)
2004 Hubbard, S., 'Jörg Lozek at Rhodes + Mann', *The Independent*, Sept
 Schmidt, J., 'New Power, New Pictures; Dresden and Leipzig', *Flash Art*, Nov/Dec, no. 239

Contact
Binz & Krämer, Cologne, Germany
www.binz-kraemer.de

| MARTIN MALONEY | ▶ 64

Born 1961, London, England
Lives London, England
University of Sussex, England, 1980–83
London College of Printing, Central Saint Martins College of Art and Design, London, England, 1988–91 (including time at the School of Visual Arts, New York, USA, 1990 and Nova Scotia College of Art and Design, Halifax, Nova Scotia, Canada, 1991)
Goldsmiths Gollege, University of London, England, 1991–93

Select solo shows
2005 Timothy Taylor Gallery, London
 Galerie Xippas, Paris
2004 Xavier Hufkens, Brussels
2003 Gian Ferrari Arte Contemporanea, Milan
2001 Delfina Project Space, London
2000 Anthony d'Offay Gallery, London

Select bibliography
2005 Magnani, G., 'Ricordi di Scuola' *AD*, Jun
 Herbert, M., 'Martin Maloney', *Time Out London*, 15–22 Jun
2001 Freyberg, A., 'Saatchi's favourite 'bad' boy, *The Evening Standard*, 1 May
 de Cruz, G., 'The Artists' Champion', *Art Review*, Apr
 Jones, J., 'Paint misbehaving', *The Guardian*, 17 Apr
2000 Gayford, M., 'Jolly bright, jolly clever and jolly deceptive', *The Daily Telegraph*, 23 Feb

Contact
Timothy Taylor, London, England
www.timothytaylorgallery.com

| MARGHERITA MANZELLI | ▶ 30

Born 1968, Ravenna, Italy
Lives Milan, Italy
Academy of Fine Arts, Ravenna, Italy, 1986–91

Select solo shows
2004 Irish Museum of Modern Art, Dublin
 Art Institute of Chicago, Chicago
2003 Museo Nazionale Delle Arti Del XXI Secolo, Milan
2002 Greengrassi, London

Select bibliography
2004 Madesani, A., 'Margherita Manzelli', *Arte e Critica*, Oct/Dec, p. 68
 Spaid, S., 'Margherita Manzelli', *artUS*, Jun/Aug, pp. 26–7
 Grabner, M., 'Margherita Manzelli', *Art Papers*, Jul/Aug, p. 50
2003 Trimming, L., 'Margherita Manzelli: Greengrassi', *Flash Art*, Jan/Feb, p. 50
2002 Celant, G., 'Limbo Femminile', *L'Espresso*, 20 Jul
2001 Grabner, M., 'Painting at the Edge of the World', *Frieze*, Jun/Aug, p. 117

Contact
Greengrassi, London, England
www.greengrassi.com

| RUI MATSUNAGA | ▶ 86

Born 1968, Ube, Japan
Lives London, England
MA Royal Academy of Arts, London, England, 1999–2002
BA Central Saint Martins College of Art and Design, London, England, 1996–99

Select group shows
No solo shows to date. Group shows have included:
2005 Wooster Projects, New York
 Jerwood Space, London
2004 Liverpool Biennale, Liverpool

Select bibliography
2005 Gleadell, C., 'Academic Brilliance', *The Telegraph Magazine*, 5 Feb
2002 Falconer, M., 'Hot off the Press', *Royal Academy Magazine*, Jun
 'Best of the Graduate Shows', *Art Review*, Jun
 Mullins, C., 'A Royal Revolt', *The Independent on Sunday*, 2 Jun

Contact
The artist can be contacted at
rui.matsunaga@tiscali.co.uk

| DAWN MELLOR | ▶ 72

Born 1970, Manchester, England
Lives London, England
MA Royal College of Art, London, England, 1996
BA Central Saint Martins College of Art and Design, London, England, 1992

Select solo shows
2004 Galerie Drantmann, Brussels
2003 Team Gallery, New York
2002 Galerie Drantmann, Brussels
2001 Victoria Miro Gallery, London
2000 Galerie Drantmann, Brussels
 Galleria Il Caprocorno, Venice

Select bibliography
2003 Smith, R., 'Girls Gone Wild', *The New York Times*, 4 Jul
2002 Turner, G. T., 'Dawn Mellor', *Art in America*, Oct
 Januszczak, W., 'Dawn Mellor', *The Sunday Times: Culture Magazine*, 2 Jun
 Grant, C., 'Dawn Mellor', *Make Magazine*, no. 92
2001 Coomer, M., 'Dawn Mellor', *Time Out London*, 5–12 Dec

Contact
Victoria Miro, London, England
www.victoria-miro.com

| MUNTEAN AND ROSENBLUM | ▶ 76

Markus Muntean born 1962, Graz, Austria
Adi Rosenblum born 1962, Haifa, Israel
Both artists have worked together since 1992
Both artists live in Vienna, Austria and London, England
Both studied at the Academy of Fine Arts, Vienna, Austria

Select solo shows
2005 Maureen Paley, London
2004 Australian Centre for Contemporary Art, Melbourne
 Tate Britain, London
2003 Maureen Paley, London
 Galleria Franco Noero, Turin
2002 Sommer Contemporary Art, Tel Aviv
2001 Georg Kargl, Vienna

Select bibliography
2005 Lafuente, P., 'Pretty Vacant', *Art Review*, Sept, pp. 74–7
2004 'Untitled (Silent Sighs…)', *Dazed & Confused*, Aug, pp. 88–9
 Renton, A., 'New blood on the walls', *The Evening Standard*, 24 Feb
 Jones, J., 'Muntean/Rosenblum', *The Guardian*, 26 Apr
2003 Herbert, M., 'Muntean/Rosenblum', *Art Monthly*, Jun
2002 Grosenick, U. and Riemschneider, B., *Art Now*, pp. 316–19
2001 Wood, C., 'Muntean/Rosenblum', *Art Monthly*, Jul/Aug

Contact
Maureen Paley, London, England
www.maureenpaley.com

| WANGECHI MUTU | ▶ 110

Born 1972, Nairobi, Kenya
Lives New York, USA
BFA Cooper Union for the Adavancement
 of the Arts and Sciences, New York,
 USA, 1996
MFA Yale University, New Haven, USA, 2000

Select solo shows
2005 Miami Art Museum, Miami
 Susanne Vielmetter Los Angeles Projects,
 Los Angeles
2003 Susanne Vielmetter Los Angeles Projects,
 Los Angeles
 Jamaica Center for the Arts and Learning,
 Queens, New York

Select bibliography
2005 Lo, M., 'Wangechi Mutu', *Flash Art*, May/Jun
 Harrison, S., 'Pin-up', *Art Monthly*, Feb
 Brielmaier, I., 'Wangechi Mutu: Re-Imagining
 The World', *Parkett*, no. 74, pp. 6–13
 Lo, M., 'Wangechi Mutu', *Flash Art*, May/Jun,
 no. 242, p. 146
 Ciuraru, C., 'Cutting Remarks', *Art News*, Nov
 Muhammad, D. E., 'Body Politic', *Art Review*, Sept
 Kerr, M., 'Extreme Makeovers – Wangechi Mutu
 creates collages of fantastical creatures,
 Art on Paper, Jul/Aug, p. 28–9
2004 Muhammad, E. D., 'Body Politic',
 Art Review, Sept
 Martin, C., 'Looking Both Ways', *Flash Art*,
 Jan/Feb
2003 Pagel, D., 'Harrowing, hallucinatory visions:
 Wangechi Mutu at Susanne Vielmetter Los
 Angeles Projects', *The Los Angeles Times*, 24 Oct

Contact
Susanne Vielmetter Los Angeles Projects
Los Angeles, USA, *www.vielmetter.com*

| CHRIS OFILI | ▶ 112

Born 1968, Manchester, England
Lives London, England
MA Royal College of Art, London, England, 1993
BA Chelsea School of Art, London, England, 1991

Select solo shows
2005 Tate Britain, London
 The Studio Museum in Harlem, New York
 Contemporary Fine Arts, Berlin
2003 British Pavilion, Venice Biennale, Venice
2002 Victoria Miro Gallery, London
2001 Gallery Side 2, Tokyo
2000 Victoria Miro Gallery

Select bibliography
2005 Searle, A. 'Ofili: the blue period',
 The Guardian, 22 Nov
 Dorment, R., 'Like nothing you've ever
 seen before', *The Daily Telegraph*, 20 Sept
 Lubbock, T., 'Been there, dung that',
 The Independent, 19 Sept
 Vogel, C., 'An Artist's Gallery of Ideas',
 The New York Times, 5 May

2003, Dorment, R., 'The Chosen One',
 The Telegraph Magazine, 14 Jun
2002 *The Upper Room*, Victoria Miro, London,
 Satz, A., 'Chris Ofili Profile', *Tema Celeste*, Autumn
 Lubbock, T., 'Monkey Business',
 The Independent, 9 Jul
 Jones, J., 'Paradise Reclaimed', *The Guardian
 Weekend Magazine*, 15 Jun

Contact
Victoria Miro, London, England
www.victoria-miro.com

| YAN PEI-MING | ▶ 46

Born 1960, Shanghai, China
Lives Dijon, France
Villa Medicis, Academie de France, Rome, Italy,
 1993–94
L'Institut des Hautes Etudes en Arts Plastiques,
 Paris, France, 1988–89

Select solo shows
2004–05 Kunsthalle, Mannheim
2004 Galerie Rodolphe Janssen, Brussels
 Galerie Anne de Villepoix, Paris
 Neuer Kunstverein, Aschaffenburg
2003 Musée des Beaux-Arts, Dijon
 Musée des Beaux-Arts, Besançon
 Frac Champagne-Ardenne/Le Collège, Reims
2002 Galerie Bernier/Eliades, Athens
2001 Galerie Max Hetzler, Berlin
 Galerie Art & Public, Geneva

Select bibliography
2005 Pei-Ming, Y., *Hommage à mon père*, Dijon-
 Shanghai-Guangdong, Fine Arts Popular Editions
 of Shanghai and Les Presses du réel, Dijon
2004 *The Way of the Dragon*, Galerie Anne de
 Villepoix, Paris
2003 Pei-Ming, Y., *The Way of the Dragon*,
 Les presses du réel, Dijon)

Contact
Galerie Rodolphe Janssen, Brussels, Belgium
www.galerierodolphejanssen.com

| BÉNÉDICTE PEYRAT | ▶ 172

Born 1967, Paris, France
Lives Paris, France and Karlsruhe, Germany
Académie de Port-Royal, Paris, France, 1985–88

Select solo shows
2005 Thomas Rehbein, Cologne,
2004 SWR Galerie, Stuttgart
 Herrenhaus Edenkoben, Edenkoben
2003 Schloss Izards, Périgueux
 Laden Nr. 5, Bad Ems

Select bibliography
2005 Bénédicte Peyrat, Galerie Michael Schultz,
 Berlin
2003 Gallwitz, K. (ed.), *Bénédicte Peyrat*,
 Künstlerhaus Schloss Balmoral

Contact
Thomas Rehbein Galerie, Cologne, Germany
www.rehbein-galerie.de

| ELIZABETH PEYTON | ▶ 74

Born 1965, Danbury, USA
Lives New York, USA
BFA School of Visual Arts, New York, USA, 1984–87

Select solo shows
2005 Sadie Coles HQ, London
2004 Gavin Brown's enterprise, New York
2003 Neugerriemschneider, Berlin
 The Wrong Gallery, New York
 Regan Projects, Los Angeles
2002 Sadie Coles HQ at the Royal Academy
 of Art, London
2001 Deichtorhallen, Hamburg

Select bibliography
2005 Higgs, M., *Elizabeth Peyton*, Rizzoli, New York
2003 Bonami, F. and Simons, R. (eds), *The Fourth
 Sex: Adolescent Extremes*, Pitti Imagine Discovery
 and Charta, Milan
 Morton, T., 'Elizabeth Peyton', *Frieze*, May, p. 87
2002 Peyton, E., 'Artist Project', *Tate Magazine*,
 Sept/Oct, pp. 64–72
 Gingeras, A., *Vitamin P*, Phaidon, London
 and New York
2001 Peyton, E. (ed) *Prince Eagle: An Artist's
 Book*, Powerhouse Books/Thea Westreich,
 New York

Contact
Sadie Coles HQ, London, England
www.sadiecoles.com

| NEO RAUCH | ▶ 140

Born 1960, Leipzig, Germany
Lives Leipzig, Germany
Hochschule für Grafik und Buchkunst, Leipzig,
 Germany, 1981–90

Select solo shows
2005 David Zwirner, New York
 Centro de Arte Contemporáneo Malága, Malaga
 The Leipziger Volkszeitung Collection, Academy
 of Arts, Honolulu
2004 Albertina, Vienna
2003 St Louis Art Museum, St Louis, Missouri
2002 David Zwirner, New York
2001 Sammlung Deutsche Bank, Mannheimer
 Kunstverein, Mannheim
2000 Museum Galerie für Zeitgenössische Kunst,
 Leipzig (touring to Munich and Zurich)

Select bibliography
2005 Verwoert, J., 'Neo Rauch', *Frieze*, Oct, p. 211
 Volk, G., 'Figuring the New Germany',
 Art in America, Jun/Jul, pp. 154–59, 197
2004 Burton, J., 'Fabulism', *Artforum*, Jan, p. 62
2002 Gingeras, A., 'Neo Rauch: A Peristaltic
 Filtration System in the River of Time',
 Flash Art, Nov/Dec, pp. 66–69

2001 Girst, T., 'The Parallel Universe of Neo
 Rauch', *Tema Celeste*, Summer, pp. 60–3

Contact
David Zwirner, New York, USA
www.davidzwirner.com

| DANIEL RICHTER | ▶ 94

Born 1962, Entin, Germany
Lives Berlin and Hamburg, Germany
Hochschule der Bildenden Künste, Hamburg,
 Germany, 1991–95

Select solo shows
2005 Contemporary Fine Arts, Berlin
 Hamburger Kunsthalle, Hamburg
2004 David Zwirner, New York
 The Power Plant, Toronto, Ontario (touring to
 Morris and Helen Belkin Art Gallery, Vancouver)
2003 Galerie Benier/Eliades, Athens
2002 K21 Kunstsammlung Nordrhein-Westfalen,
 Düsseldorf
2001 Patrick Painter Inc., Los Angeles
 Kunsthalle zu Kiel, Kiel
2000 Contemporary Fine Arts, Berlin
 Gesellschaft für Aktuelle Kunst, Bremen

Select bibliography
2005 'Kunstpause mit Daniel Richter',
 Monopol, Oct/Nov, pp. 90–1
2004 Kealy, S., 'Daniel Richter, The Morris & Helen
 Belkin Art Gallery', *Flash Art*, Nov/Dec, p. 121
 Rubinstein, R., 'Allegories of Anarchy',
 Art in America, Dec, p. 120–23
2002 Diederichsen, D., 'Why I'm not a
 Conservative', *Modern Painters*, Vol. 15, no. 4,
 Winter, pp. 79–83
2000 Romano, G., 'Daniel Richter: Beauty
 Through Confusion', *Flash Art*, no. 213,
 Summer, pp. 82–4

Contact
David Zwirner, New York, USA
www.davidzwirner.com

| JAMES RIELLY | ▶ 66

Born 1956, Wrexham, Wales
Lives and works in France
Belfast College of Art, Belfast, Northern Ireland,
 1980–81
Gloucester College of Art & Design, Cheltenham,
 England, 1975–78

Select solo shows
2005 Timothy Taylor Gallery, London,
2004 Galeria Ramis Barquet, New York
 Galeria DV, San Sebastián
2002 Centro de Arte de SalamancaFond
 Regional d'Art Contemporain Auvergne,
 Clermont-Ferrand
2001 Timothy Taylor Gallery, London
 Spencer Brownstone Gallery, New York

Select bibliography
2005 Honigman, A. F., 'James Rielly',
 Tema Celeste, Jun, p. 83
 MacMillan, I., 'Black is the colour',
 Modern Painters, Mar, pp. 82–5
 Exley, R., 'James Rielly', *Flash Art*, Mar/Apr, p. 57
2004 Cohen, D., 'Gallery-going', *The New York Sun*,
 7 Oct
2003 Hubbard, S., 'James Rielly at
 Timothy Taylor Gallery', *The Independent*,
 18 Mar, p. 13
2001 Buck, L., 'Pitching and Catching at Lisson',
 The Art Newspaper, Sept

Contact
Timothy Taylor, London, England
www.timothytaylorgallery.com

| CHRISTOPH RUCKHÄBERLE | ▶ 118

Born 1972, Pfaffenhofen, Germany
Lives Leipzig, Germany
BFA Hochschule für Grafik und Buchkunst,
 Leipzig, Germany, 2000
MFA Hochschule für Grafik und Buchkunst,
 Leipzig, Germany, 2002

Select solo shows
2005 Galerie Kleindienst, Leipzig
 Galleri Nicolai Wallner, Copenhagen
2004 LFL Gallery, New York
 Sutton Lane, London
 Galleri Nicolai Wallner, Copenhagen
2003 LIGA Gallery, Berlin
2002 Galerie Kleindienst, Leipzig

Select bibliography
2005 Marsh, A., 'Christoph Ruckhäberle:
 Sutton Lane', *Flash Art*, Jan/Feb
 Volk, G., 'Figuring the New Germany',
 Art in America, Jun/Jul
2004 Egan, M., 'Neue School', *The New York Times
 Style Magazine*, Autumn 2004, pp. 126, 128
 Volk, G., 'Figuring the New Germany',
 Art in America, Jun/Jul
 Johnson, K., 'Christoph Ruckhäberle',
 The New York Times, 16 Jul
 Price, M., 'Mixed Paint: Christoph Ruckhäberle',
 Flash Art, Nov/Dec
 Ribas, J., 'Debut: Christoph Ruckhäberle',
 Art Review, Sept

Contact
Zach Feuer Gallery (LFL), New York, USA
www.zachfeuer.com

| CHÉRI SAMBA | ▶ 134

Born 1956, Kinto-M'Vuila, DR Congo
Lives Kinshasa, DR Congo

Select solo shows
2005 Southern University, Houston, USA
 Kunstverein Braunschweig, Braunschweig
2004 Fondation Cartier pour l'art
 contemporain, Paris

2003 Galerie Peter Herrmann, Berlin
 Musée Royal de l'Afrique, Tervuren
2000 Centre Culturel de Zoo, Kinshasa
Select bibliography
2005 Grässlin, K., Les débuts de Chéri Samba,
 Kunstverein Braunschweig
2002 Blackmun Visona, M. et al., A *History of
 Art in Africa*, Prentice Hall Inc. and Harry
 N. Abrams, Inc.

Contact
Gallerie Peter Hermann, Berlin, Germany
www.galerie-herrmann.com

| WILHELM SASNAL | ▶ 152

Born 1972, Tarnow, Poland
Lives Tarnow, Poland
Painting, Academy of Fine Arts, Kraków,
 Poland, 1994–99
Architecture, Polytechnic, Kraków,
 Poland, 1992–94

Select solo shows
2005 MATRIX Program for Contemporary Art
 The Berkeley Art Museum, Berkeley
 Anton Kern Gallery, New York
2004 Hauser & Wirth, Zurich
 Anton Kern Gallery, New York
 Camden Arts Centre, London
2003 Sadie Coles HQ, London
 MUHKA, Antwerp
 Kunsthalle Zurich, Zurich
2002 Galerie Johnen & Schöttle, Cologne
 Foksal Gallery Foundation, Warsaw
2001 Galeria Raster, Warsaw

Select bibliography
2004 Kantor, J., 'The Tuymans Effect',
 Artforum, Nov
 Dailey, M., 'Painting Recording/Malerei
 als Aufzeichnung', *Parkett*, May
 Szymaczyk, A., 'Sludge/Schlamm', *Parkett*, May
 Jansen, G., 'Petite Sensation', *Parkett*, May
 Wilhelm S., *Night Day Night*, Hatje Cantz,
 Germany

Contact
Anton Kern Gallery, New York, USA
www.antonkerngallery.com

| JENNY SAVILLE | ▶ 32

Born 1970, Cambridge, England
Lives Sicily, Italy
BA Glasgow School of Art, Scotland, 1989–92

Select solo shows
2005, Gagosian Gallery, New York
 Museo d'Arte Contemporanea Roma, Rome
2004 Gagosian Gallery, London
 University of Massachusetts Amherst,
 East Gallery
2003 Gagosian Gallery, New York
2001 C&M Arts, New York

Select bibliography
2003 Roberts, A., 'The female gaze: Jenny Saville',
 The Observer, 20 Apr
2003 Murphy, A., 'An obsession with bodily
 extremes', *The Sunday Telegraph*, 3 Sept
 Darwent, C., 'Jenny Saville', *Modern Painters*,
 Summer

Contact
Gagosian Gallery, New York and Los Angeles, USA
and London, England
www.gagosian.com

| DANA SCHUTZ | ▶ 128

Born 1976, Livonia, Michigan, USA
Lives Brooklyn, New York, USA
MFA Columbia University, New York, USA, 2002
BFA Cleveland Institute of Art, Cleveland,
 USA, 2000

Select solo shows
2005 Site Santa Fe, Santa Fe, New Mexico
 Contemporary Fine Arts, Berlin
2004 JCCC/Nerman Museum of Contemporary
 Art, Overland Park, Kansas
 Zach Feuer Gallery (LFL), New York
2003 Galerie Emmanuel Perrotin, Paris
 Mario Diacono Gallery, Boston
2002 Zach Feuer Gallery (LFL), New York

Select bibliography
2005 'Dana Schutz', *Parkett*, no. 75, pp. 26–64
2004 Dailey, M., 'Laying It On Thick', *Artforum*,
 Apr, pp. 138–41
 Halley, P., 'Dana Schutz', *Index Magazine*,
 Feb/Mar, pp. 30–5
 Smith, R., 'Dismemberment as Motif in a Study
 of Mayhem', *The New York Times*, 6 Dec
2003 Cotter, H., 'Art in Review: Dana Schutz',
 The New York Times, 3 Jan, p. E42
 Eleey, P., 'Dana Schutz: LFL Gallery, New York',
 Frieze, no. 73, Mar, p. 97

Contact
Zach Feuer Gallery (LFL), New York, USA
www.zachfeuer.com

| RAQIB SHAW | ▶ 108

Born 1974, Calcutta, India
Lives London, England
BA Central Saint Martins College of Art
 and Design, London, England, 1998–2001
MA Central Saint Martins College of Art
 and Design, London, England, 2002

Select solo shows
2005 Deitch Projects, New York
2004 Victoria Miro Gallery, London

Select bibliography
2005 Goodbody, B. L., 'Raqib Shaw', *Time Out
 New York*, 22–28 Sept
 Cotter, H., 'Raqib Shaw', *The New York
 Times*, 30 Sept
2004 Dyer, R., 'Raqib Shaw in conversation with
 Richard Dyer', *Wasafiri*, no. 42, Summer
 Williams, E., 'Raqib Shaw', *Tema Celeste*, Jun
 Exley, R., 'Raqib Shaw', *Flash Art*, no. 236,
 May/Jun
 Geland, R., 'Raqib Shaw: Victoria Miro Gallery',
 Time Out London, 3 Mar

Contact
Victoria Miro, London, England
www.victoria-miro.com

| MARI SUNNA | ▶ 48

Born 1972, Espoo, Finland
Lives Finland
MA Chelsea College of Art and Design, London,
 England, 1999–2000
Free Art School, Helsinki, Finland, 1994–98
Lahti Design Institute, Lahti, Finland, 1989–94

Select solo shows
2004 The Approach, London
2002 Finsk–Norsk Kulturinstitutt
 Galerie Anhava, Helsinki
2001 The Approach, London
 Galerie Anhava, Helsinki

Select bibliography
2004 *On Reason and Emotion*, Sydney Biennale 2001
 Currah, M., 'Mari Sunna', *Time Out London*,
 26 Sept–3 Oct
2002 *Mari Sunna*, Galerie Anhava, Helsinki
 Mari Sunna, The Approach, London

Contact
The Approach, London, England
www.theapproach.co.uk

| NEAL TAIT | ▶ 156

Born 1965, Edinburgh, Scotland
Lives London, England
MA Royal College of Art, London, England,
 1991–93
BA Chelsea College of Art, London,
 England, 1987–91

Select solo shows
2005 Sies + Höke Galerie, Düsseldorf
2004 Sies + Höke Galerie, Düsseldorf
 Monica de Cardenas, Milan
2003 White Cube, London
2002 Douglas Hyde Gallery, Dublin
 Sies + Höke Galerie, Düsseldorf
2000 White Cube, London

Select bibliography
2005 Jameson, C., 'Düsseldorf: Sies + Höke.
 Neal Tait', *Contemporary*, 15 May,
 no.72, p. 67
2003 Mullins, C., 'Neal Tait at White Cube',
 Art in America, Oct, no. 10
 Guner, F,. 'Neal Tait. The Burnished Ramp',
 Modern Painters, Autumn, p. 116
 Higgie, J., 'Private Lives', *Frieze*, Jun/Jul/Aug
 Mac Giolla Léith, C., *Neal Tait. The Burnished
 Ramp*, Jay Jopling/White Cube, London
2002 Hutchinson, J. and Pakesch, P., *Neal Tait*,
 Douglas Hyde Gallery, Dublin Burgi, B. and
 Pakesch, P., *Painting on the Move*, Kunstmuseum
 Basel, Kunsthalle Basel

Contact
White Cube, London, England
www.whitecube.com

| AYA TAKANO | ▶ 106

Born 1976, Saitama, Japan
Lives Kyoto, Japan
BA Tama Art University, Tokyo, Japan, 2000

Select solo shows
2005 Blum & Poe, Los Angeles
2004 Museum of Contemporary Art, Los Angeles
2003 Galerie Emmanuel Perrotin, Paris
2002 nanogalerie, Paris
2000 NADiff, Tokyo

Select bibliography
2005 Demir, A. 'Art et mode: du mécénat au
 marketing', *Le Journal des Arts*, 21 Jan, pp. 11–12
 Jana, R., 'Cute d'etat', *Time Out New York*,
 28 Apr– 28 May, pp. 73–4
2004 Bellafante, G., 'The Frenchwoman, In All Her
 Moods', *The New York Times*, 5 Mar, p. B9

Contact
Blum & Poe, Los Angeles, USA
www.blumandpoe.com

| DJAMEL TATAH | ▶ 80

Born 1959, Saint-Chamond, France
Lives Paris, France
Ecole des beaux-arts de Saint-Etienne,
 France, 1981–86

Select solo shows
2005 Musée d'Art Contemporain Lyon, Lyon
2004 JGM Galerie, Paris
 Chapelle Saint-Martin de Méjean, Arles
2002 Galerie Liliane & Michel Durand-Dessert,
 Paris
 Centre d'Art de Salamanque, Salamanque
 Centre d'Art de Valladolid, Vallladolid
2001 Galerie Confluence(s) IUFM, Lyon

Select bibliography
2005 Dagen, P., 'A Lyon, trois expositions
 exemplaires de la scène francaise de l'art actuel',
 Le Monde, 30 Jun
2004 Dagen, P., 'Djamel Tatah et ses visages
 obsessionnels', *Le Monde*, 3 Jun
2002 Fulchéri, F., 'Djamel Tatah',
 Le journal des arts, 3–16 May
 Maldonado, G., 'Djamel Tatah', *Artforum*, Oct
 Verhargen, E., 'La peinture solitaire de Djamel
 Tatah', *Art press*, Oct
 Piguet, P., 'Une figuration abstraite',
 Art absolument, Dec

Contact
Liliane & Michel Durand-Dessert, Paris, France,
lm.durand-dessert@wanadoo.fr

| LUC TUYMANS | ▶ 150

Born 1958, Mortsel, Belgium
Lives Antwerp, Belgium
Sint-Lukasinstituut, Brussels, Belgium, 1976–79
Ecole Nationale Supérieure des Arts Visuels de la
 Cambre, Brussels, Belgium, 1979–80

Select solo shows
2005 Compton Verney House Trust, Warwickshire
 Zeno X Gallery, Antwerp
2004 Tate Modern, London (touring to Düsseldorf)
 Museo Tamayo, Mexico City
2003 Kunstverein Hannover, Hannover
 Pinakothek der Moderne, Munich
 Kunstmuseum, St Gallen
 Helsinki Kunsthalle, Helsinki
 2002 Zeno X Gallery, Antwerp
2001 White Cube, London
 Belgian Pavilion, Venice Biennale, Venice

Select bibliography
2005 Saltz, J., 'The Richter Resolution',
 Modern Painters, Apr
2004 Drolet, O., 'Luc Tuymans: The Truth
 of the Matter' *Flash Art*, no. 235, Mar/Apr
 Mullins, C., 'Canvassing Opinion',
 The Financial Times, 22 May
 Tuymans, L., 'Adrian Searle, Pauline
 Olowska, Peter Doig and Chris Ofili talk
 about Luc Tuymans', *Tate Etc.*, no. 1, Summer
2003 Smith, R., 'Luc Tuymans' *The New
 York Times* 9 May
2001 Birnbaum, D., 'More is Less', *Artforum*, Sept
 Herbert, M., 'Luc Tuymans', *Tema Celeste* Nov/Dec

Contact
Zeno X Gallery, Antwerp, Belgium
www.zeno-x.com

| NICOLA TYSON | ▶ 42

Born 1960, London, England
Lives New York, USA
MA Central Saint Martins College of Art and
 Design, London, England, 1989
BA Central Saint Martins College of Art and
 Design, London 1980–81 and Chelsea School
 of Art, London, England, 1979–80

Select solo shows
2005, Douglas Hyde Gallery, Dublin
 Sadie Coles HQ, London
 Friedrich Petzel Gallery, New York
2003 Friedrich Petzel Gallery, New York
 Galerie Nathalie Obadia, Paris
2002 Friedrich Petzel Gallery, New York
2001 Galeria Camargo Vilaca, Sao Paolo

Select bibliography
2005 Searle, A., *Nicola Tyson*, Douglas Hyde Gallery,
 Dublin and Sadie Coles HQ, London

2004 Grassner, H., 'Preface', *Moving energies # 021*,
 Museum Folkwang, Essen
2002 Cotter, H., 'Nicola Tyson', *The New York
 Times*, 24 May, p. E37
2001 Krajewski, S., 'Extended Review: Blurry
 Lines, John Michael Kohler Center for the Arts',
 New Art Examiner, Mar, p. 47

Contact
Sadie Coles HQ, London, England
www.sadiecoles.com

| RICHARD WATHEN | ▶ 170

Born 1971, London, England
Lives London, England
BA Winchester School of Arts, Winchester,
 England, 1995
MA Chelsea School of Art, London, England, 1996

Select solo shows
2005 Salon 94, New York
2004 MW Projects, London

Select bibliography
2005 Smith, R., 'Making An Entrance At Any Age',
 The New York Times, 6 May, pp. 26–7
 Mulholland, N., 'Expander', *Frieze*, no. 88,
 Jan/Feb, p. 125
2004 Coomer, M., 'Unpeacable Kingdom: MW
 Projects', *Time Out London*, 26 May–2 Jun, p. 50
2003 O'Reilly, S., 'Selected Paintings', *Frieze*,
 no. 79, Nov, pp. 105–6
2002 Guner, F., 'Guns and Roses',
 Metro, 10 Jul, p. 1

Contact
Max Wigram Gallery, London, England
www.maxwigram.com

| MATHEW WEIR | ▶ 166

Born 1977, Ipswich, England
Lives London, England
MA Royal College of Art, London, England,
 2002–04
BA Hons Fine Art Winchester School of Art,
 Winchester, England, 1995–96

Select solo shows
2005 Emily Tsingou Gallery, London
2004 Roberts & Tilton, Los Angeles

Select bibliography
2005 Coomer, M., 'A Violet from Mother's Grave',
 Time Out, 27 Jul–3 Aug
 Searle, A., 'Don't Look Now', *The Guardian*, 18 Jul
 Morton, T., 'Mathew Weir', *Frieze*, May
2004 Burnett, C., 'Breaking God's Heart',
 Frieze, Mar
 Vincent, M., 'Bloomberg New Contemporaries',
 Art Monthly, Sept
 Charlesworth, J. J., ' Fever: New Painting in
 London', *Flash Art*, Nov/Dec

Contact
Emily Tsingou Gallery, London, England
www.emilytsingougallery.com

| ZHANG XIAOGANG | ▶ 160

Born 1958, Kunming, Yunnan province, China
Lives Beijing, China
BA Sichuan Academy of Fine Arts, Chongqing,
 China, 1982

Select solo shows
2004 Hong Kong Arts Centre, Hong Kong
2000 Max Protetch Gallery, New York

Select bibliography
2005 Barboza, D., 'A Chinese Painter's
 New Struggle: To Meet Demand', *The New
 York Times*, 31 Aug
2001 Lovelace, C., 'Xiaogang at Max Protetch',
 Art in America, 1 Mar

Contact
Chinese Contemporary, London, England
www.chinesecontemporary.com

| LISA YUSKAVAGE | ▶ 38

Born 1962, Philadelphia, USA
Lives New York, USA
MFA Yale School of Art, New Haven, USA, 1986
BFA Tyler School of Art, Temple University,
 Philadelphia, USA, 1984

Select solo shows
2004 Greengrassi, London
2003 Marianne Boesky, New York
2002 Greengrassi (at The Galleries Show,
 Royal Academy), London
2001 Studio Guenzani, Milan
 Centre d'Art Contemporain, Geneva
 Marianne Boesky, New York

Select bibliography
2004 Higgie, J., 'Women on the Verge',
 Frieze, Oct
 Kastner, J., 'Deviation standard: Jeffrey Kastner
 on SITE Santa Fe', *Artforum*, May
 Landi, A., 'Disturbing Beauty',
 ARTnews, Jan
2003 Boucher, B., 'Lisa Yuskavage',
 Flash Art, Oct
2002 Holmes, P., 'The Royal Treatment',
 Art and Auction, Oct
 Smiley, J., 'Just Like a Woman',
 Harper's Bazaar, Jan
2001 Lovelace, C., 'Lisa Yuskavage: Fleshed Out',
 Art in America, Jul, p. 80–5
 Gilmore, J., 'Lisa Yuskavage',
 Tema Celeste, Mar/Apr

Contact
David Zwirner, New York, USA
www.davidzwirner.com

Select Bibliography

Select bibliographies for all the artists featured in the book can be found under individual biographies.

Adams, B., 'Picabia: the new paradigm', *Art in America*, March 2003

Barthes, R., *Camera Lucida: Reflections on Photography*, Flamingo, 1984 (originally published as *La Chambre Claire*, Editions du Seuil, 1980)

Baudrillard, J., *The Ecstasy of Communication*, Semiotext(e), 1987 (originally published as *L'Autre par lui-même*, Editions Galilée, 1987)

Bell, J., *What is Painting? Representation and Modern Art*, Thames & Hudson, 1999

Biesenbach K. et al., *Greater New York* (exh. cat.), PS1, 2005

Bois, Y. A., *Painting as Model*, The MIT Press, 1990

Brilliant, R., *Portraiture*, Reaktion Books, 1991

Byatt, A. S., *Portraits in Fiction*, Chatto & Windus, 2000

Bürgi, B. M. et al., *Painting on the Move* (exh. cat.), Kunstmuseum/Kunsthalle Basel, 2002

Charlesworth, J. J., *We Have Left the City Gates* (exh. cat.), The Nunnery, 2005

Crimp, D., *On the Museum's Ruins*, The MIT Press, 1993

Darwent, C., 'Absence Minded', *Art Review*, April 2005

Elkins, J., *The Master Narratives and their Discontents*, Routledge, 2005

Elkins, J., *What Painting Is*, Routledge, 2000

Ferguson, R., *The Undiscovered Country*, Armand Hammer Museum of Art, Los Angeles, 2004

Fogle, D. (ed.), *Painting at the edge of the world* (exh. cat.), Walker Art Center, Minneapolis, 2001

Foster, H. (ed.), *Postmodern Culture*, Bay Press, 1983 (reprinted by Pluto Press, 1985)

Foster, H., *The Return of the Real*, The MIT Press, 1996

Gianelli, I. (ed.), *Transavantgardia* (exh. cat.), Castello di Rivoli Museo d'Arte, 2002

Gingeras, A. M. et al., *Cher Peintre* (exh. cat.), Centre Georges Pompidou, 2002

Gombrich, E., *Art & Illusion: A study in the psychology of pictorial representation*, Phaidon, 1960

Harrison, C. and Wood, P., *Art in Theory*, Blackwell, 1992

Hoptman, L. et al., *2004 Carnegie International* (exh. cat.), Carnegie Museum of Art, 2004

Hutchinson, J. et al., *Huts* (exh. cat.), The Douglas Hyde Gallery, Dublin, 2005

Iles, C. et al., *Whitney Biennial 2004* (exh. cat.), Whitney Museum of American Art, 2004

Joachimides, C. M. (ed.), *New Spirit in Painting: The Catalogue of the Royal Academy Exhibition*, Weidenfeld Nicolson Illustrated, 1981

Kantor, J., 'The Tuymans Effect', *Artforum*, November 2004

Kent, S. et al., *Young British Art: The Saatchi Decade*, Booth-Clibborn Editions, 1999

Krauss, R. E., *The Originality of the Avant-Garde and Other Modernist Myths*, The MIT Press, 1986

Lewis-Williams, D., *The Mind in the Cave*, Thames & Hudson, 2002

Maloney, M. et al., *Die Young Stay Pretty* (exh. cat.), Institute of Contemporary Arts, 1998

Myers, T. R., 'Little Boy Boom: Takashi Murakami and his protégés invade New York', *Modern Painters*, April 2005

Price, D., *The New Neurotic Realism* (exh. cat.), Saatchi Gallery, 1998

Rorimer, A., *New Art in the 60s and 70s: Redefining Reality*, Thames & Hudson, 2001

Rosenthal, N., *Sensation: Young British Artists from the Saatchi Collection* (exh. cat.), Royal Academy, London, 1987

Saltz, J., 'The Richter Resolution', *Modern Painters*, April 2005

Schwabsky, B., *The Triumph of Painting: The Saatchi Gallery*, Jonathan Cape, 2005

Schwabsky, B. et al., *Vitamin P: New Perspectives on Painting*, Phaidon, 2002

Sontag, S., *On Photography*, Penguin, 1979

Steadman, P., *Vermeer's Camera*, Oxford University Press, 2002

Storr, R., *Gerhard Richter: Doubt and Belief in Painting*, Museum of Modern Art, New York, 2003

Tuchman, M. and Eliel, C. S., *Parallel Visions: Modern Artists and Outsider Art* (exh. cat.), Princeton University Press, 1992

Tusa, J., *On Creativity*, Methuen, 2004

Weatherford, M. (ed.), *Cave Painting: Peter Doig, Chris Ofili and Laura Owens*, Santa Monica Museum of Art, 2002

Woodall, J. (ed.), *Portraiture: Facing the subject*, Manchester University Press, 1997

List of Illustrations

p. 42 (r) Nicola Tyson, *Portrait No. 47*, 2003. Acrylic on paper, 50.8 x 35.6 cm (20 x 14 in). © the artist. Courtesy Sadie Coles HQ, London

p. 43 Nicola Tyson, *Figure with Arm Extended*, 2004. Oil on linen, 147.3 x 116.8 cm (58 x 46 in). © the artist. Courtesy Sadie Coles HQ, London

p. 44 Marlene Dumas, *The Blindfolded*, 2002. Oil on canvas, 3 panels. Each panel 130 x 110 cm (51 3/16 x 43 5/16 in). Hauser & Wirth Collection, Switzerland. Photo Ben Cohen. Courtesy Zwirner and Wirth, New York

p. 45 (a) Marlene Dumas, *Lucy*, 2004. Oil on canvas, 110 x 130 cm (43 3/4 x 51 1/4 in). Photo Rupert Steiner. Courtesy Frith Street Gallery, London

p. 45 (b) Marlene Dumas, *Stern*, 2004. Oil on canvas, 110 x 130 cm (43 3/4 x 51 1/4 in). Photo Rupert Steiner. Courtesy Frith Street Gallery, London

p. 46 (l) Yan Pei-Ming, *Self Portrait*, 2005. Oil on linen, 350 x 350 cm (137 3/4 x 137 3/4 in). Courtesy the artist

p. 46 (a) Yan Pei-Ming, *Petite Mendiante*, 2005. Oil on linen, 300 x 300 cm (118 1/16 x 118 1/16 in). Courtesy the artist

p. 46 (b) Yan Pei-Ming, *Pope Jean-Paul II*, 2005. Oil on linen, 300 x 300 cm (118 1/16 x 118 1/16 in). Courtesy the artist

p. 47 Yan Pei-Ming, *Mao Zedong's Remains*, 2002. Oil on linen, 150 x 300 cm (59 x 118 1/8 in). Courtesy the artist

p. 48 Mari Sunna, *Make it Double*, 2004. Oil on board, 150 x 110 cm (59.1 x 43.3 in). Courtesy The Approach, London

p. 49 (a) Mari Sunna, *Embrace*, 2004. Oil on board, 85 x 90 cm (33.5 x 35.4 in). Courtesy The Approach, London

p. 49 (b) Mari Sunna, *One No One*, 2005. Ink on paper, 29 x 27 cm (11 1/2 x 10 1/2 in). Photo Jussi Tiainen. Courtesy Galerie Anhava, Helsinki

p. 50 (l) Barnaby Furnas, *Untitled (Execution)*, 2003. Watercolour and ink on paper, 63.5 x 50.8 cm (25 x 20 in). Courtesy of Marianne Boesky Gallery

p. 50 (r) Barnaby Furnas, *John Brown*, 2004. Mixed media on linen, 168 x 127 cm (66 x 50 in). Courtesy of Marianne Boesky Gallery

p. 51 Barnaby Furnas, *Suicide I*, 2002. Urethane on linen, 152.4 x 99 cm (60 x 39 in). Courtesy of Marianne Boesky Gallery

p. 52 Rezi van Lankveld, *Pieta*, 2005. Oil on board, 30.7 x 25.6 cm (78 x 65 in). Courtesy The Approach, London

p. 53 Rezi van Lankveld, *Linger*, 2004. Oil on board, 17.3 x 15.7 cm (44 x 40 in). Courtesy The Approach, London

p. 54 Martin Maloney, *Box Junction*, 2004. Oil on canvas, 259.7 x 213.4 cm (102 1/4 x 84 in). © the artist. Courtesy Timothy Taylor Gallery, London

p. 56 Alex Katz, *Ada, Late Summer*, 1994. Oil on canvas, 121.9 x 182.9 cm (48 x 72 in). Chrysler Museum of Art, Norfolk, Virginia. Museum purchase with funds provided by Oriana and Arnold McKinnon, David and Susan Goode, Leah and Richard Waitzer, Dylan, Max, Jessica and Leyla Sandler, Mrs George M. Kaufman, Mrs Charles R. Dalton, Jr., Dr Paul and Renée Mansheim, Pat and Jeff Brown, Mary Ellen and Daniel Dechert, Barbara and Andrew Fine, Mr and Mrs Harry T. Lester, Gus and Deanne Miller, Nancy and Malcolm Branch, Mr and Mrs Theodore D. Galanides, Martha and Richard Glasser, Dr and Mrs Robert C. Rowland, Jr., Dr Robert and Judy Rubin, Melanie and Ken Wills, Anne and Lawrence Fleder, Marion Johnson Lidman, Lois and Hil Strode, and matching funds from Norfolk Southern Corporation, Caterpillar, Inc., Georgia–Pacific Corporation, and Texas Instruments. Additional funds provided by the Walter P. Chrysler, Jr., Art Purchase Fund and Landmark Communications Art Purchase Fund. Photo Ellen Page Wilson, courtesy PaceWildenstein, New York. © Alex Katz/VAGA, New York/DACS, London 2006

p. 58 Thomas Eggerer, *The Privilege of the Roof*, 2004. Acrylic on canvas, 121.9 x 233.7 cm (48 x 92 in). Courtesy of the artist and the Friedrich Petzel Gallery, New York

p. 59 Thomas Eggerer, *The Wisdom of Concrete*, 2004. Acrylic on canvas, 228.6 x 200.7 cm (90 x 79 in). Courtesy the artist and the Friedrich Petzel Gallery, New York

p. 60 Jules de Balincourt, *Poor Planning*, 2005. Oil, enamel and spray paint on panel, 71.1 x 106.7 cm (28 x 42 in). Courtesy Zach Feuer Gallery (LFL), New York

p. 61 Jules de Balincourt, *Amateur Night (Steakout)*, 2004. Oil and enamel on panel, 111.8 x 149.9 cm (44 x 59 in). Courtesy Zach Feuer Gallery (LFL), New York

p. 62 Geraint Evans, *Las Vegas*, 2002. Acrylic on board, 65 x 72 cm (25 1/2 x 28 3/8 in). Courtesy Wilkinson Gallery, London

p. 63 Geraint Evans, *A Berkshire Z Boy*, 2004. Acrylic on board, 90 x 106 cm (35 1/2 x 41 3/4 in). Courtesy Wilkinson Gallery, London

p. 64 Martin Maloney, *Stroller*, 2004. Oil on canvas, 259.7 x 213.4 cm (102 1/4 x 84 in). © the artist. Courtesy Timothy Taylor Gallery, London

p. 65 Martin Maloney, *Loafers*, 2004. Oil on canvas, 213.4 x 259.7 cm (84 x 102 1/4 in). © the artist. Courtesy Timothy Taylor Gallery, London

p. 66 (l) James Rielly, *Deep Down I'm Shallow*, 2004. Oil on linen, 203.2 x 182.9 cm (80 x 72 in). © the artist. Courtesy Timothy Taylor Gallery, London

p. 66 (r) James Rielly, *Black Rabbit*, 2001. Oil on canvas, 198 x 167.5 cm (78 x 66 in). © the artist. Courtesy Timothy Taylor Gallery, London

p. 67 James Rielly, *In Mind*, 2003. Oil on canvas, 183 x 149.8 cm (72 x 59 in). © the artist. Courtesy Timothy Taylor Gallery, London

p. 68 (l) Mathew Cerletty, *Untitled*, 2005. Oil and wood on canvas, 60.9 x 55.9 cm (24 x 22 in). Courtesy Rivington Arms, New York

p. 68 (a) Mathew Cerletty, *Untitled*, 2004. Oil and prosthetic teeth on canvas, 96.5 x 96.5 cm (38 x 38 in). Courtesy Rivington Arms, New York

p. 68 (b) Mathew Cerletty, *The Faux Pas*, 2004. Oil on canvas, 182.9 x 137.2 cm (72 x 54 in). Courtesy Rivington Arms, New York

p. 69 Mathew Cerletty, *The Bath*, 2002. Oil on canvas, 86.4 x 50.8 cm (34 x 20 in). Courtesy Rivington Arms, New York

p. 70 Eric Fischl, *Bedroom Scene No. 8*, 2004. Oil on linen, 140.9 x 213.4 cm (55 1/2 x 84 in). Courtesy Jablonka Galerie, Cologne

p. 71 Eric Fischl, *Bathroom Scene No. 4*, 2005. Oil on linen, 188 x 233.7 cm (74 x 92 in). Courtesy Jablonka Galerie, Cologne

p. 72 Dawn Mellor, *Christina Wieners*, 2004. Oil on canvas, 152 x 91 cm (59 13/16 x 35 13/16 in). Courtesy the artist and Victoria Miro Gallery, London

p. 73 Dawn Mellor, *Madonna Molotov*, 2004. Oil on canvas, 106.5 x 121.5 cm (41 15/16 x 47 13/16 in). Courtesy the artist and Victoria Miro Gallery, London

p. 74 (l) Elizabeth Peyton, *Peconic (Ben)*, 2002. Oil on board, 27.9 x 35.6 cm (11 x 14 in). © the artist. Courtesy Sadie Coles HQ, London

p. 74 (r) Elizabeth Peyton, *Pauline*, 2005. Oil on board, 25.4 x 20.3 cm (10 x 8 in). © the artist. Courtesy Sadie Coles HQ, London

p. 75 Elizabeth Peyton, *Ken and Nick*, 2005. Oil on board, 27.9 x 22.9 cm (11 x 9 in). © the artist. Courtesy Sadie Coles HQ, London

p. 77 Muntean/Rosenblum, *Untitled (Everything High Above...)*, 2003. Acrylic on canvas, 203 x 180 cm (79 15/16 x 70 15/16 in). Courtesy Maureen Paley Gallery, London

p. 78 Jun Hasegawa, *23 Figures*, 2004. Household gloss paint on canvas, 152.4 x 304.8 cm (60 x 120 in). Courtesy 20.21 Galerie, Essen

p. 79 Jun Hasegawa, *Untitled*, 2004. Household gloss paint on canvas, 157.4 x 213.3 cm (61 15/16 x 83 15/16 in). Courtesy 20.21 Galerie, Essen

p. 80 Djamel Tatah, *Untitled*, 2003. Oil and wax on linen, 200 x 250 x 3 cm (78 3/4 x 98 1/2 x 1 1/8 in). Private collection. © Karin Maucotel/Paris-Musées. Courtesy Galerie Kamel Mennour, Paris

p. 82 Peter Doig, *Gasthof*, 2004. Oil on canvas, 275 x 200 cm (108 1/4 x 78 3/4 in). Photograph by Jochen Littkeman. Courtesy Contemporary Fine Arts, Berlin

p. 84 Takashi Murakami, *Jellyfish Eyes-MAX & Shimon in the Strange Forest*, 2004. Acrylic on canvas mounted on board, 150 x 150 x 5 cm (59 1/16 x 59 1/16 x 1 15/16 in). Courtesy Blum & Poe, LA. ©2004 Takashi Murakami/Kaikai Kiki Co., Ltd. All Rights Reserved.

p. 84 Yoshitomo Nara, *My 13th Sad Day*, 2002. Acrylic on canvas over fibreglass, diameter 179.7 cm (70 3/4 in), depth 26 cm (10 1/4 in). Courtesy of Marianne Boesky Gallery

p. 85 David Harrison, *Miss Kitty in Paradise*, 2005. Oil on canvas, 91.5 x 76 cm (36 x 29 15/16 in). Courtesy the artist and Victoria Miro Gallery, New York

p. 86 Rui Matsunaga, *Light Sabre*, 2005. Oil on canvas, 122 x 90 cm (48 x 35 1/2 in). Courtesy the artist

p. 87 (l) Rui Matsunaga, *Eternal Sunshine*, 2005. Oil on canvas, 128 x 102 cm (50 1/2 x 40 in). Courtesy the artist

p. 87 (r) Rui Matsunaga, *Keeper of the Garden*, 2005. Oil on canvas, 128 x 102 cm (50 1/2 x 40 in). Courtesy the artist

p. 88 (a) Henning Kles, *Ludergrube II*, 2004. Oil and paint on canvas, 190 x 165 cm (74 13/16 x 64 15/16 in). Gift of Junge Freunde 2005 Hamburger

Index